100 Years of
Boxing
Twentieth Century in Pictures

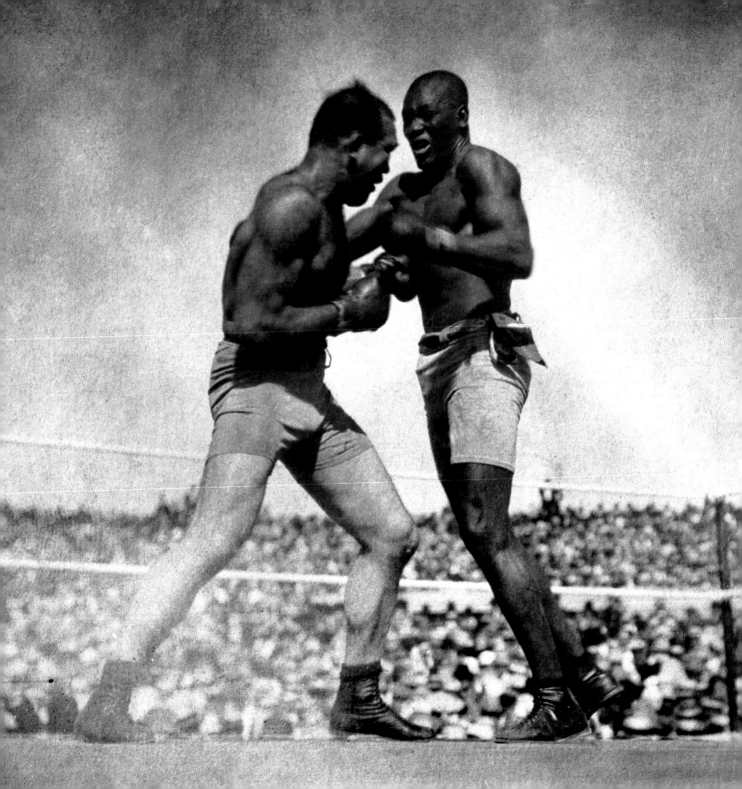

100 Years of
Boxing
Twentieth Century in Pictures

PRESS
ASSOCIATION

AMMONITE
PRESS

First Published 2010 by
Ammonite Press
an imprint of AE Publications Ltd,
166 High Street, Lewes, East Sussex, BN7 1XU

Text © AE Publications Ltd
Images © Press Association Images
© Copyright in the Work AE Publications Ltd

ISBN 978-1-906672-55-3

British Cataloguing in Publication Data. A catalogue
record of this book is available from the British Library.

Editor: Ian Penberthy
Series Editor: Richard Wiles
Picture research: Press Association Images
Design: Gravemaker + Scott

Colour reproduction by GMC Reprographics
Printed by Hung Hing in China

Page 2: Jack Johnson (R) clashes
with former undefeated heavyweight
champion James J Jeffries in Reno,
Nevada, USA before 22,000 fans.
Johnson's rise to prominence had
sparked racial animosity among
whites, and Jeffries had come out
of retirement saying, *"I am going
into this fight for the sole purpose
of proving that a white man is better
than a Negro."* When the stronger,
nimbler Johnson had proved his
dominance, Jeffries' corner threw in
the towel after 15 rounds in fear of
a knockout. The outcome triggered
race riots across the United States.
4th July, 1910

Page 5: Referee Ike Powell raises
Henry Cooper's hand after the
boxer had taken the Commonwealth
and British heavyweight title from
new champion Brian London in
a 15-round decision on points, at
Earls Court, London.
12th January, 1959

Page 6: America's Mike Tyson looks
dejected after losing to England's
Danny Williams in a heavyweight
contest at the Freedom Hall,
Louisville, Kentucky, USA. Amid
a turbulent private life, Tyson had
staged numerous comeback fights.
During the bout with Williams, he
tore a ligament in his knee and was
knocked out in the fourth round.
31st July, 2004

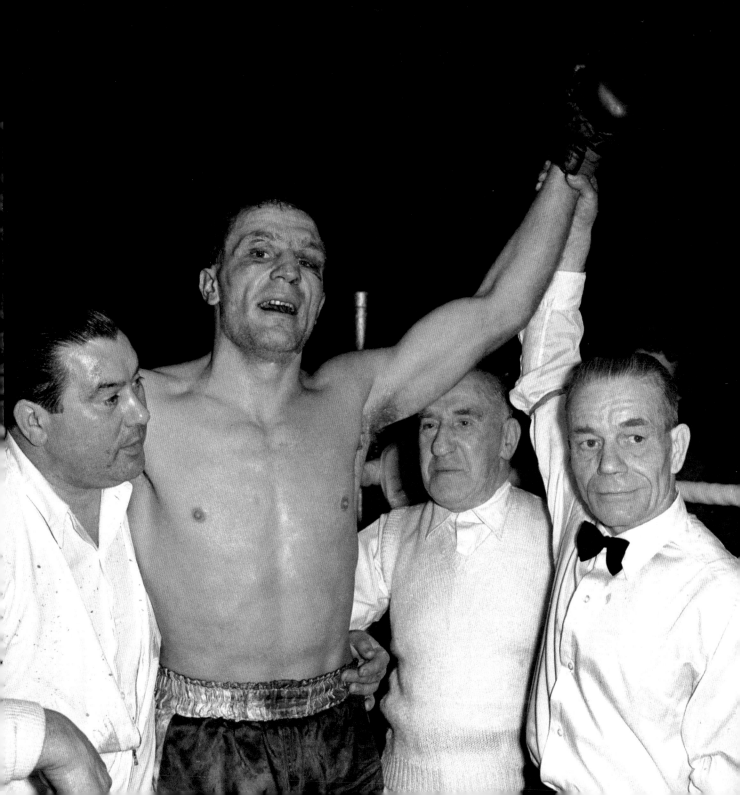

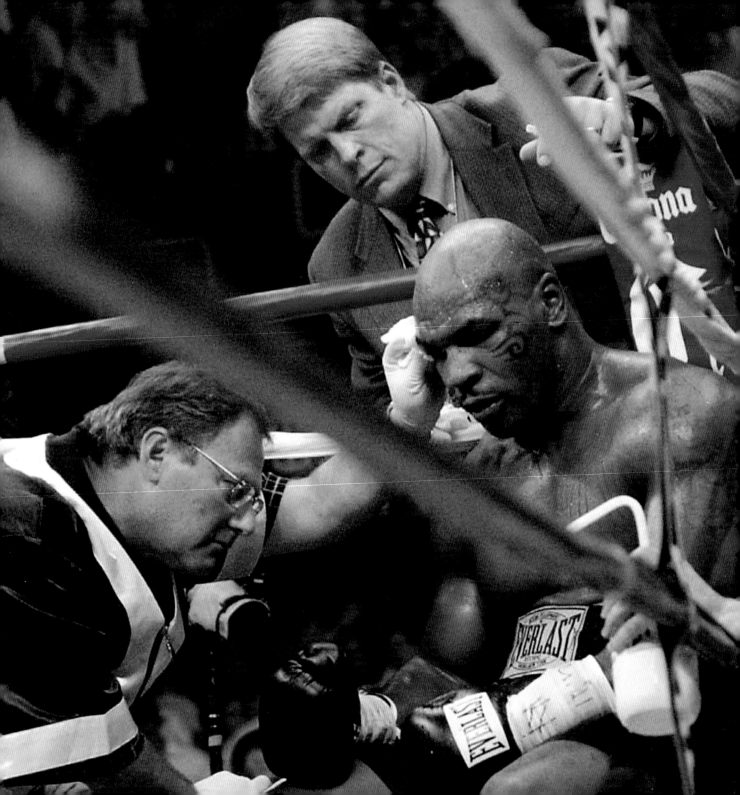

Introduction

Fighting with fists is one of the earliest combat sports: fights are depicted in relief carvings from Sumeria and ancient Egypt; the ancient Greeks held contests in which combatants wore lethal spiked gloves; while a brutal form of the sport was practised by ancient Romans in gladiatorial arenas. But the term 'boxing' only came into use in 18th-century Britain, when the bare-knuckle 'prizefight' – which had no written rules, no weight divisions and no referee – became a popular spectator event.

The London Prize Ring rules of 1838 introduced the concept of the ring and the 'count' for knocked-down boxers, while banning biting, head-butting and hitting below the belt, but it was not until the Marquess of Queensbury rules of 1867 that a set of written rules was established – and padded gloves used to lessen the physical damage to both combatants. Legitimacy did not follow until the next century, however, and the rules establishing three-minute rounds, a total of up to 12 rounds, the minute's rest in the corner and the point system allocated by ringside judge have governed the sport ever since. Despite the presence of a referee to control the conduct of the fighters, monitor their ability to fight within safety limits, count out knocked-down fighters and rule on fouls, the ring remains a dangerous place. Apart from the 'cauliflower' ears, broken noses, cuts and contusions that characterize the visage of a fighter, some boxers have suffered permanent brain injury, while others have died as a result of their sport.

Many underprivileged youngsters graduated from brawling in the streets to the discipline of the gymnasium as a chance to escape poverty, when otherwise they might have been lured into a life of crime and violence. Professional boxing has long been motivated by money: fighters compete for trophies and a share of the purse, promoters make millions from the gate, while spectators bet on the result of a bout. The amateur sport flourished, however, after boxing was included in the 1908 London Olympics. In three or four rounds, the fighters – wearing protective headgear – are awarded points on the number of clean blows landed, regardless of impact, judged by a scoring strip across the knuckles of the gloves. But for many young fighters, the amateur ring is a nursery where they can hone their skills and gain experience for a professional career.

Throughout a century of competitive boxing, the photographers of the Press Association have been stationed ringside to capture the excitement, triumphs, tragedies and controversies of boxing for the newspapers and sporting journals of the day, encapsulating this primal sport of skill, brutality and grace, which pits man against man – or, in the modern era, woman against woman – with only their fists as weapons and agility their defence.

Jem Mace, born in Beeston, Norfolk, in 1831, was a successful bare-knuckle prizefighter who, after the introduction of the Queensberry Rules of 1867, toured the USA and Australia helping to promote gloved boxing. He became the first heavyweight boxing champion of the world, after defeating American champion Tom Allen on 10th May, 1870. In later life he was an exhibition boxer and last appeared in the ring aged 78. Having squandered his money on gambling, he ended his life as a penniless busker in 1910.

19th May, 1890

American James John 'Gentleman Jim' Corbett, considered by many to be the 'father' of modern boxing because of his scientific approach and innovative technique of wearing down his opponent with jabs, won the World Heavyweight Boxing Championship on 7th September, 1892 at the Olympic Club in New Orleans, USA by knocking out John L Sullivan in the 21st round. In addition to boxing, Corbett also enjoyed a career as an actor in both theatre and low-budget films.
1891

James 'Jim' Driscoll, from
Cardiff, Wales, entered the
boxing ring to fight his way
out of poverty. He was the
first featherweight to win
the Lonsdale Belt in 1910;
he also became British
featherweight champion.
1st April, 1907

Middleweight boxer Johnny Douglas, from Stoke Newington, London, became a gold medalist at the 1908 Olympic Games held in London, fighting three bouts on the same day. Douglas was also a skilled cricketer, captaining the England team 18 times between 1911 and 1921. He drowned, aged 48, when the *Oberon,* the ship on which he was travelling with his father, collided with another vessel in foggy weather when returning from Finland on 19th December, 1930.
27th October, 1908

Londoner Richard Gunn took the gold medal in the featherweight division at the 1908 Olympic Games. He remains the oldest man ever to win an Olympic boxing crown, a feat achieved at the age of 37 years and 254 days. So much better than his rivals, he had been asked to retire by the Amateur Boxing Association (ABA) after his third successive win. He obliged, but returned to take his Olympic victory. During his boxing career, Gunn lost only one fight in 15 years. He died in London aged 90.

27th October, 1908

American James Edward 'Jimmy' Britt (L) and Englishman Johnny Summers, lightweight boxers, sign a contract for their second meeting on 22nd February, 1909. The pair had previously fought on 2nd November, 1908 in a spirited ten-round bout won by Britt. On their second outing, Britt had the upper hand until the eighth round, but, holding in clinches more than was usual in England, he received several warnings from referee Eugene Corri. At the end of the 20th round, the decision was given to Summers on points.

January, 1909

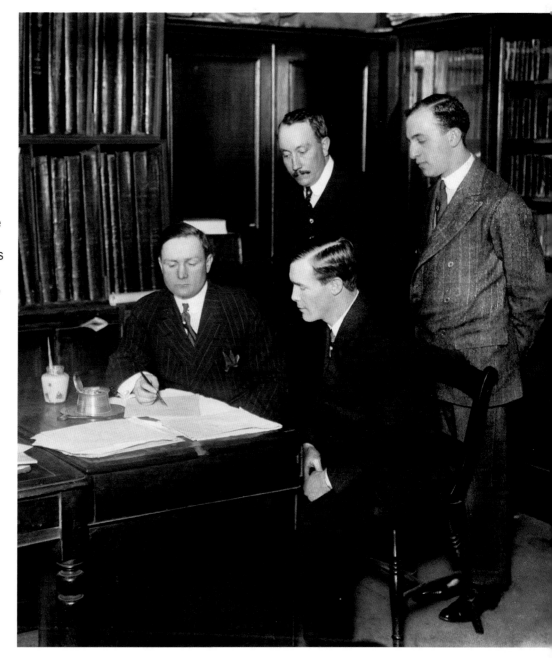

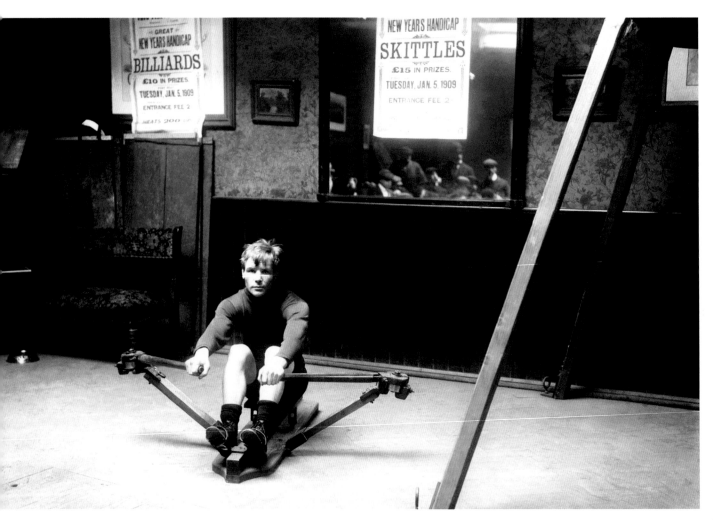

Middlesbrough born
Johnny Summers, 27, trains
on a rowing machine in
preparation for his third bout
against the Californian Jimmy
Britt on 31st July, 1909.
1st July, 1909

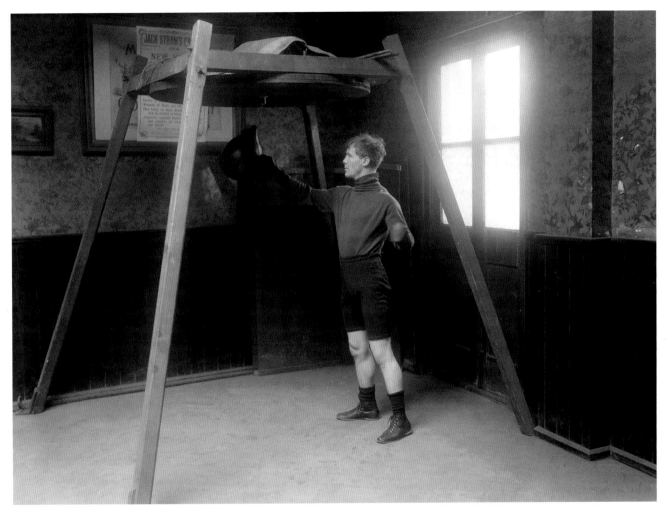

Summers trains on a
punchball before his
upcoming fight with Jimmy
Britt of the USA.
1st July, 1909

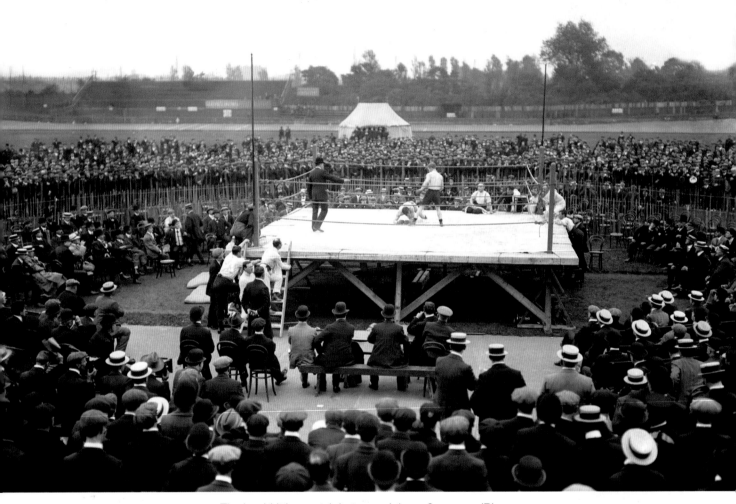

The hard-hitting match between Johnny Summers (R)
and Jimmy Britt was held in an open-air ring in West Ham,
London, before an enthusiastic crowd of 5,000 people.
Summers outclassed his opponent from the start, knocking
out the American in the ninth round with a swinging blow to
the point of the jaw that swept him off his feet.
31st July, 1909

Jim Driscoll, world featherweight champion, announced his retirement shortly after beating Owen Moran at the National Sporting Club, Covent Garden, London. Driscoll's final official record is 63 bouts, four lost, six drawn, with 39 knockouts. After the well-loved boxer died of pneumonia at the age of 44, more than 100,000 people lined the streets of Cardiff for his funeral.
27th January, 1913

Irish heavyweight Petty Officer Matthew 'Nutty' Curran strikes a pose before his defeat of Gunner Ellis with a first-round knockout on 10th January at the Old Cosmo Rink, Plymouth, Devon.

January, 1913

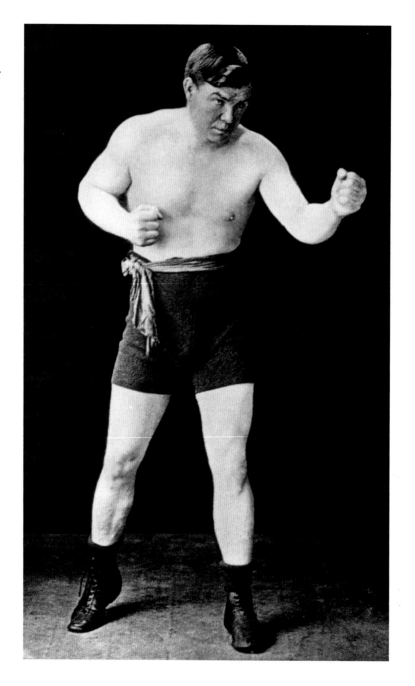

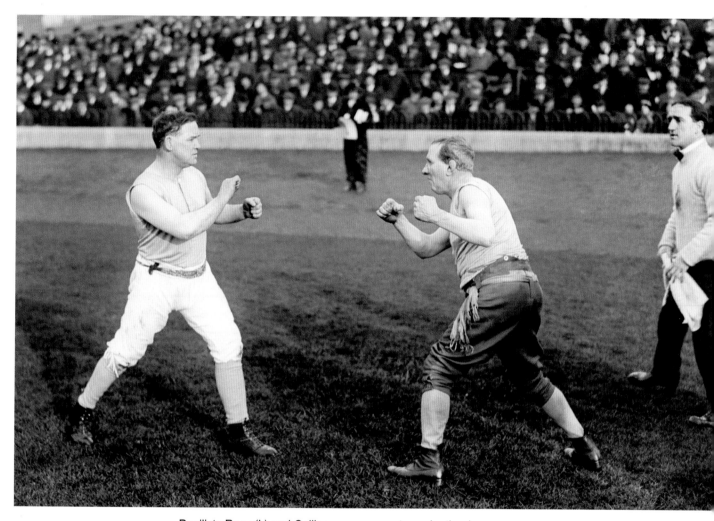

Pugilists Ross (L) and Collinson square up to each other in a bare-knuckle bout watched closely by the referee. Although fighting without boxing gloves, opponents had to follow the London Prize Ring rules that had been promulgated in 1838, which specified a broad range of holds, throws and attire. The ultimate aim, however, was to down your man with a blow.

1st August, 1914

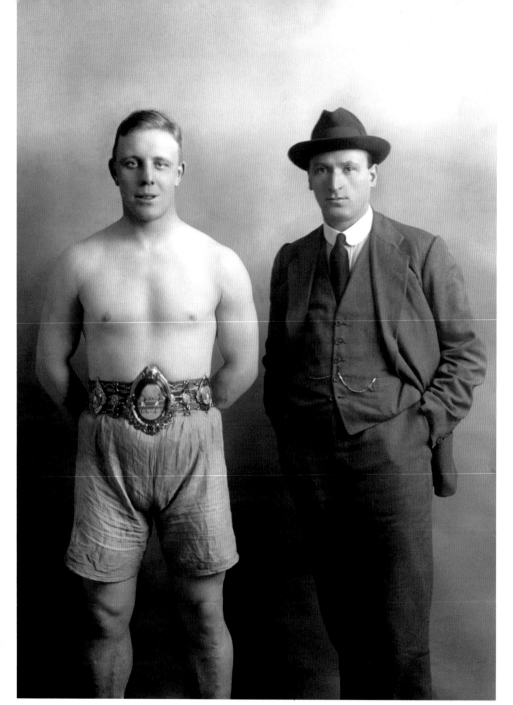

Light heavyweight boxing
champion Harry Reeve
(L), with his manager Dan
Sullivan, proudly displays
the champion's belt he had
won by defeating Dick Smith
on 10th October, 1916 at
the National Sporting Club,
Covent Garden, London.
In his career of 70 wins,
50 losses and 20 no-
decisions, Reeve fought
many big names in boxing
from middleweight up to
heavyweight.
January, 1917

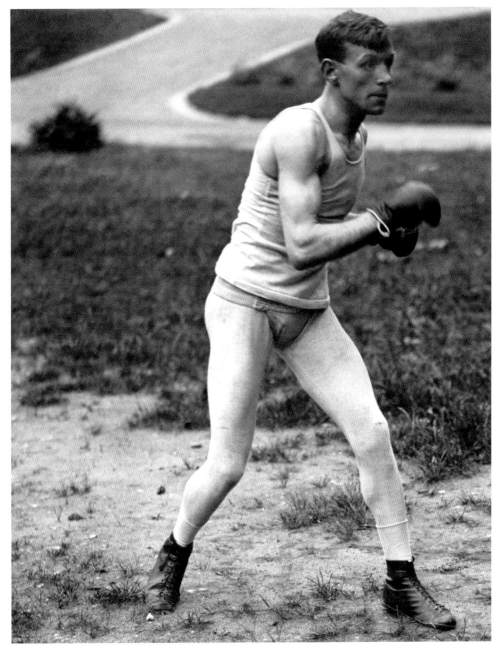

The first official world flyweight champion, Jimmy Wilde, in training. Despite his small, pale and frail-looking frame – he never achieved eight stones throughout his career – he was courageous, possessed blindingly fast hands and, pound for pound, was a devastating puncher.
1918

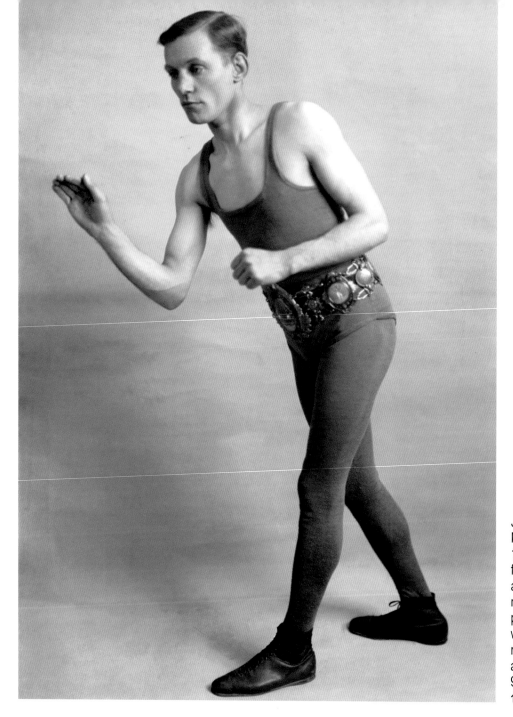

Jimmy Wilde, born in Merthyr Tydfil, Wales, in 1892, began fighting in fairground boxing booths, accepting challenges from members of the audience or performing exhibition bouts with other fighters. He had a record of 137 wins, 5 losses and 8 no-decisions, with 99 wins by knockout.
1919

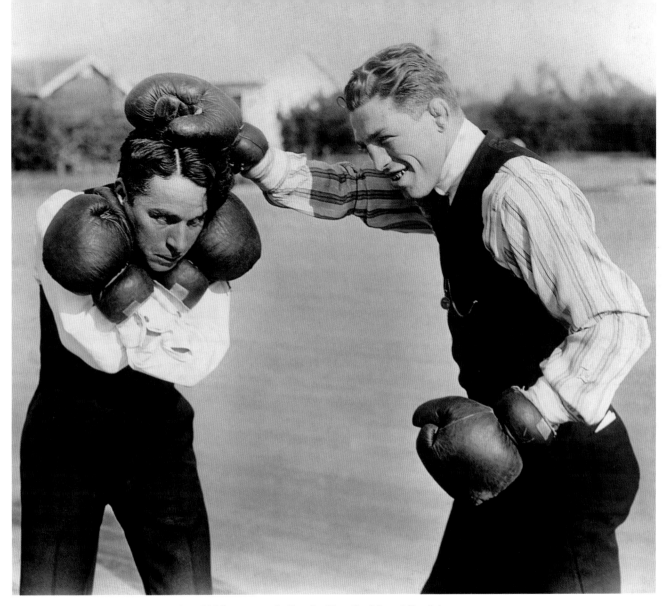

Just kidding around. Charlie Chaplin (L) and English boxer Ted 'Kid' Lewis engage in a friendly match. World welterweight champion Lewis, credited with being the first fighter to use a mouthpiece, enjoyed celebrity status, and Chaplin was godfather to his son.
January, 1919

World flyweight boxing champion Jimmy Wilde (L) chats with champion jockey Steve Donoghue during a race meeting at Windsor.
8th April, 1919

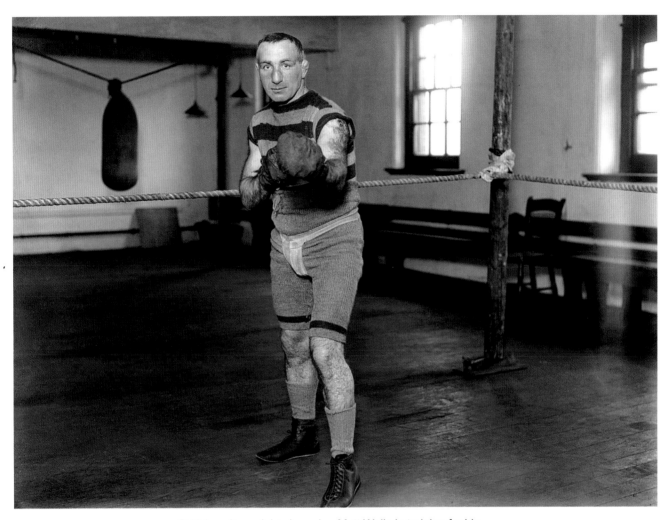

British welterweight champion Matt Wells in training for his fight with Ted 'Kid' Lewis, which would take place on Boxing Day at the Royal Albert Hall, Kensington, London. Walworth born Wells would lose the bout in the 12th round due to a technical knockout.

24th December, 1919

Stand on me. Owen 'The Fearless' Moran, a former
featherweight boxing champion, who retired in 1916 with
more than 100 fights to his name, stands on Phil Bloom, a
lightweight boxer in training at Wembley, Middlesex.
23rd January, 1920

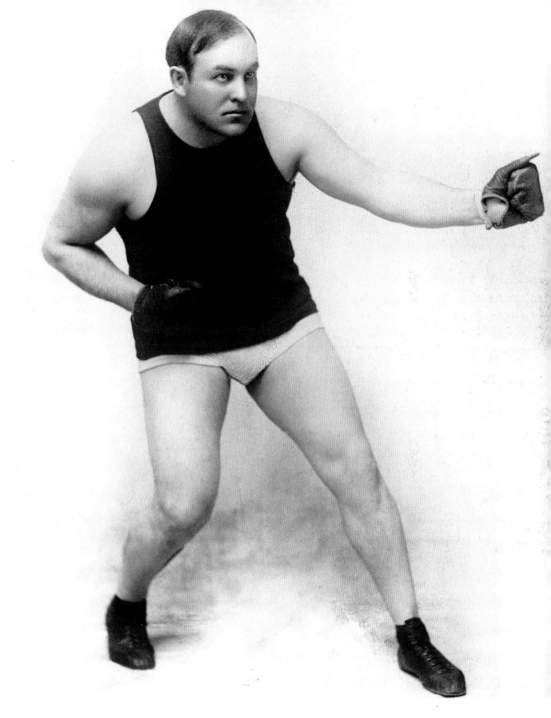

Short, squat, but quick and bouncy with a stinging, sharp punch, Tommy Burns, born Noah Brusso, is the only Canadian born heavyweight champion of the world, and the first fighter to agree to a heavyweight championship bout with a black boxer. Jack Johnson took the title in a match held in Sydney, Australia on 26th December, 1908. Burns boxed infrequently after losing the title and retired after suffering his only knockout loss to British champion Joe Beckett, in July 1920.

1st February, 1920

British, European and Commonwealth welterweight champion Johnny Basham, 'The Happy Wanderer', from Newport, Wales, the day before he lost the titles to Ted 'Kid' Lewis at Olympia, London after a technical knockout in the 19th round.
8th June, 1920

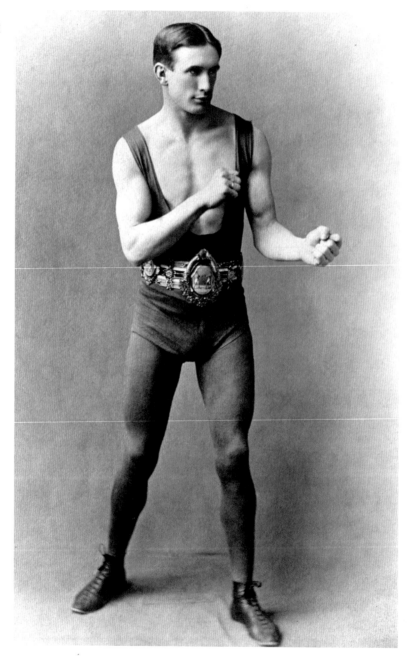

100 Years of Boxing • Twentieth Century in Pictures

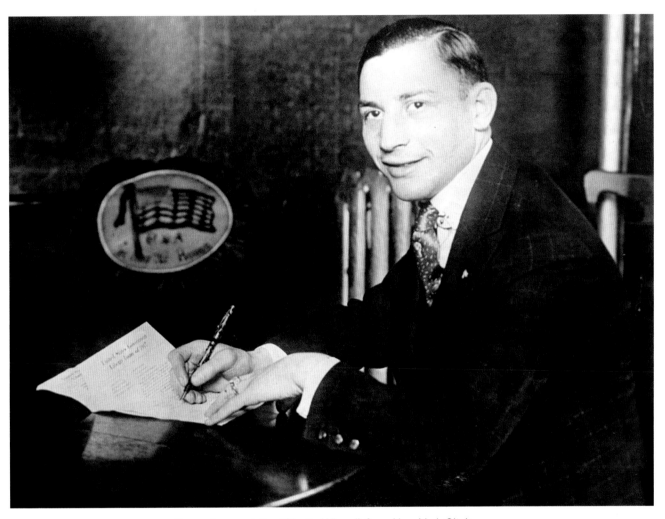

Benny Leonard, the 'Ghetto Wizard', from New York City's
East Side, signs the contract to fight fellow American
Charley White for the world lightweight title at Benton
Harbor, Michigan, United States, on 5th July, 1920. Despite
being thrown out of the ring by White in round five, Leonard
knocked out his opponent in the ninth round.

30th June, 1920

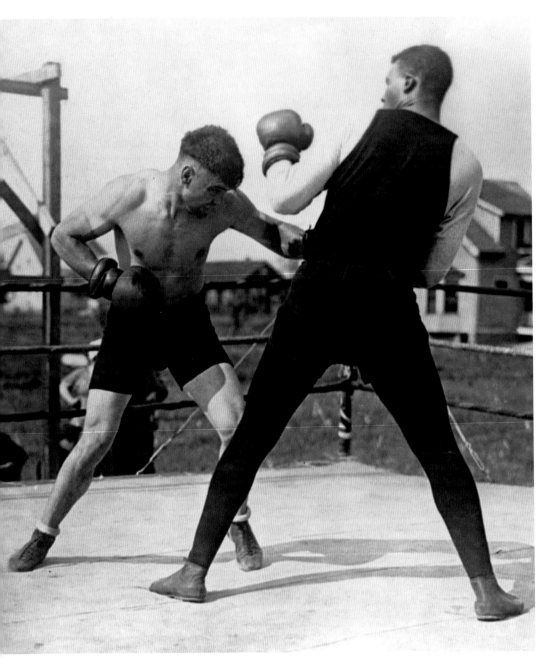

Jack 'Manassa Mauler' Dempsey, the American heavyweight boxer, who held the title from 1919 to 1926, spars in the ring five days prior to his defence of the world heavyweight title against Billy Miske at Benton Harbor, USA.

1st September, 1920

Dempsey was renowned as an aggressive boxer with a powerful punch; he kept in shape by sparring, cross training and exercising each day. The boxer's powerful right hook would knock out Miske in the third round of his defending bout for the world heavyweight title.

1st September, 1920

A look of determination on the face of Yorkshire welterweight boxer Ernie Rice, who, five days before, had suffered a technical knockout in the seventh round of a bout against Pat Mills, in only his second match. During his career of 197 rounds boxed, Rice won 11 bouts with 10 knockouts, but lost 12.

25th September, 1920

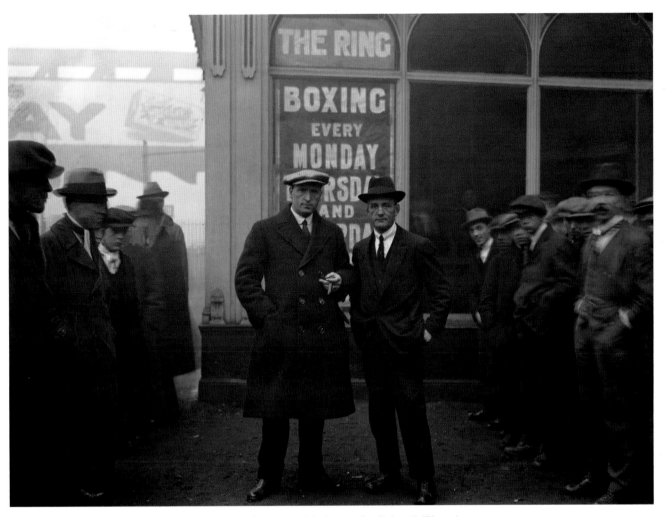

Retired Welsh featherweight boxer Jim Driscoll (R) and
manager Dan Sullivan outside The Ring, Blackfriars,
London. The venue was opened in 1910 by former British
heavyweight champion Dick Burge as a showcase for top-
class boxing at prices the working class could afford. The
building was destroyed in 1942 when it received two direct
hits from a German bomber.
1st November, 1920

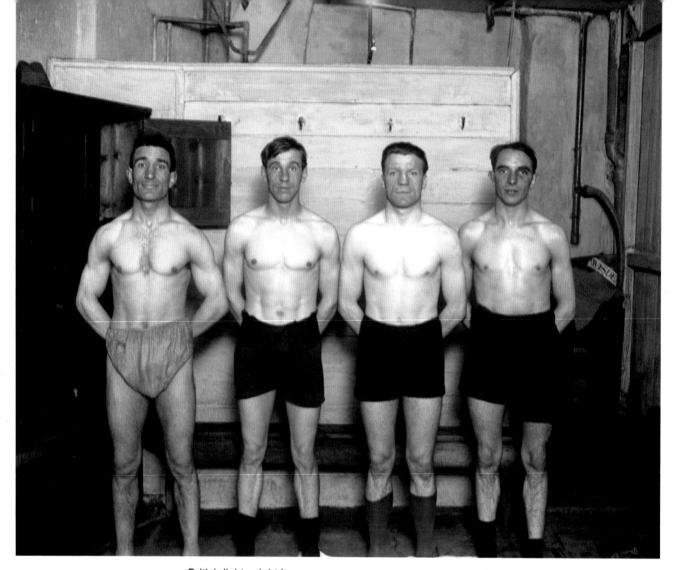

British lightweight boxers:
(L–R) Ernie Rice, Seaman
Smith, Jack Josephs and
Tommy Phillips.
1st November, 1920

Boxing competitions between women began with a demonstration bout at the 1904 Summer Olympics, and there was a resurgence of interest in women's boxing in Berlin, Germany in 1921. It would not be until the 2012 Games in London, however, that three women's weight classes would be admitted to the programme.
11th June, 1921

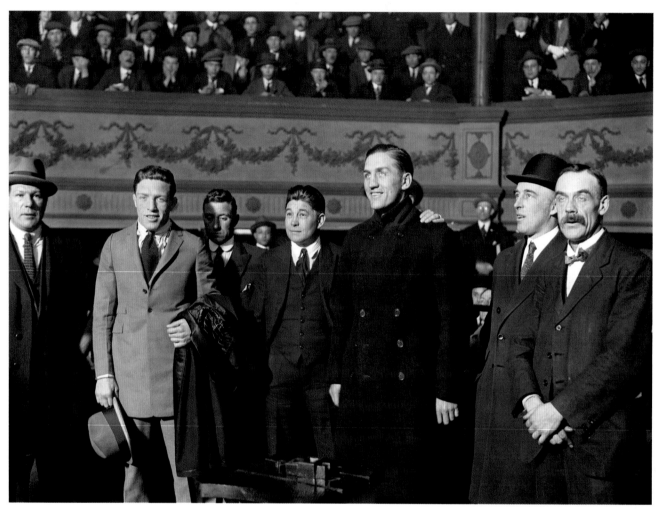

Ted 'Kid' Lewis (second L) and light heavyweight champion Frenchman Georges Carpentier (fifth L), after weigh in at The Ring. Also pictured is Francois Descamps, Carpentier's manager (fourth L) and promoter Major Arnold Wilson (second R). The following day, in the first round of the bout at Olympia, Lewis began strongly until referee Joe Palmer (third L) placed a hand on his shoulder to warn against holding. While Lewis was distracted, Carpentier let fly a vicious right: Lewis crashed to the canvas and was counted out only 2 minutes and 15 seconds into the bout.

10th May, 1922

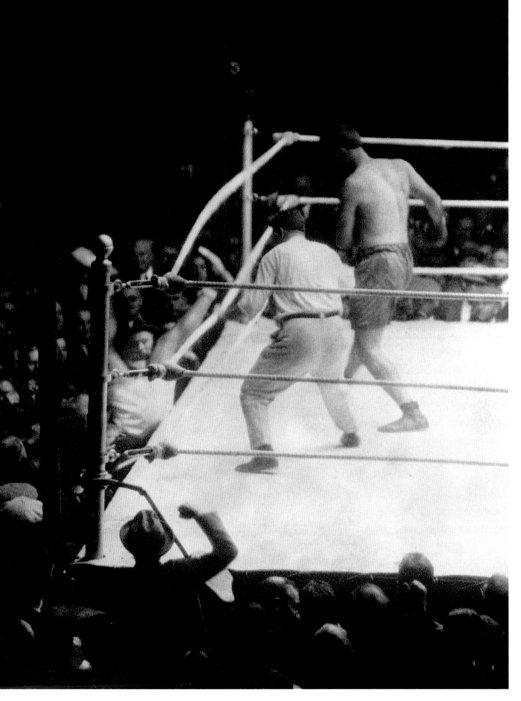

In New York, USA, Argentinian Luis Firpo knocked world heavyweight champion Jack Dempsey through the ropes and into the Press row, where his head struck a reporter's typewriter. Dempsey was helped back into the ring on the count of nine, despite being outside for 17 seconds, and went on to knock out Firpo in the second round.
14th September, 1923

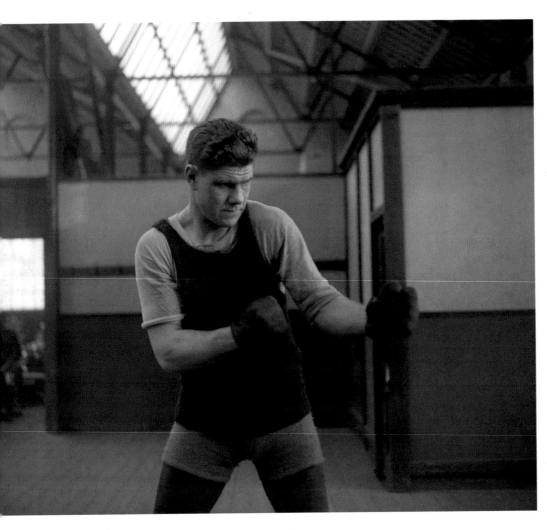

Frank Goddard, 'The Fighting Farmer', training for his bout against Jack Bloomfield to claim the vacant British Boxing Board of Control (BBBofC) British heavyweight title. Goddard had first won the title on 26th May, 1919, by beating Jack Curphey, but lost it the following month to Joe Becket, who later vacated the title. Goddard regained the title on 21st November after Bloomfield was disqualified for hitting his opponent while he was down.

17th November, 1923

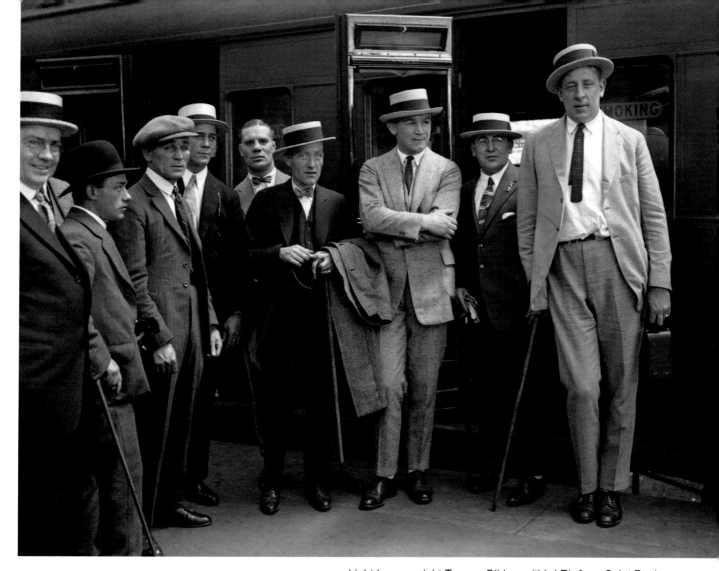

Light heavyweight Tommy Gibbons (third R), from Saint Paul, Minnesota, USA, arrives in London for his bout with Jack Bloomfield on 9th August, 1924, the first ever boxing event to be held at Wembley Stadium. Leaning on his cane (R) is 6ft 3in English heavyweight 'Bombardier' Billy Wells.
12th July, 1924

One of the most popular boxers in history, Jack Dempsey, on arrival at Southampton. After his controversial fight with Luis Firpo in 1923, Dempsey did not defend his title for three years.
1925

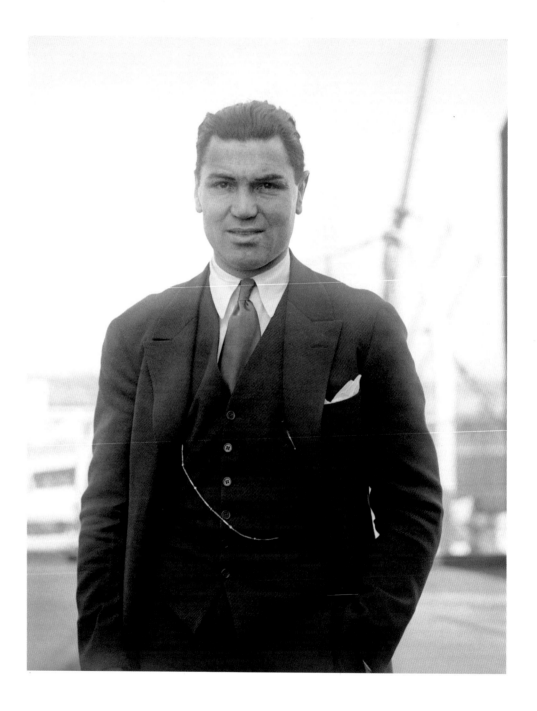

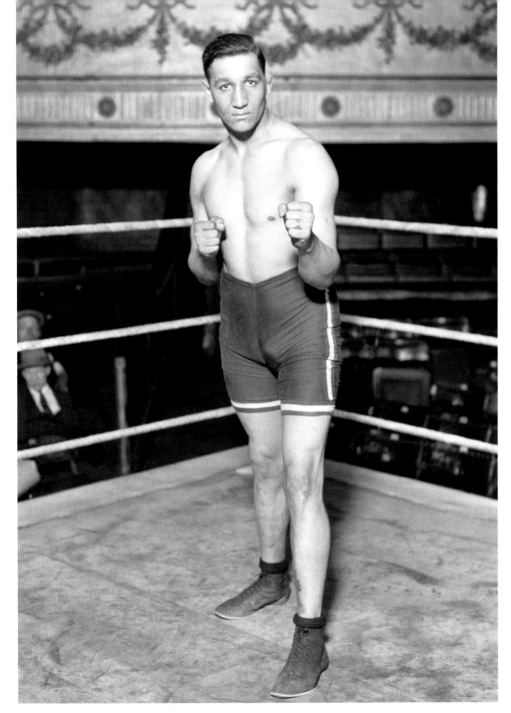

Billy 'Gipsy' Daniels, British light heavyweight champion. Daniels, who was born in Wales, was given his nickname by American promoter James J Johnstone, who thought he looked like a gypsy and dressed him in bandana, neckerchief and hooped earrings.
1925

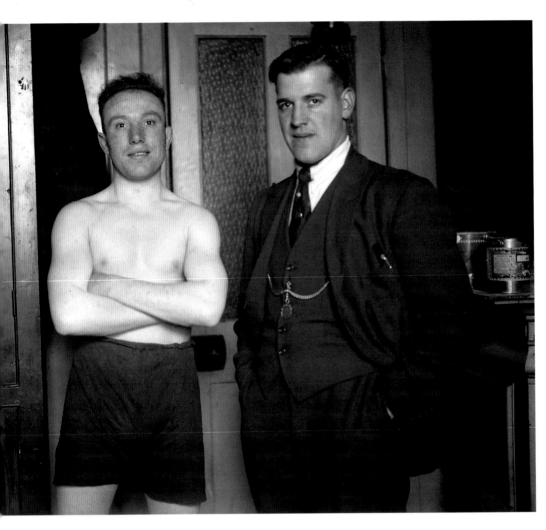

Johnny Curley (L), from Lambeth, south London, became British featherweight boxing champion on 30th March, 1925 after winning a bout against George McKenzie at the National Sporting Club, Covent Garden, London; he held the title until 1927. In his career, he fought in 166 bouts, won 118, lost 30 and drew 17.

31st March, 1925

Irish boxer Johnny Sullivan (L) and light heavyweight Len Harvey, from Stoke Climsland, Cornwall, after weighing in at The Ring. The bout, held at the National Sporting Club, Covent Garden, was a 20-round battle of tactical boxing, which Sullivan would win on points.
1st March, 1926

Three days before the event, Irish-American James Joseph 'Gene' Tunney strikes a sparring pose during the build-up to his world heavyweight title challenge against defending champion Jack Dempsey, at the Sesquicentennial Stadium, Philadelphia, USA. Tunney, who had lost only once in his career, would win on points after ten rounds, watched by a record attendance of 120,557 people.

20th September, 1926

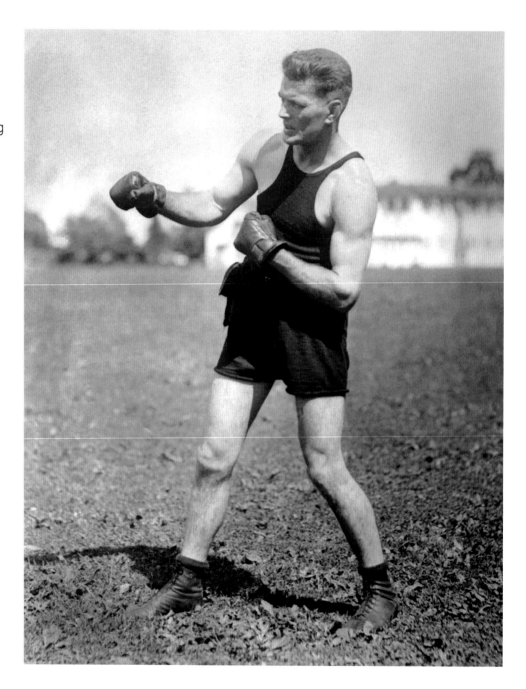

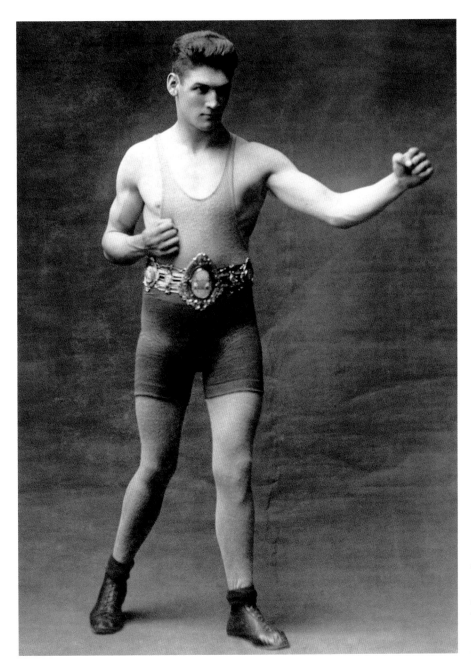

Birmingham boxer Jack
Hood proudly displays
his British welterweight
titleholder's belt, which
he won after a 20-round
decision over Harry Mason,
from Leeds; he held the title
until he retired in 1934.
23rd July, 1927

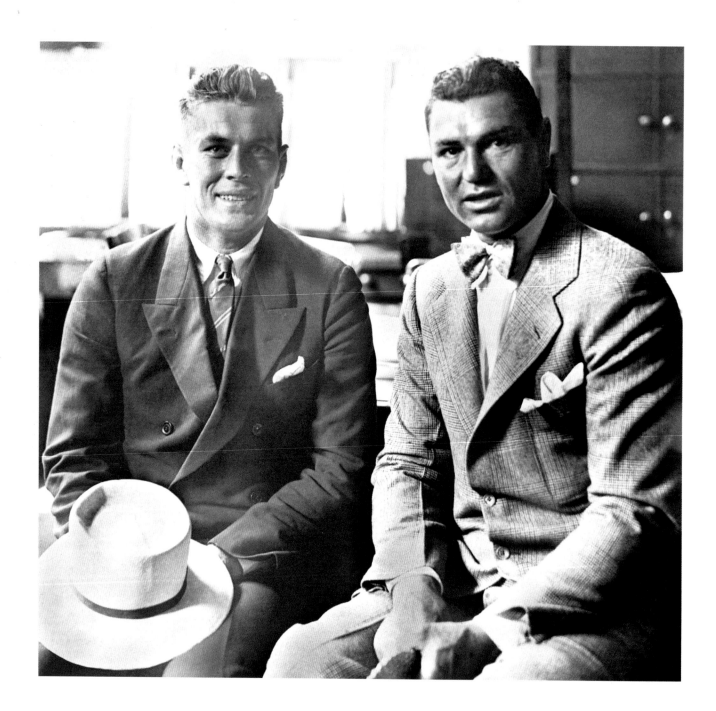

Facing page: Gene Tunney (L) and Jack Dempsey, who were to meet in a much-anticipated rematch in Chicago, USA, where Dempsey hoped to regain the world heavyweight championship he had lost the previous year.
14th September, 1927

Heavyweight champion Gene Tunney (R) looks up from the canvas after being floored by a punch from challenger Jack Dempsey in the seventh round. Tunney allegedly stayed down for 14 seconds, referee Dave Barry having persuaded Dempsey to retreat to a neutral corner before beginning his count. Tunney recovered to win on points, but his victory was blighted by the controversy of 'The Long Count'.
22nd September, 1927

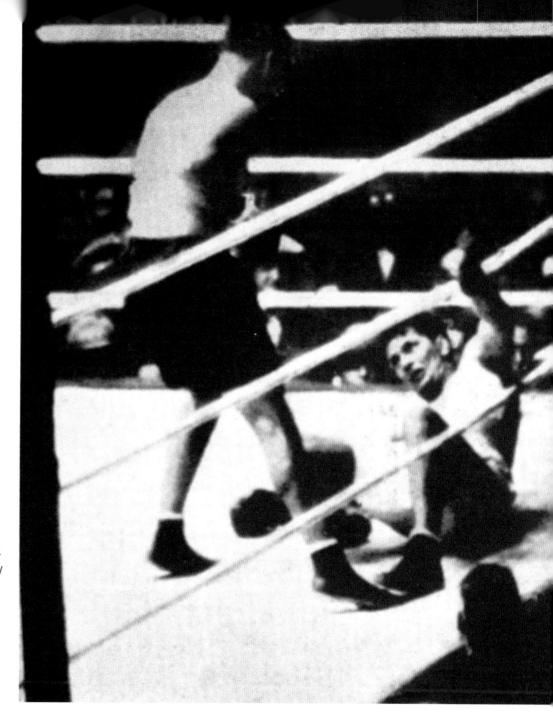

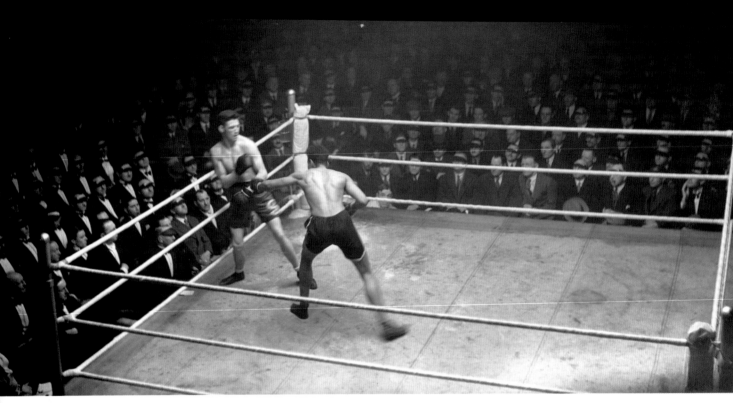

The Prince of Wales was in the audience (front row, centre R) for the fight between Len Johnson and Jack Hood at The Ring. Hood won on points in the 15th round.
13th February, 1928

Jack 'Kid' Berg, 'The Whitechapel Whirlwind' (R), from London's East End, shakes hands with Jack Donn before their light welterweight fight at the Queen's Hall in London. Berg won after Donn was disqualified in the tenth round.

27th February, 1928

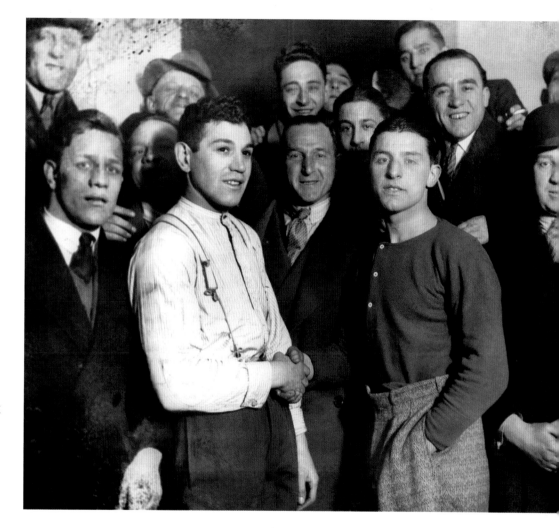

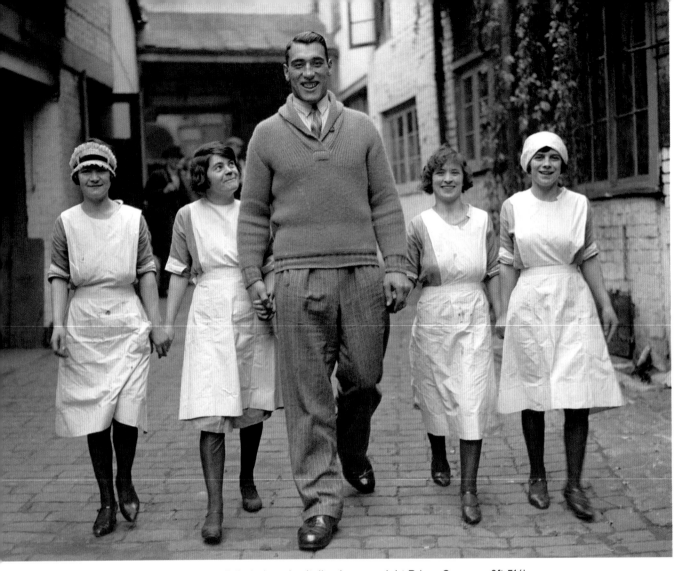

Tall, dark and... Italian heavyweight Primo Carnara, 6ft 5½in tall and weighing 284 pounds, takes a stroll with a group of young maids at his hotel, on the day that he would fight Londoner Jack Stanley, at the Royal Albert Hall, London. The powerful Italian took just 1 minute and 45 seconds to dispense with his hapless opponent in a technical knockout.

17th October, 1929

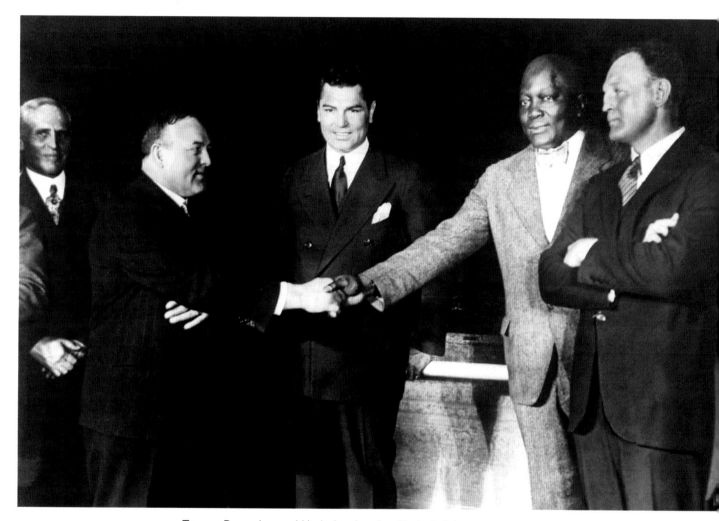

Tommy Burns (second L) shakes hands with Jack Johnson, the man who had wrested the world heavyweight title from him in 1908, watched by Jack Dempsey (third L) and 'Young' Bob Fitzsimmons (R), son of the legendary British born New Zealand boxer Robert James Fitzsimmons.

12th December, 1929

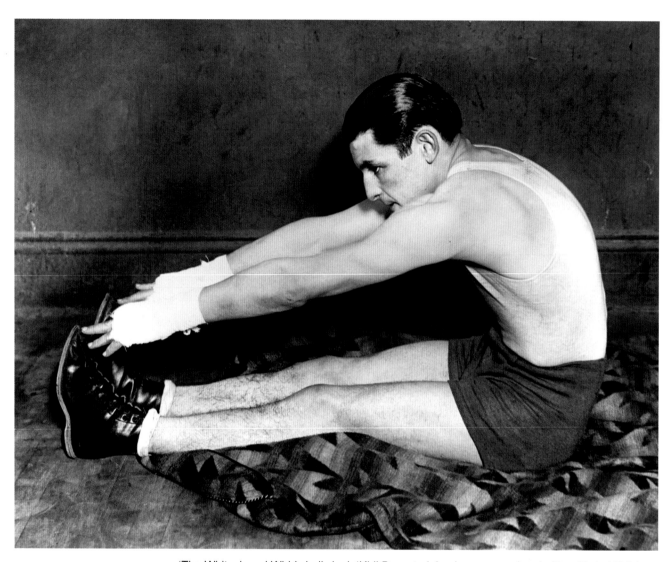

'The Whitechapel Whirlwind', Jack 'Kid' Berg, training in a gymnasium in New York, USA in preparation for a fight against American Tony Canzoneri at Madison Square Garden, New York, on 17th January, 1930. The Londoner would triumph after ten rounds, during which Canzoneri received a merciless beating.

January, 1930

Ted 'Kid' Lewis, former world welterweight champion. Lewis, who was Jewish, had once acted as a bodyguard and local election candidate for Oswald Moseley's New Party, but had parted company with Moseley when his subsequent British Union of Fascists adopted an anti-Semitic stance.
1st October, 1931

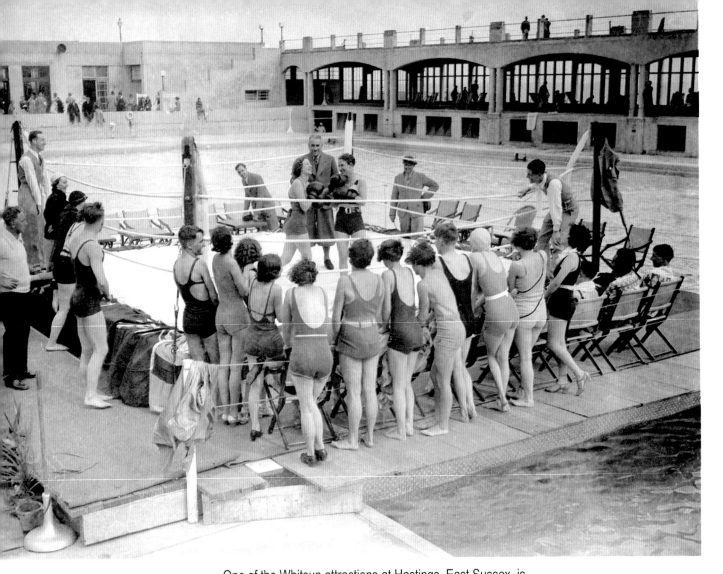

One of the Whitsun attractions at Hastings, East Sussex, is
a boxing ring on a raft constructed over a swimming pool.
Classes of young girl boxers have been formed, and displays
attract much attention among holidaymakers.
20th May, 1934

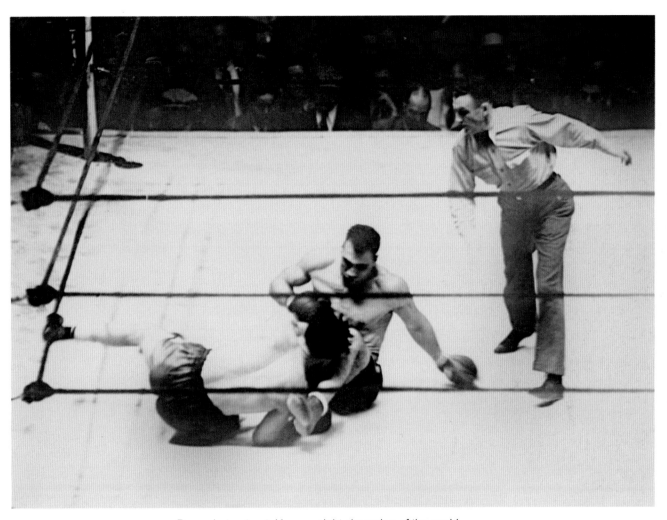

Down, but not out. Heavyweight champion of the world Primo Carnera (R) lays into American challenger Maximilian Adelbert 'Madcap Maxie' Baer (L) even as the two boxers attempt to regain their feet, Baer having lost his balance after knocking Carnera to the canvas. Baer would go on to win the title with a knockout in the 11th round.

14th June, 1934

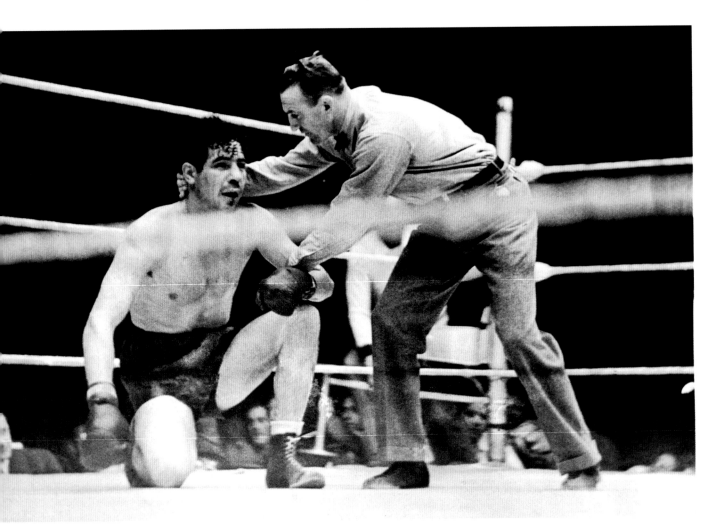

Referee Arthur Donovan (R) helps the defeated former
champion Max Baer to his feet after the American had been
knocked out in the fourth round by Joe Louis.
24th September, 1935

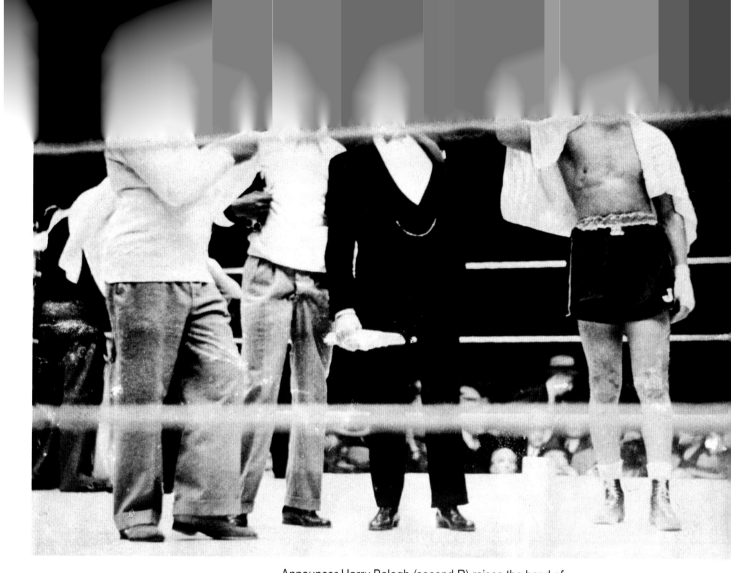

Announcer Harry Balogh (second R) raises the hand of the victorious Joe Louis (R), watched by Louis' trainer Jack 'Chappie' Blackburn (second L), after the 'Brown Bomber' had knocked out Max Baer in the fourth round, after just 3 minutes and 9 seconds.
24th September, 1935

British light welterweight
Jack 'Kid' Berg (R) sparring
with Jimmy Taylor.
11th March, 1936

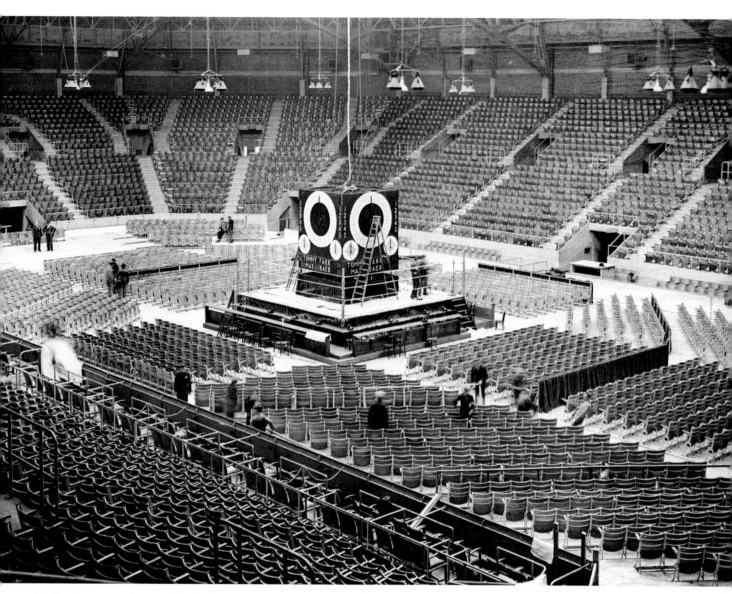

Seating is arranged around the boxing ring at the centre of Harringay Arena, London, in preparation for the bout between Britain's Tommy Farr and the USA's Max Baer, on 15th April, 1937. The steel-roofed arena, built adjacent to Harringay Stadium, the premier greyhound racing and speedway venue, was erected in just eight months between February and October 1936.

23rd March, 1937

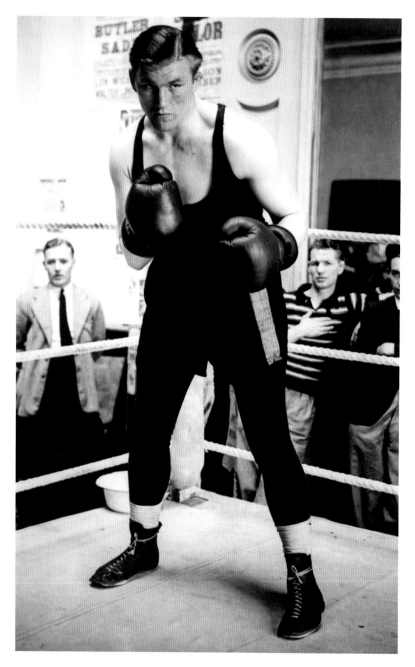

Welsh boxer Tommy Farr, known as 'The Tonypandy Terror', became British and Empire heavyweight champion when he beat South African Ben Foord on points in the 15th round, at Harringay Stadium.
6th April, 1937

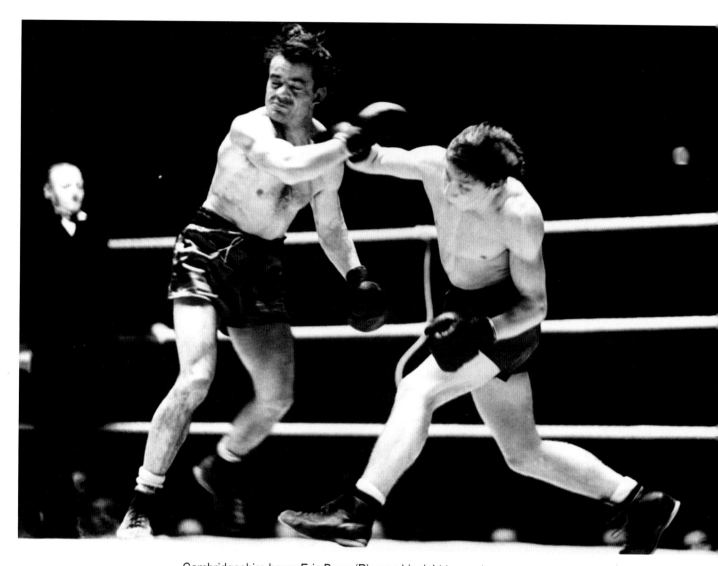

Cambridgeshire boxer Eric Boon (R) uses his right to great
effect during his attempt to retain the British lightweight
title in a bout against Londoner Dave Crowley, at Harringay
Arena. Boon, known as the 'Fen Tiger', would succeed in his
quest by knocking out Crowley in round seven.
9th December, 1939

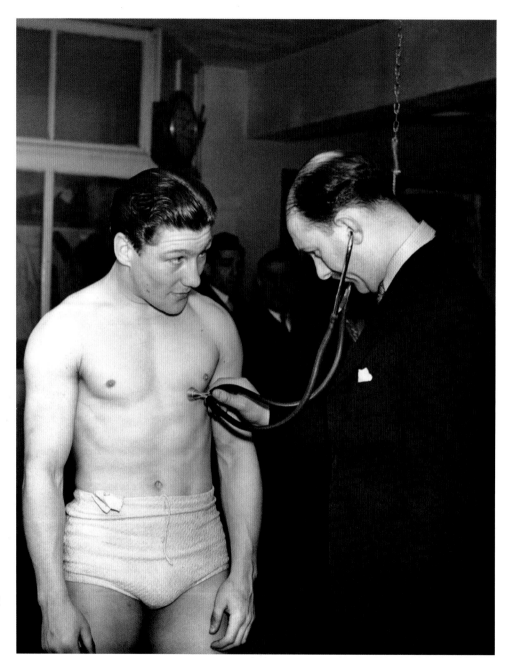

British lightweight champion Eric Boon undergoes a medical examination and is pronounced fit. He had the distinction of having fought in the first televised British championship, on 23rd February, 1939 at Harringay Arena, against Arthur Danahar. Boon won the bout with a technical knockout in the 14th round.

26th February, 1940

Sergeant Freddie Mills training at Feltham, using the edge of the boxing ring for abdominal exercises, two days before his challenge against Pilot Officer Len Harvey for the British and Commonwealth light heavyweight titles.
18th June, 1942

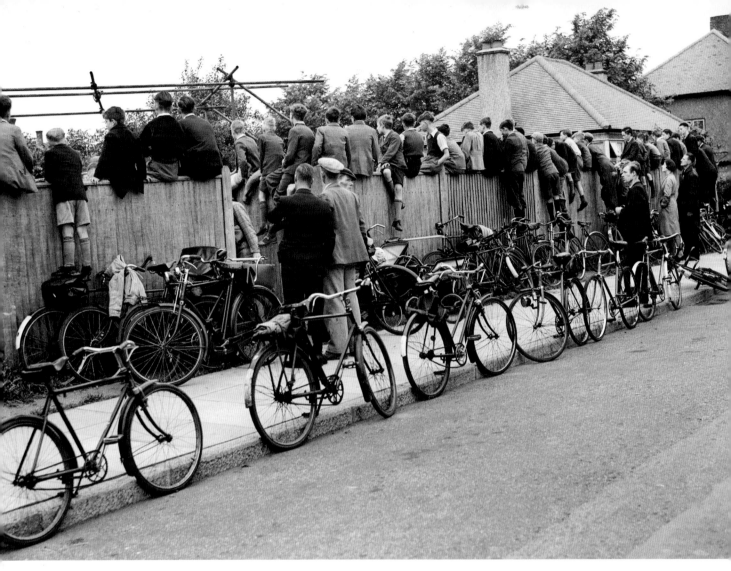

A crowd of boys arrived on bicycles to watch Freddie Mills in training for the title fight, which would take place later in the day at White Hart Lane, Tottenham, London, but they had to climb the fence for a glimpse. Attended by a crowd of 40,000, the match was won by Mills with a knockout just 58 seconds into the second round.

20th June, 1942

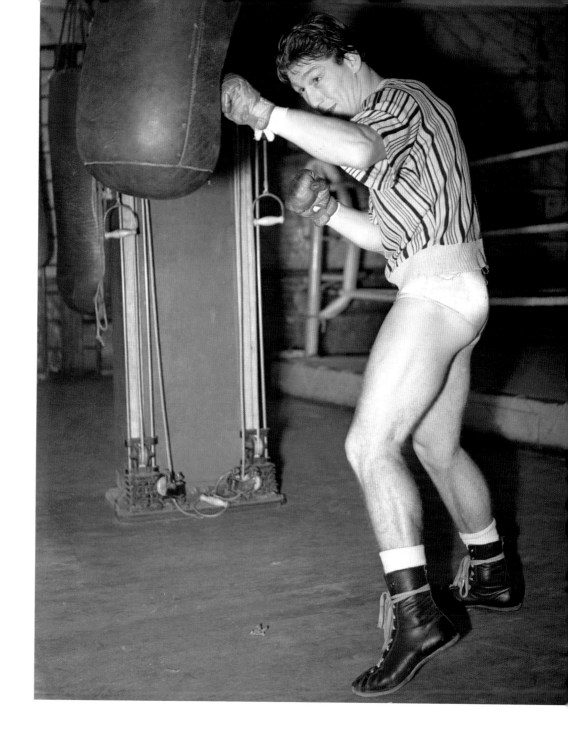

Welterweight boxer
Eric Boon training
with a punchbag.
25th October, 1947

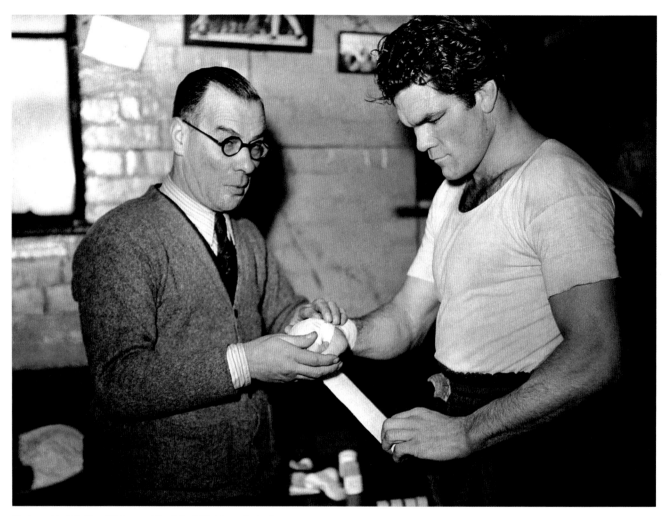

Trainer Nat Seller (L) tapes Freddie Mills' hands before
a sparring session. Boxers' hands are taped tightly for
protection, to lessen the risk of their bones bowing out from a
punch and breaking. The 'boxing fracture', consisting of a tiny
break on the fleshy part of the little finger, is a common injury.
20th January, 1948

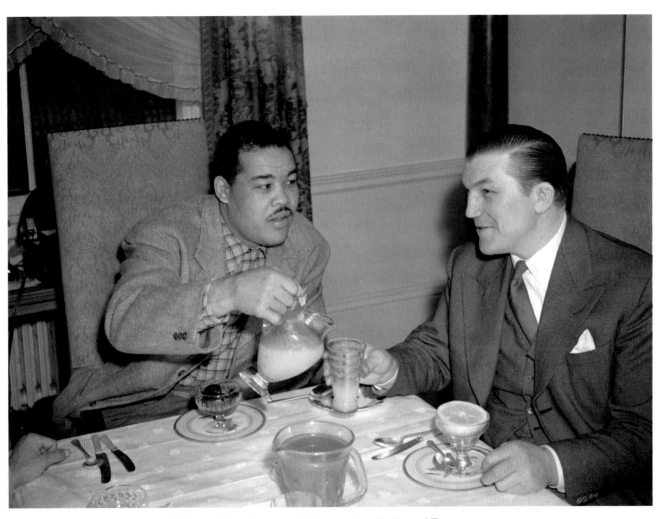

I'll be mother. Heavyweight boxers Joe Louis and Tommy
Farr take breakfast together in London. Farr, from
Tonypandy, South Wales, had gone the full 15 rounds with
the American world champion on 30th August, 1937 before
losing on points.
9th March, 1948

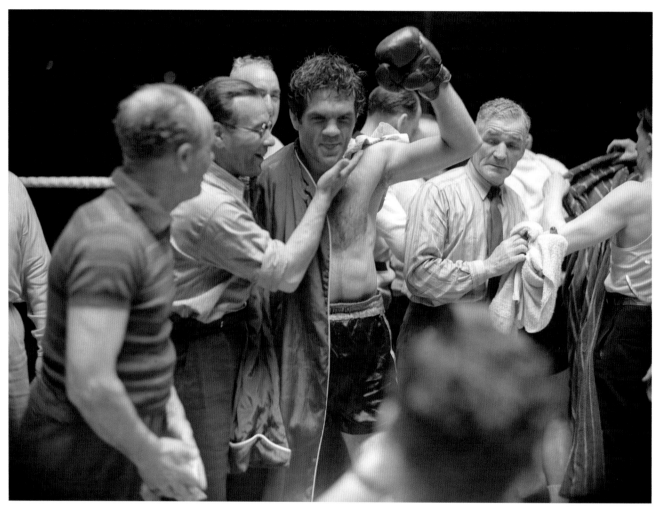

Freddie Mills celebrates beating American Gus Lesnevich on points in the world light heavyweight title fight at White City Stadium, London. It was Mills' second attempt at wresting the title from Lesnevich. In the first, on 14th May, 1946, he received a severe beating, floored twice in the second round and twice in the tenth, before the referee stopped the fight. On the second attempt, Lesnevich's defeat was attributed to cuts over both eyes, which streamed with blood from the opening round onwards.
26th July, 1948

Facing page: A bout is in progress between Great Britain's Henry Carpenter (R) and Belgium's A Bollaert (L) in the (emptied) Empire Pool, Wembley, Middlesex, during the London Olympic Games.
10th August, 1948

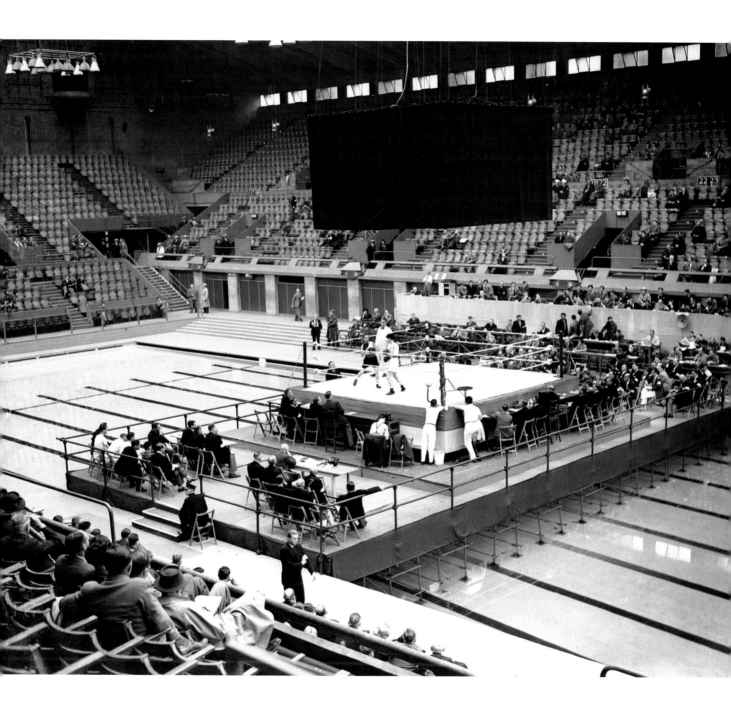

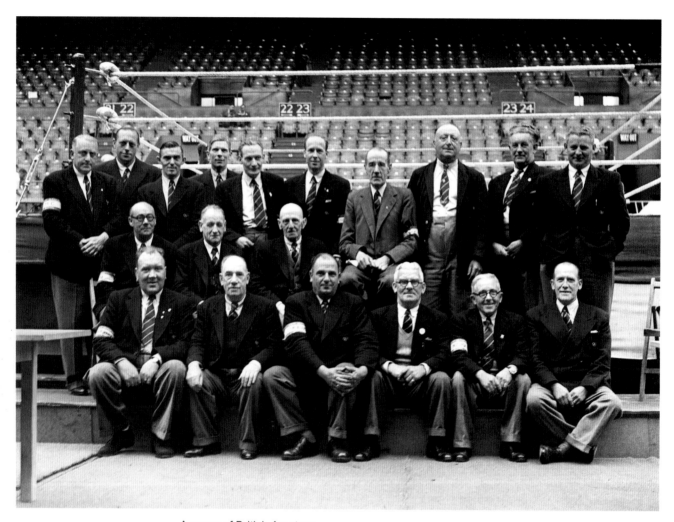

A group of British Amateur
Boxing Association (ABA)
officials at the London
Olympic Games.
12th August, 1948

World light heavyweight champion Freddie Mills takes a break from training to pose for the camera. 'Fearless Freddie' would defend his hard-won title against American Joey Maxim on 24th January, 1950. After dominating the first three rounds, Mills was assaulted by a flurry of head punches in the tenth and was knocked out. A few weeks later, he announced his retirement.

14th January, 1950

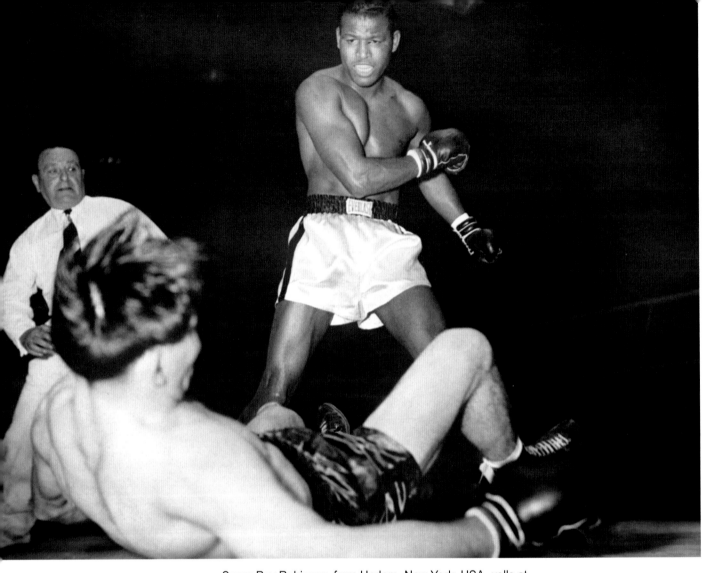

Sugar Ray Robinson, from Harlem, New York, USA, yells at
his opponent, the Frenchman Jean Stock, to climb to his feet
and continue the fight, held at the Palais des Sports, Paris.
Robinson would require only two of the ten rounds to defeat
Stock with a technical knockout.
27th November, 1950

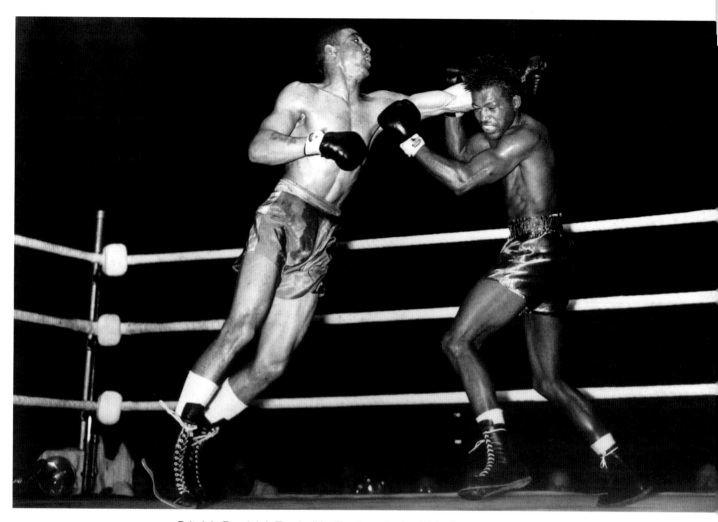

Britain's Randolph Turpin (L), 'The Leamington Licker',
unleashes an explosive left, narrowly missing Sugar Ray
Robinson's ear, during the world middleweight title fight
at Earls Court, London, which he would win on points
after 15 rounds.
10th July, 1951

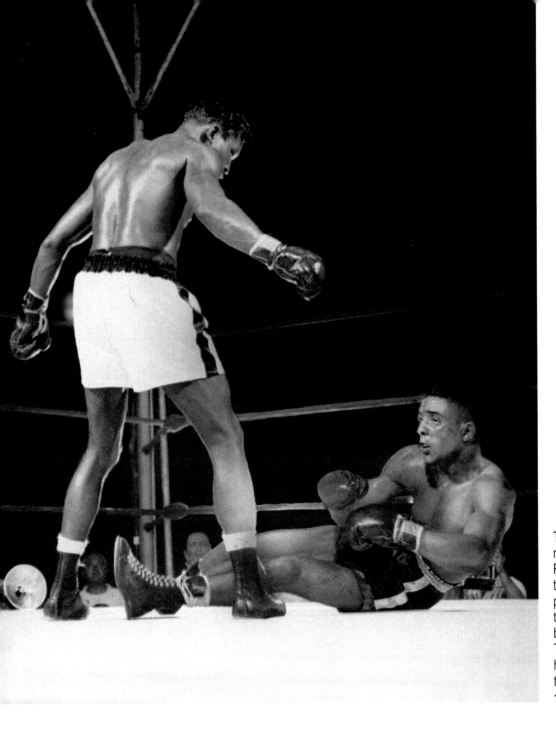

Turpin would lose the world middleweight title to Sugar Ray Robinson less than three months after their previous bout. Knocked to the canvas in the tenth round by the powerful American, Turpin could only gaze helplessly as he lost to a technical knockout.
12th September, 1951

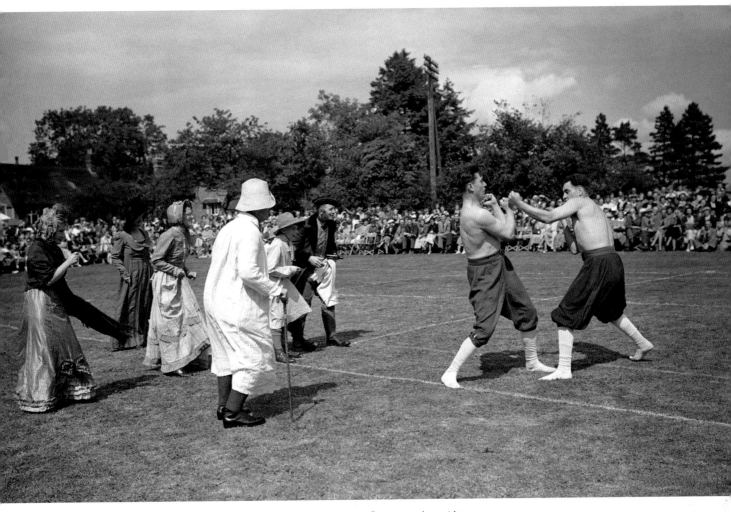

The villagers of Abinger Common, Surrey took part in a Pageant of English Sports Through the Ages, playing games in the costume and manner of the days when they first became popular in the countryside. Eighteenth-century boxing was portrayed by members of the Surrey Constabulary, watched by the Ladies and Gentleman of Westcott.

7th June, 1952

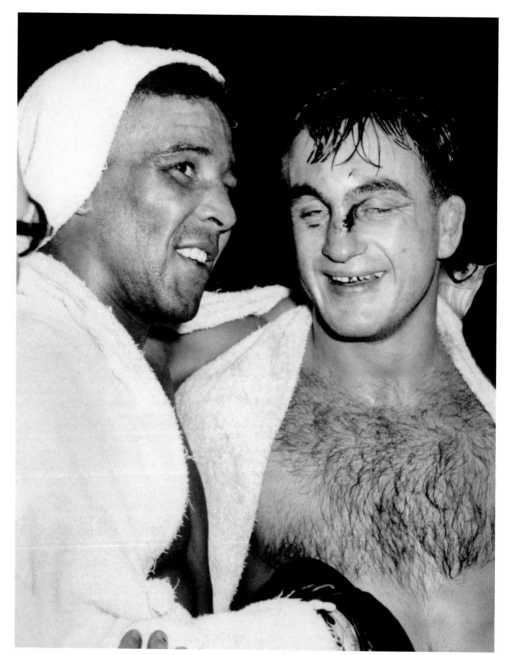

A friendly scrap. Randolph Turpin (L) shares a post-fight smile with his opponent, France's Charles Humez, whom he beat on points, at White City Stadium, London, to take the European middleweight title vacated by Sugar Ray Robinson, who had retired in December 1952 to take up a career singing and tap dancing.

9th June, 1953

100 Years of Boxing • Twentieth Century in Pictures

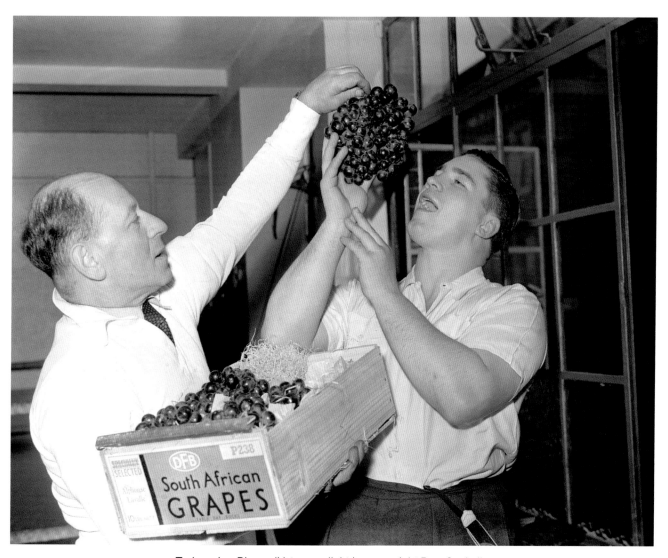

Trainer Joe Bloom (L) teases light heavyweight Don Cockell with a bunch of grapes. The boxer had experienced difficulty in making the weight for light heavyweight fights and subsequently decided to fight as a heavyweight.
5th March, 1954

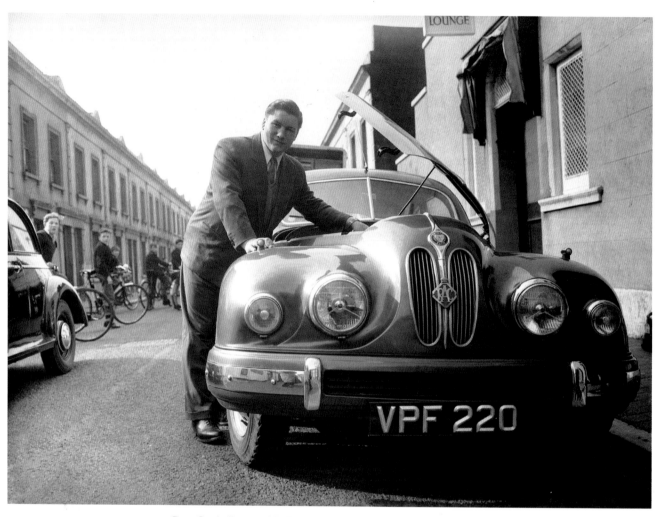

Don Cockell tunes his Bristol sports car. Since moving into the heavyweight rankings, Cockell had scored some notable wins against American fighters, such as Roland LaStarza in March, 1954, which put him in line for a title fight against world champion Rocky Marciano, the first British world title bid since Tommy Farr had fought Joe Louis in 1937.
5th April, 1955

Italian-American Rocky Marciano, heavyweight champion of the world from 23rd September, 1952 until 27th April, 1956, was the only heavyweight champion to retire without losing a fight in his professional career. He fended off a challenge from British fighter Don Cockell on 16th May, 1955 with a knockout 54 seconds into the ninth round. After the fight, Marciano said, *"He's got a lot of guts. I don't think I ever hit anyone else any more often or harder."*

5th May, 1955

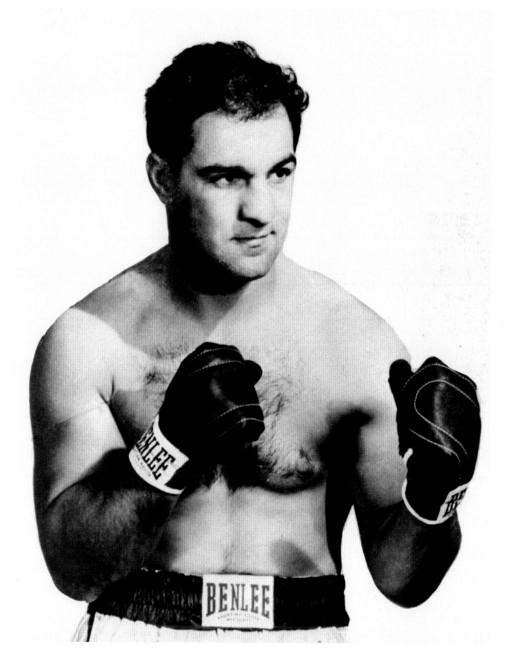

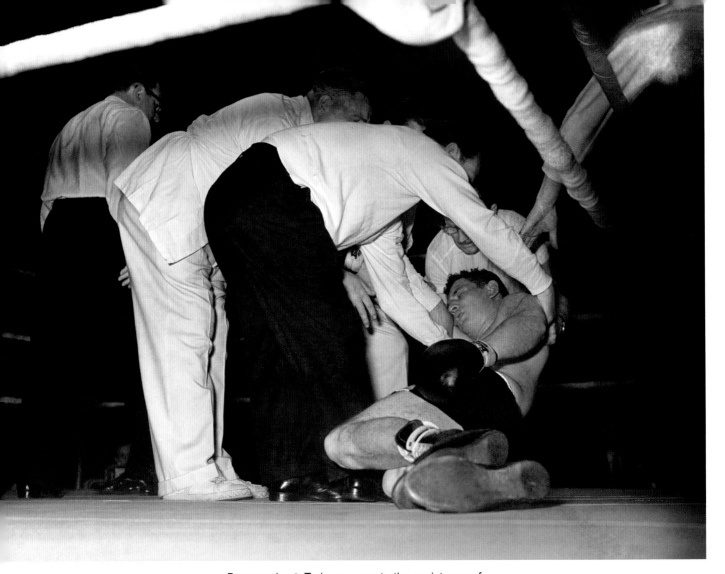

Down and out. Trainers come to the assistance of heavyweight Andre Wyns of Belgium, during the fourth round of his bout with Arthur Howard of Islington, London at Earls Court. Wyns was unable to continue.

10th May, 1955

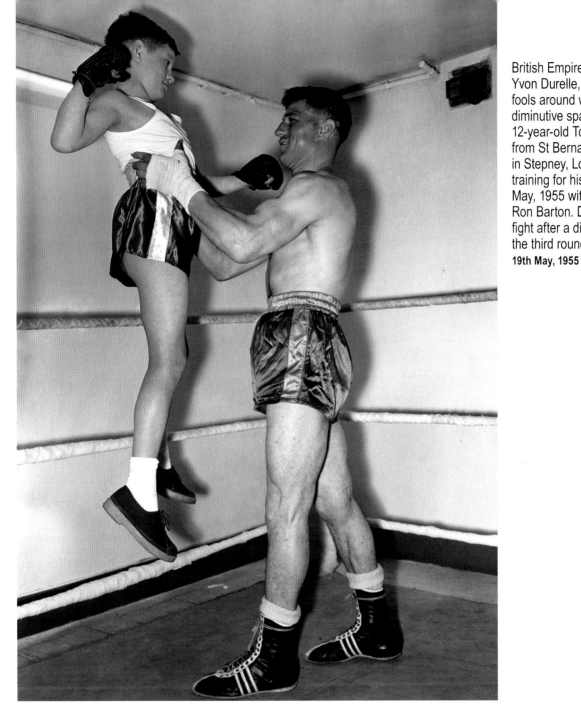

British Empire champion Yvon Durelle, from Canada, fools around with his diminutive sparring partner, 12-year-old Tony Delguidice from St Bernard School in Stepney, London, while training for his fight on 24th May, 1955 with British fighter Ron Barton. Durelle lost the fight after a disqualification in the third round.

19th May, 1955

Middleweight Moses Ward, from Detrioit, Michigan, USA, training with a punchball before his match against Yolande Pompey, from Trinidad and Tobago, on 13th March, 1956 at Harringay Arena. Ward lost the match in the seventh round after a technical knockout.

6th March, 1956

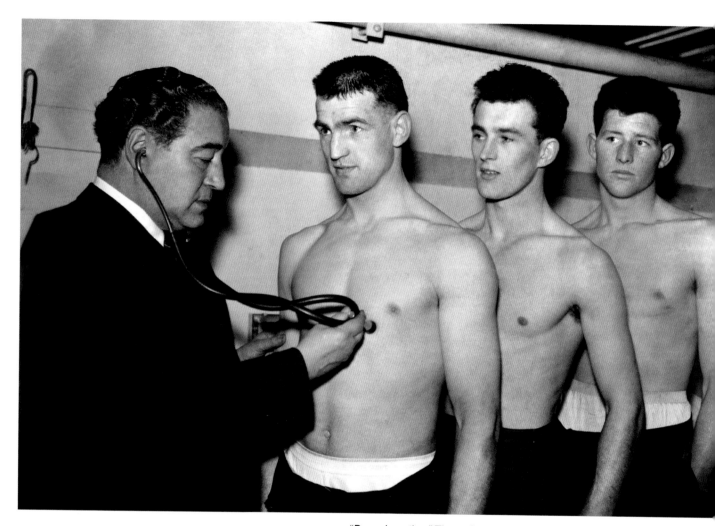

"Deep breath..." Three Scottish boxers are examined by the medical officer prior to the ABA Championships at the Empire Pool, Wembley. The boxers are (L–R) David Mooney, John McCormack and Chick Calderwood. McCormack would go on to win the light middleweight bronze medal in the 1956 Olympic Games in Melbourne, Australia.

27th April, 1956

Flyweight gold medalist in the 1956 Olympic Games in Melbourne, Australia, Terry Spinks, from Canning Town, London is chaired by his welcoming neighbours upon his triumphant homecoming.

13th December, 1956

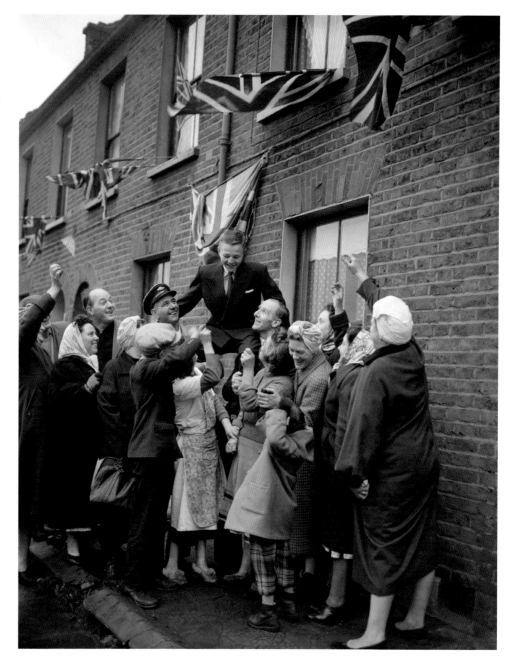

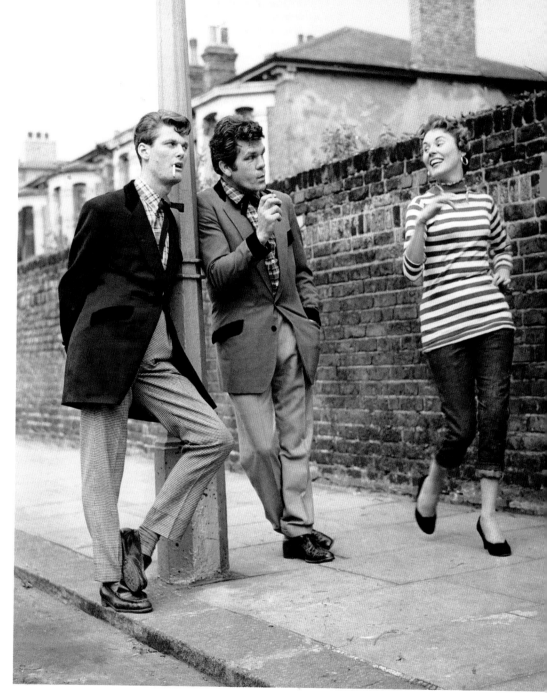

Disc jockey Pete Murray (L) and ex-boxer Freddie Mills (C), dressed as teddy boys, with actress Josephine Douglas. The trio hosted BBC television's pop music show, *Six-Five Special*. Mills also ran a nightclub that was frequented by his friends, the notorious Kray brothers. After the failure of the club, Mills suffered serious financial difficulties. He was found in his car, shot in the head, on 24th July, 1965 with a rifle nearby, and died later in hospital. An inquest ruled that he had committed suicide.

12th April, 1957

A bruised, but smiling, Henry Cooper (L), who upset the world boxing rankings with his win over highly rated American Zora Folley at the Empire Pool, Wembley, reads messages of congratulations at his Bellingham, Kent home the next day. With him are his mother and identical twin brother, George (who also boxed, as Jim Cooper). Henry is now eager for a match with American world champion Floyd Patterson.
15th October, 1958

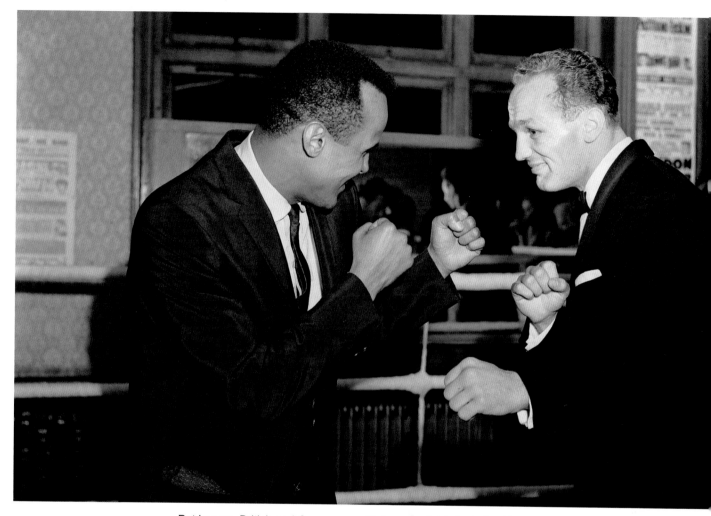

Put 'em up. British and Commonwealth heavyweight champion Henry Cooper (R) spars with singer Harry Belafonte in the ring of the gym on the first floor of the Thomas à Becket pub in the Old Kent Road, Bermondsey, London. The gym was often used for pre-fight training by Cooper, and was visited by numerous celebrities, boxers including Muhammad Ali, and the infamous Kray twins, who also sparred there.

14th September, 1959

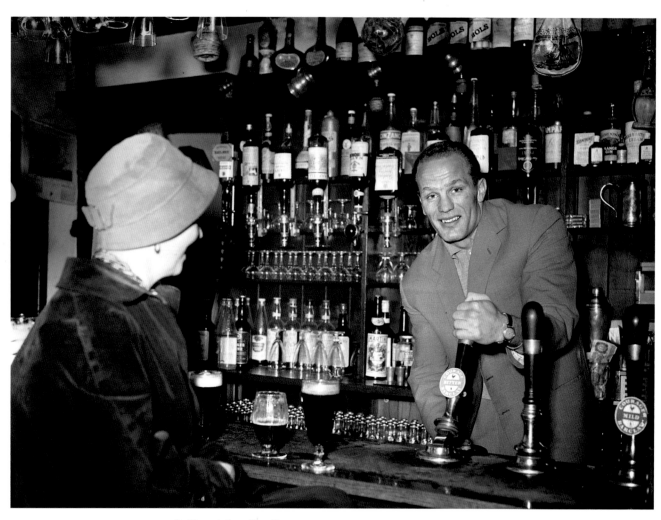

Pulling pints rather than
throwing punches,
Henry Cooper lends
a hand behind the bar of
The George public house.
30th October, 1959

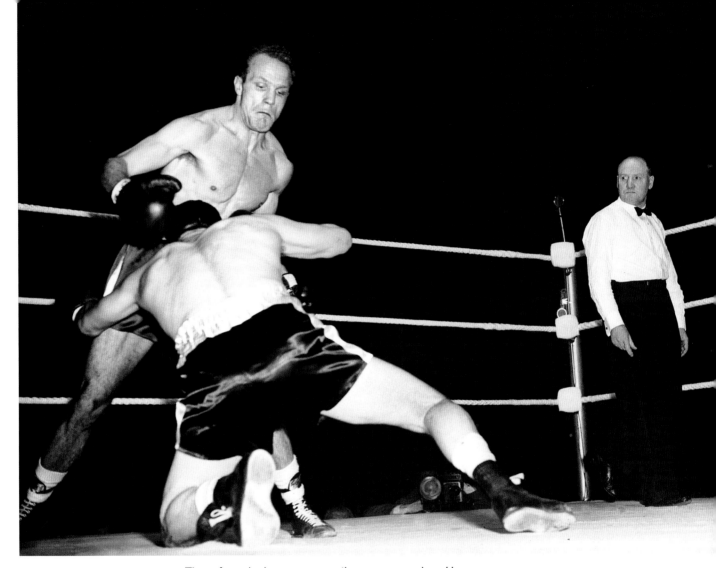

The referee looks on, apparently unconcerned, as Henry Cooper pummels the grounded Joe Erskine during the Welshman's challenge for the British and Commonwealth title. After Cooper had floored his opponent twice with powerful left hooks, Erskine was left hanging almost unconscious from the lower rope when the referee stopped the fight in the 12th round.

17th November, 1959

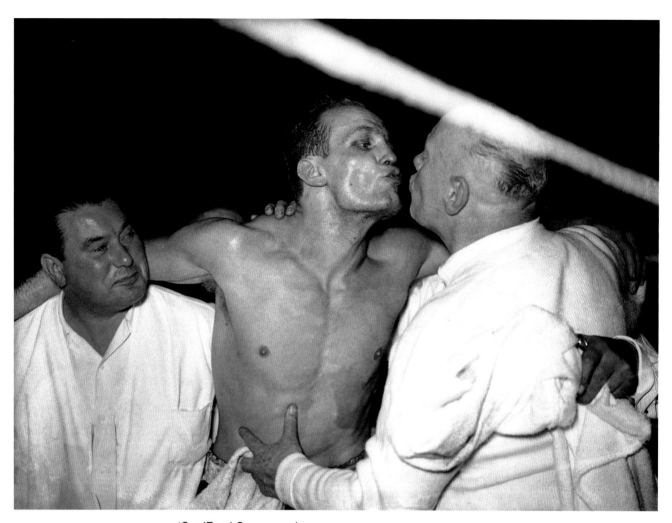

'Our 'Enry' Cooper puckers up
to celebrate retaining his title.
17th November, 1959

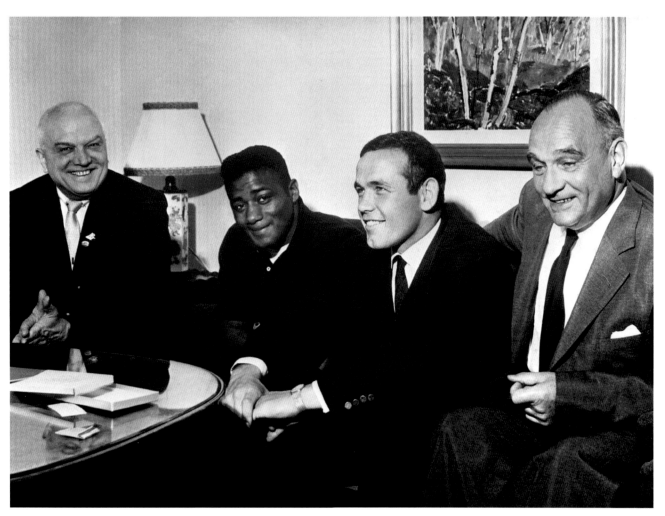

American world heavyweight champion Floyd Patterson (second L) and trainer/manager Cus D'Amato (L) meet Swede Ingemar Johansson (second R) and his manager, Edwin Ahlquist (R). In their first fight, on 26th June, 1959, Johansson claimed the title when the referee stopped the match in the third round. In a rematch on 20th June, 1960, Patterson knocked out his opponent in the fifth round, leaving Johansson unconscious for five minutes. In a 'rubber match' on 13th March, 1961, Patterson retained his title by a knockout in the sixth round.

22nd August, 1960

British boxers arrive at London Heathrow airport after competing in the Rome Olympic Games: (L–R) Dick McTaggart, bronze medal in the lightweight division; Jimmy Lloyd, bronze medal in the welterweight division; and Willie Fisher, who won the light middleweight bronze medal.

7th September, 1960

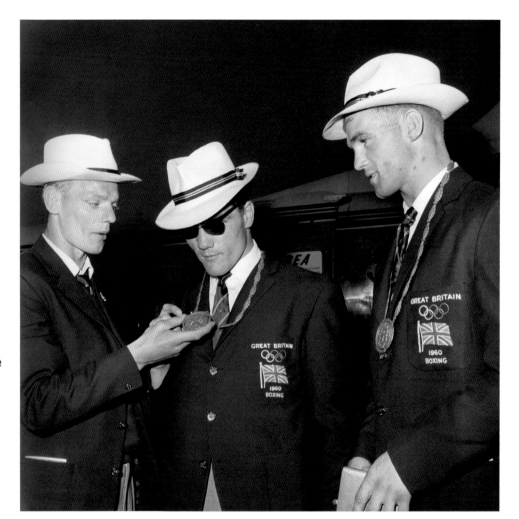

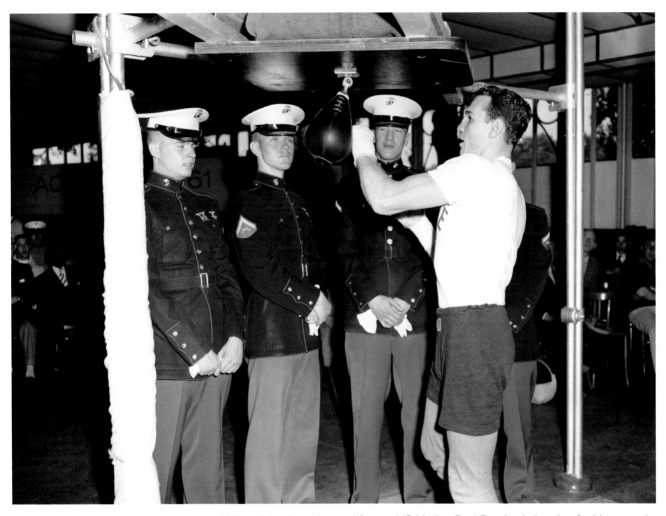

World middleweight champion and former US Marine Paul Pender, in London for his second fight against local boxer Terry Downes, on 11th July, 1961, is watched closely as he works the speedball by the four Marines who will escort him to the ring on fight night. Pender fought three matches against Downes, winning the first and third, but only the third, on 7th April, 1962, went the full distance. That bout would be the last of his career.

7th July, 1961

British and Empire heavyweight champion Henry Cooper puts in some strenuous training in London in preparation for his fight with Zora Folley. Cooper, who had outpointed the American two years before, would meet him again over ten three-minute rounds at the Empire Pool, Wembley. Folley was rated number six in the world, having been stopped earlier in the year by the Argentinian boxer Alejandro Lavarone.

29th November, 1961

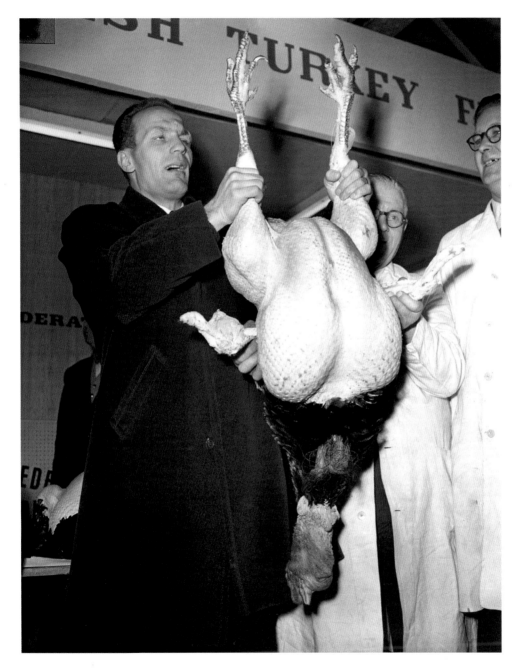

Henry Cooper holds up the biggest turkey at the National Poultry Show, London, perhaps a comment on how he felt after his surprise defeat by Zora Folley two days before, at the Empire Pool, Wembley. The champion, reeling after the first round and bleeding profusely from cuts over his left eye and forehead, had been knocked out with a right hook to the jaw just 1 minute and 6 seconds into the second round.

7th December, 1961

Perched on a chair, Sugar Ray Robinson watches London boxer Billy Walker and Welshman Dick Richardson training in preparation for Walker's forthcoming fight at the Empire Pool, Wembley on 13th November, 1962, against Canadian Phonse LaSaga. After sparring for only a few minutes, Walker started blood streaming from Richardson's nose; 'Golden Boy' would go on to knock out LaSaga in just 1 minute and 57 seconds of the first round.

31st October, 1962

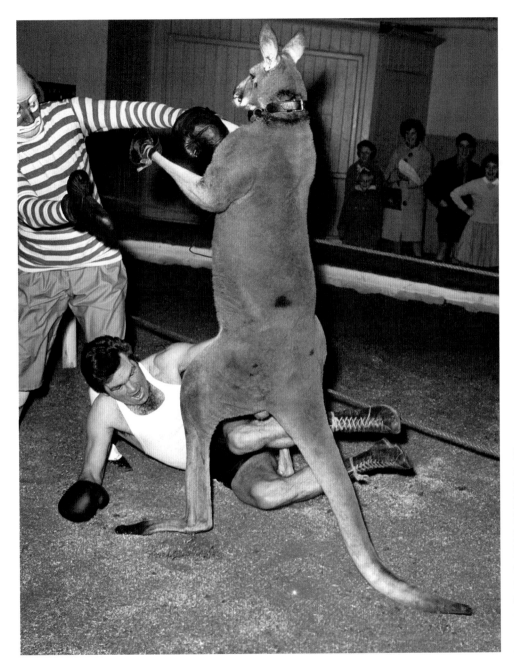

Never work with children or animals... Freddie Mills, Britain's former light heavyweight champion, is floored by George the boxing kangaroo at Ascot, Berkshire, when sparring during a publicity stunt in preparation for the opening of the Bertram Mills Circus Christmas season at Olympia, London.

25th November, 1962

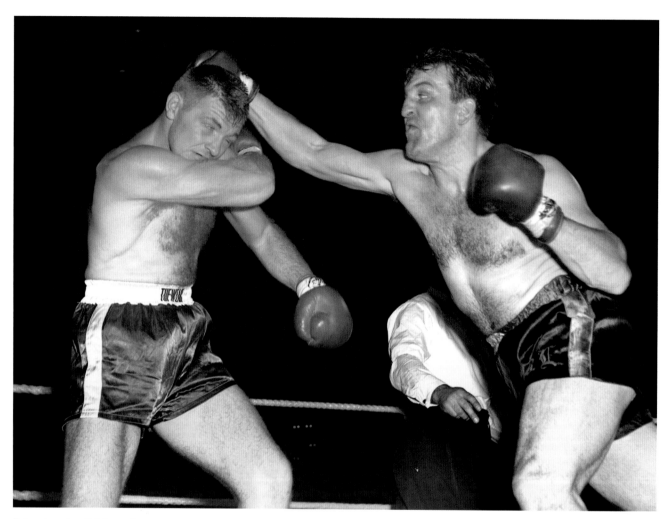

Brian London (R) launches
a right at Tom McNeeley,
during a heavyweight bout at
London's Olympia.
29th January, 1963

Facing page: Charismatic American boxer Cassius Clay
predicts that he will stop British heavyweight Henry Cooper
in five rounds at a pre-fight lunch in London's West End.
Clay was a master of pre-match hype, 'trash talking' his
opponents on television or face to face, often with rhymes.
18th June, 1963

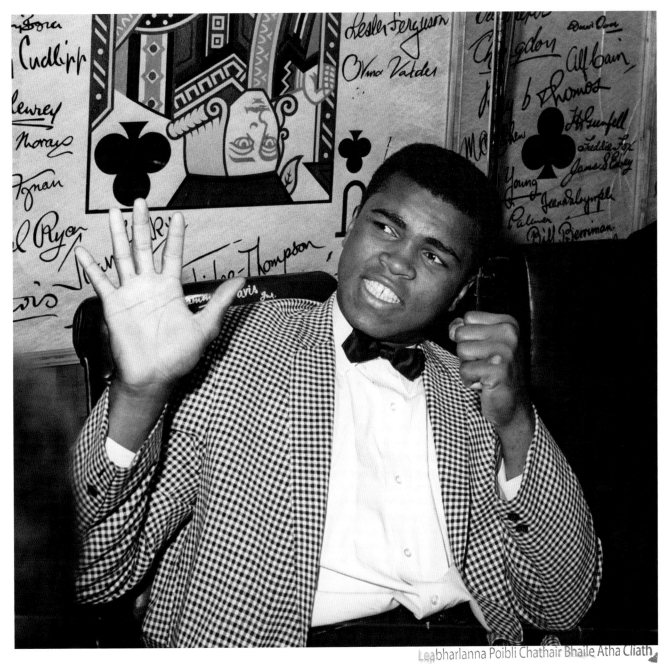

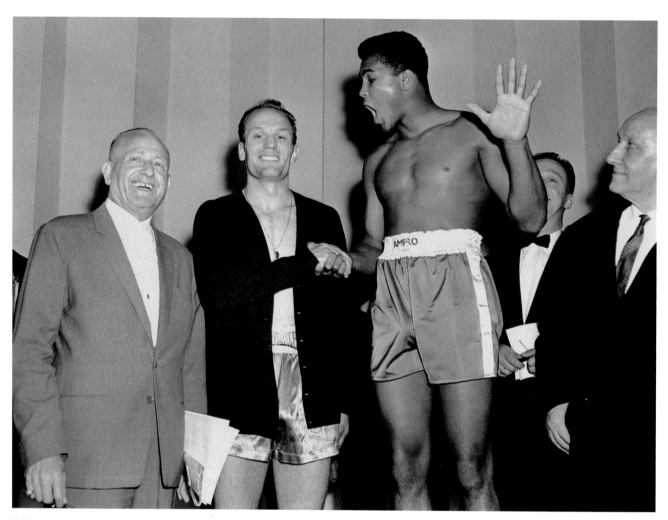

At the weigh in, Henry Cooper smiles as he offers a crushing handshake to Cassius Clay, who, ever the showman, hams it up for the Press and his adoring fans.
18th June, 1963

Facing page: Elizabeth Taylor and Richard Burton (second L), stars of the film *Cleopatra*, ringside at the Empire Pool, Wembley, for the heavyweight match between Henry Cooper and Cassius Clay.
18th June, 1963

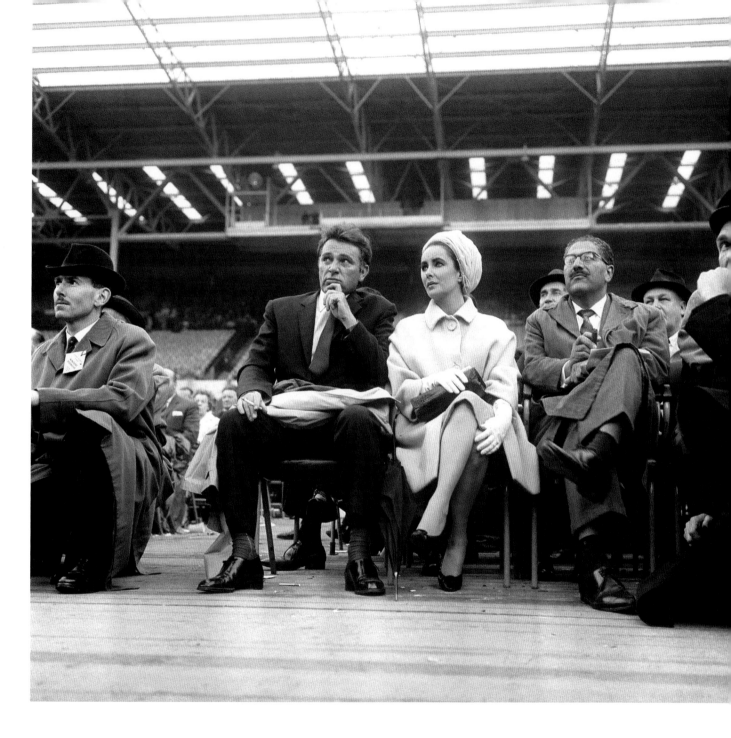

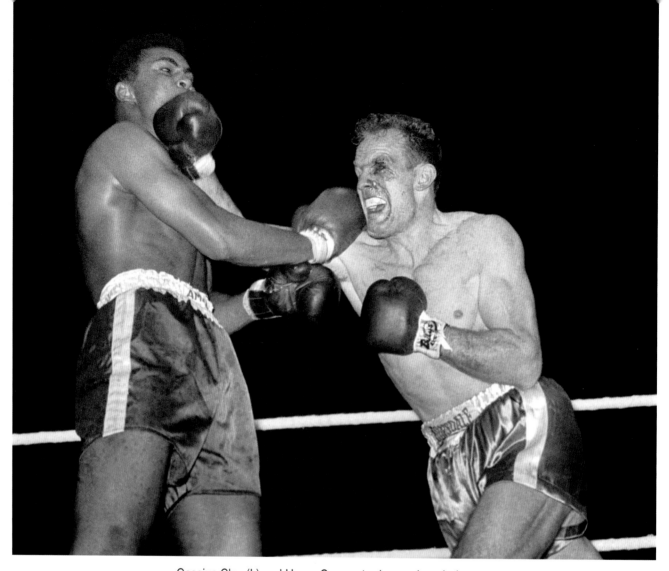

Cassius Clay (L) and Henry Cooper trade punches during their fight at the Empire Pool. Clay won after stopping Cooper in the fifth round, despite having been floored by the British champion's powerful left hook in the fourth. Later Clay said, *"Cooper hit me so hard my ancestors in Africa felt it."*
18th June, 1963

100 Years of Boxing • Twentieth Century in Pictures

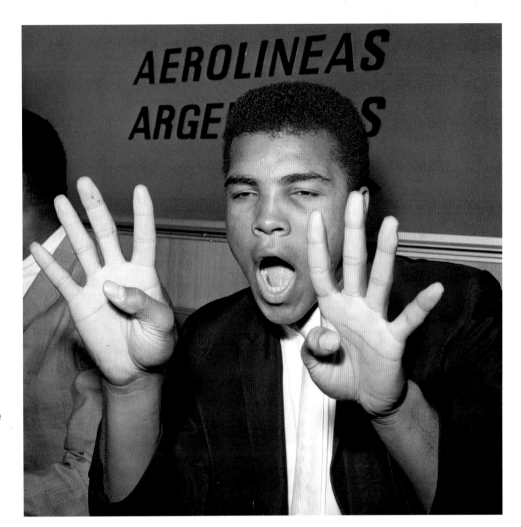

After his fifth-round victory over Henry Cooper the previous evening, and while waiting for his flight back to the USA, Cassius Clay predicts that he will beat world champion Sonny Liston in eight rounds.
19th June, 1963

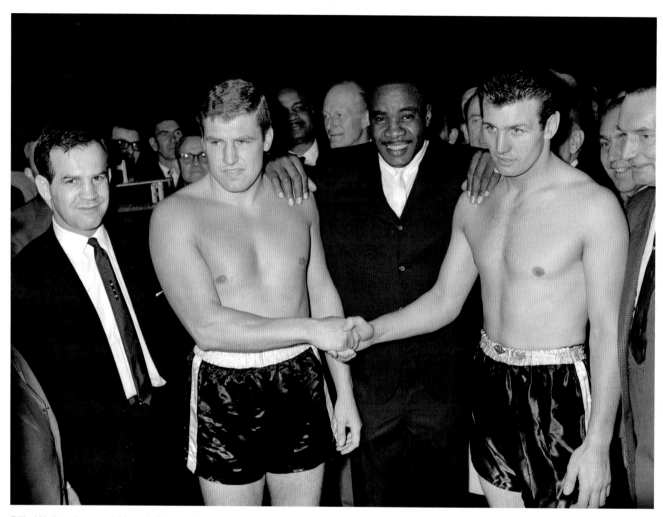

Billy Walker (second L) and Johnny Prescott shake hands
at the weigh-in for their forthcoming ten-round heavyweight
bout, to be held at the Empire Pool. Between them stands
Sonny Liston, the reigning world heavyweight champion.
10th September, 1963

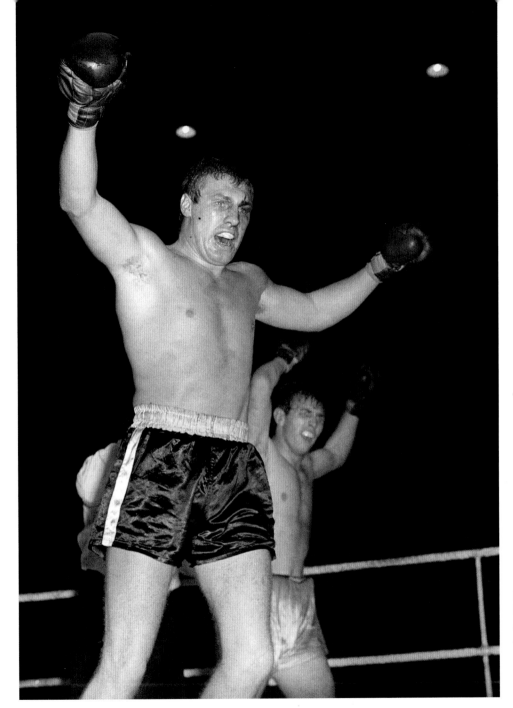

Billy Walker throws up his hands in triumph as the referee, Tommy Little, stops the contest with Johnny Prescott in his favour in the last round.
10th September, 1963

Billy Walker, 'The Blond Bomber', in training. Managed by older brother George, he began a professional career during London's Swinging Sixties. His blond hair, boyish good looks and all-action style brought the public flocking to his fights. Shrewd investment of the winning purses in a string of nightclubs and restaurants brought the brothers fame and fortune. At the age of 30, he retired from the ring and eventually became a successful property developer.
January, 1964

British and European featherweight champion Howard Winstone training at Joe Bloom's Earlham Street gym, London, in preparation for his fight against Italian Lino Mastellaro on 12th May, 1964, at the Empire Pool, Wembley, which he would win by technical knockout in the eighth round.

5th May, 1964

Heavyweight boxer Billy Walker in his training quarters at Blue House Farm, Pitsea, Essex, where he is preparing for his match with Welshman Joe Erskine at the Empire Pool on 27th October, 1964. Walker won on points in the tenth round.
23rd October, 1964

Having a ball. Trainer Danny Holland drops a medicine ball on the abdomen of lightweight Dave Charnley, 'The Dartford Destroyer', during a training session. Charnley's fight with Emile Griffith on 1st December, 1964, which he lost by technical knockout in the ninth round, would be his last before retiring. After leaving the ring, he opened a number of hair salons, and started the building and property refurbishment company with which he is still involved.
18th November, 1964

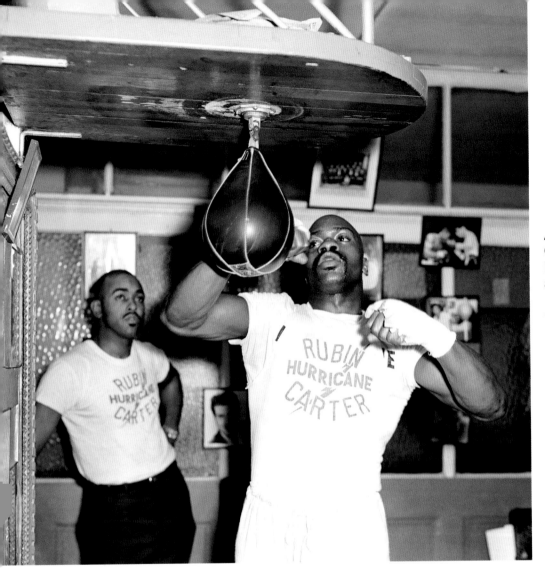

American Rubin 'Hurricane' Carter working out in Joe Bloom's gym before his fight against Harry Scott at the Royal Albert Hall, London. Carter learned to box, aged 14, while serving a sentence in a reformatory for assault and robbery. After escaping, he joined the army, only to be discharged. Later he served four years in prison for a string of violent crimes. His boxing career ended in 1966 when he received three life sentences for three murders in New Jersey. After numerous appeals, he was released, having served 20 years.

26th February, 1965

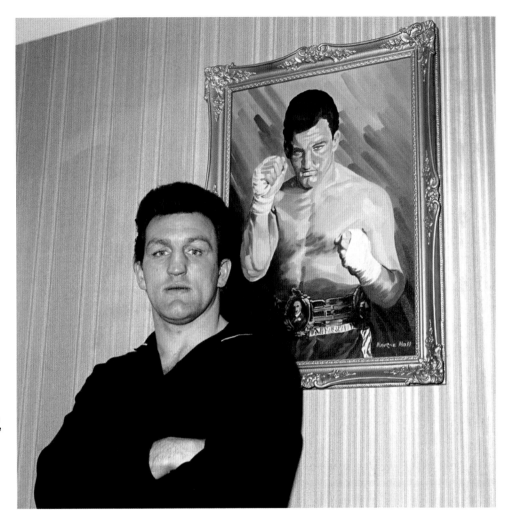

Pretty as a picture. British heavyweight boxer Brian London, 'The British Bulldog', stands beside a portrait of himself, painted by Maurice Moss, which hangs in his Blackpool home.

1st September, 1965

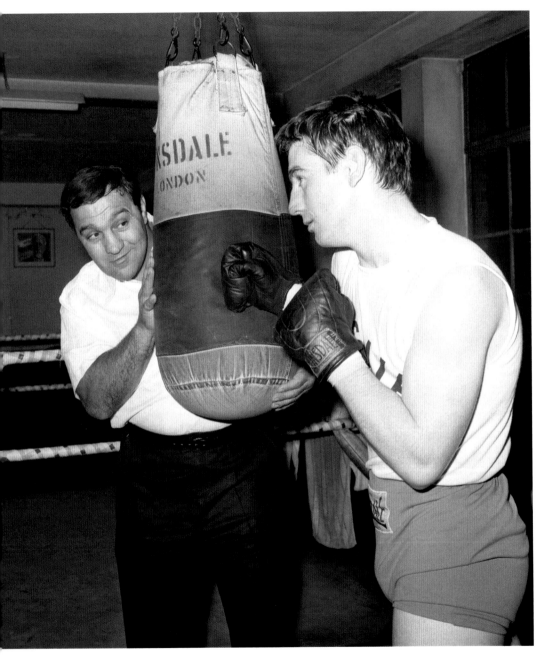

American boxing champion Rocky Marciano (L), who retired as undefeated world heavyweight champion, holds the punchbag as he passes on some tips to new British professional Pat Dwyer, at the Cambridge Gym, in London.

2nd November, 1965

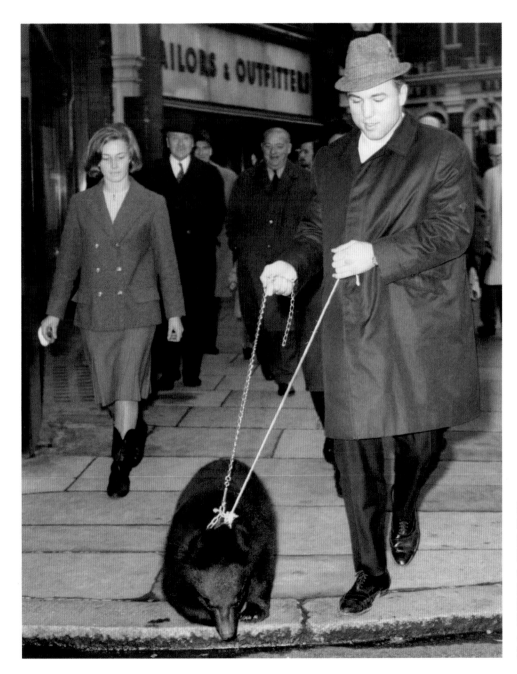

Furry friend. George Chuvalo, the Canadian heavyweight boxer, takes his bear mascot for a walk along Shaftesbury Avenue, London, on his way to Joe Bloom's gym to train for his upcoming fight with Joe Bygraves.
3rd December, 1965

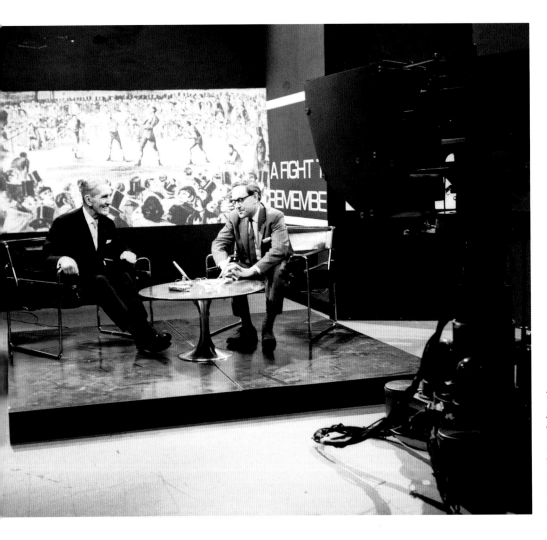

The set of BBC TV's
A Fight to Remember,
where Harry Carpenter (R)
interviews former
world light heavyweight
champion, the Frenchman
Georges Carpentier.
10th December, 1965

British heavyweight Henry Cooper hammers the punchball in front of a mirror during training at the Thomas à Becket gymnasium, Old Kent Road, London.
1st April, 1966

In the zone. Deep in concentration, Henry Cooper has a preliminary workout at the Thomas à Becket gym.
1st April, 1966

A new name, but the same bombastic fighter. American heavyweight Muhammad Ali, previously known as Cassius Clay, trains before his fight with Britain's Henry Cooper. Ali had changed his name after joining the Nation of Islam in 1964; in 1975, he would convert to orthodox Islam.

6th May, 1966

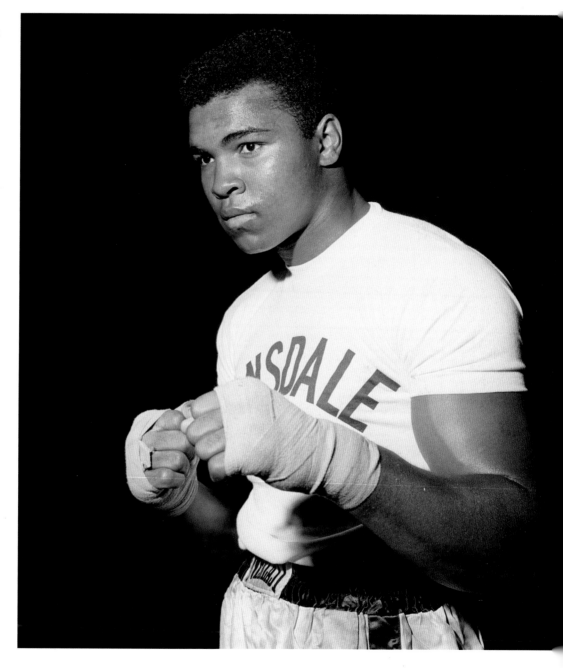

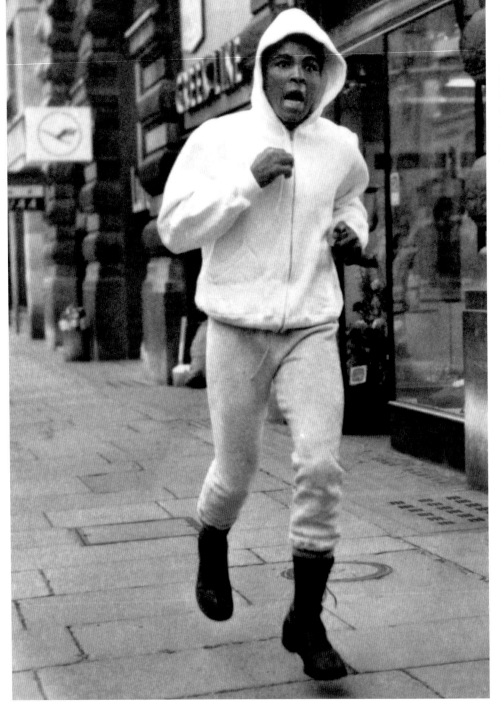

Facing page: Ali practises his batting technique in the dressing room of the West Indies Cricket Team, to the amusement of the cricketers. He had taken time out from training to visit Lord's Cricket Ground, St John's Wood, London.
16th May, 1966

As the media hype builds, Muhammad Ali, in London for his big fight against Henry Cooper, is spotted jogging in the streets around the White City Gymnasium.
11th May, 1966

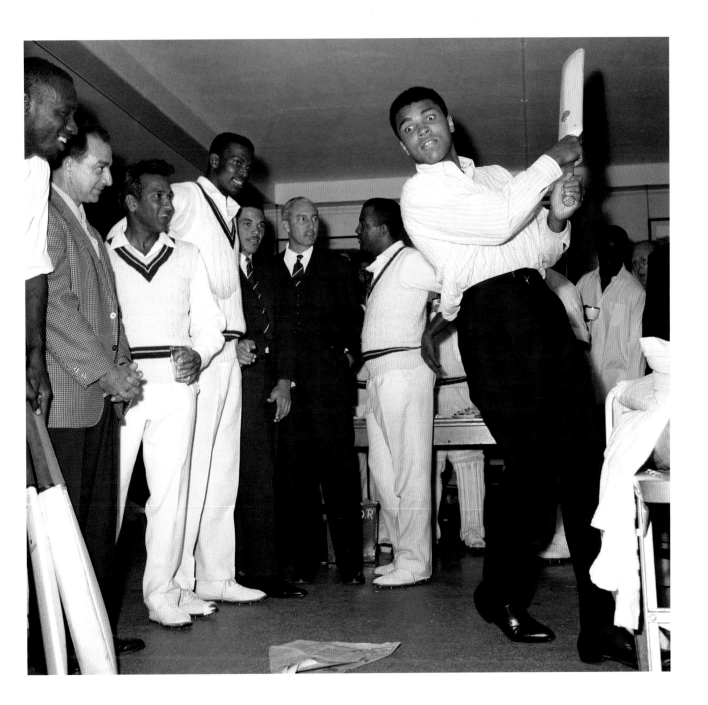

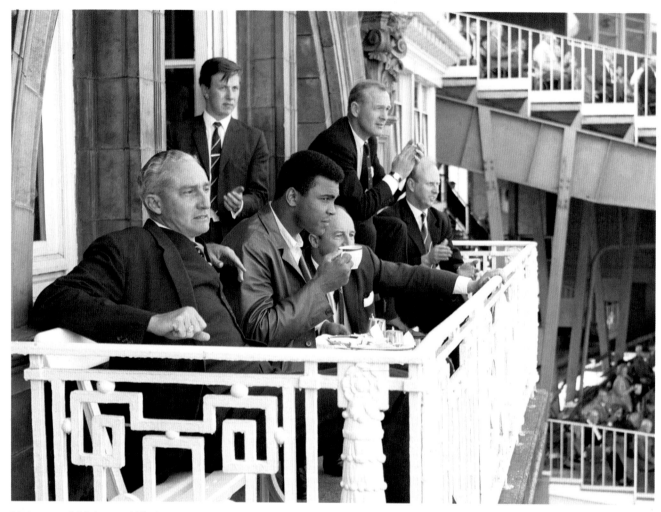

Muhammad Ali (second L) sips a cup of tea on the West Indian dressing room balcony as he watches the match between Marylebone Cricket Club and the West Indies, in the company of the visiting team's manager, Jeffrey Stollmeyer (L).
16th May, 1966

Facing page: A general view of Arsenal Stadium, Highbury, north London, as boards are laid across the pitch and a boxing ring is erected in the centre for the big fight between Muhammad Ali and Henry Cooper. Arsenal built and moved to the larger-capacity Emirates Stadium nearby in 2006, while the old stadium was redeveloped as an apartment complex.
18th May, 1966

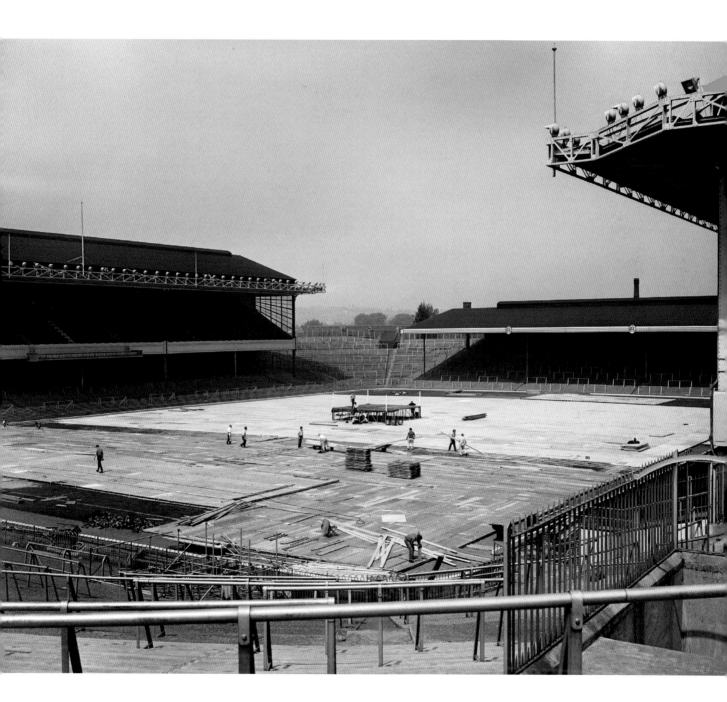

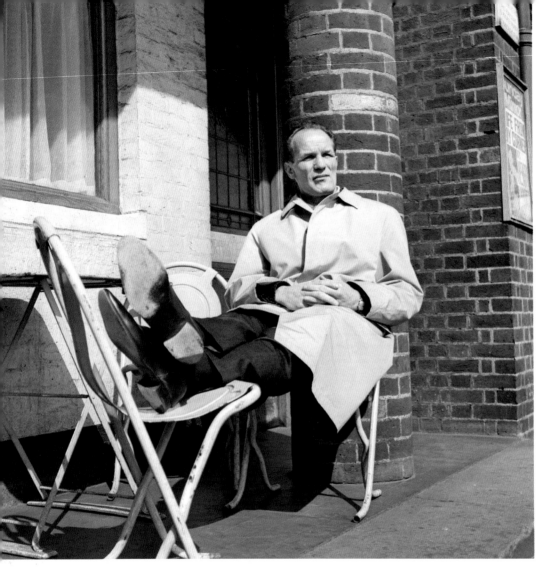

Henry Cooper puts his feet up in the sunshine outside the Duchess of Edinburgh public house in Welling, Kent. With training finished, he is taking a moment to relax before his much anticipated fight for the heavyweight championship of the world against Muhammad Ali at the Arsenal Stadium, Highbury.
20th May, 1966

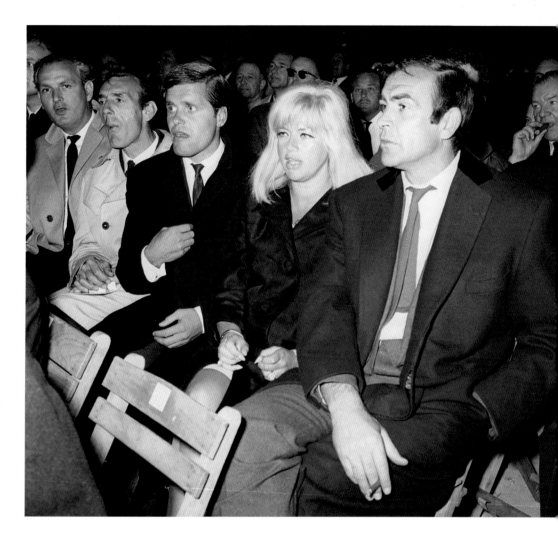

L–R: comedian Eric Sykes, singer Ronnie Carroll, actress Diana Dors and film actor Sean Connery are among the spectators waiting for the Ali versus Cooper fight.
21st May, 1966

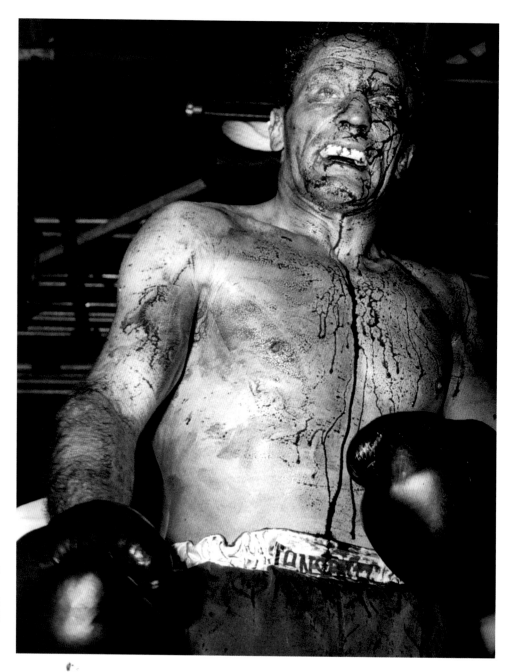

All over for Cooper. Blood pours from the face of a dejected Henry Cooper as referee George Smith stops the world championship fight in the sixth round at Highbury stadium. One of Cooper's weaknesses was a tendency to cut, and on this occasion a gash over his left eye forced the abandonment of the fight.
21st May, 1966

World heavyweight champion Muhammad Ali smiles as he plays the piano during a post-match press conference at the Piccadilly Hotel, London. He stopped playing when someone in the crowd shouted, *"Take your gloves off!"*
22nd May, 1966

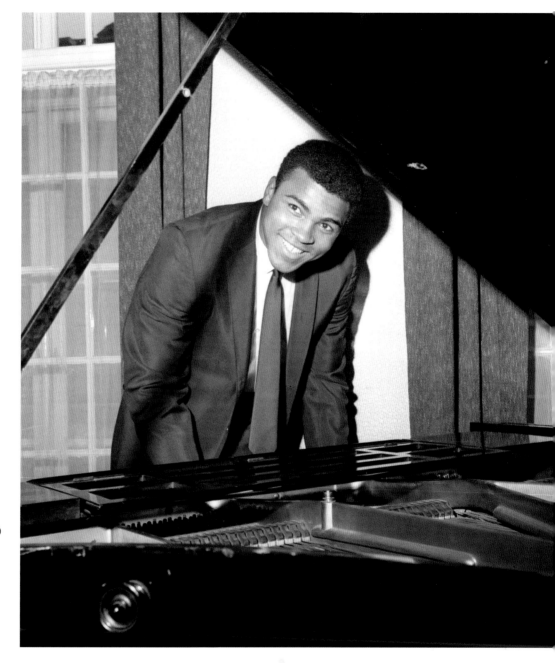

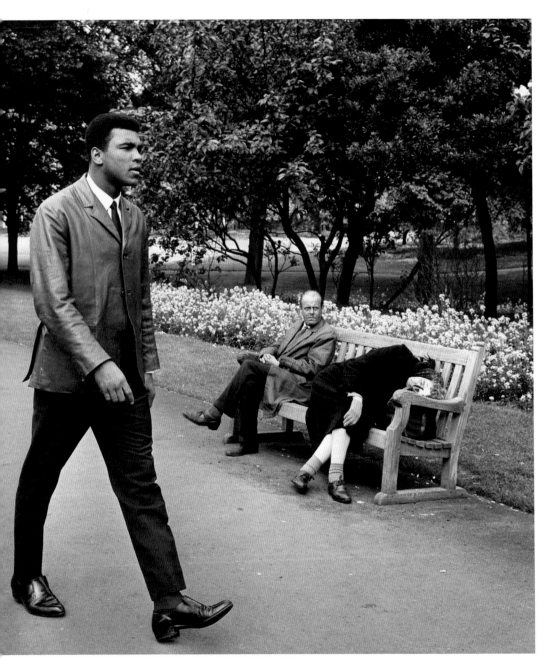

A fresh-faced Ali strolls through a London park the morning after defeating challenger Henry Cooper in the world title bout. A sleepy Londoner and her companion seem oblivious to the presence of the man who boasted, *"I am the greatest. I said that even before I knew I was."*
22nd May, 1966

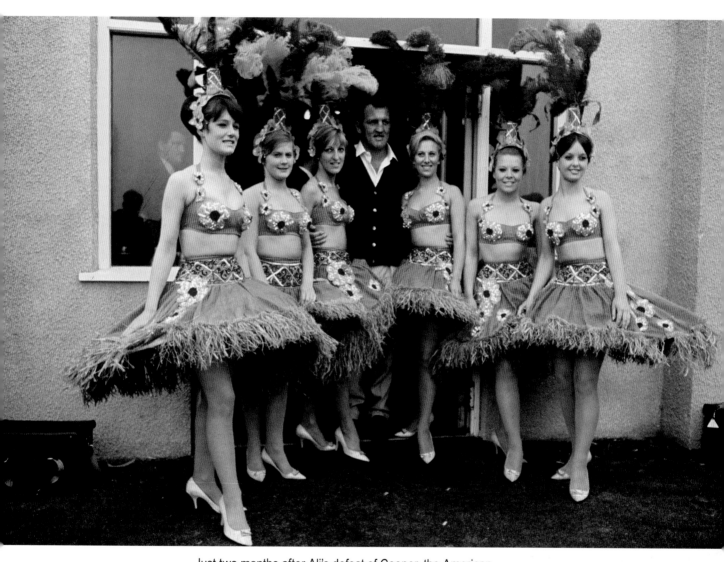

Just two months after Ali's defeat of Cooper, the American champion would be back in England to take on another challenger for his world heavyweight title. 'British Bulldog' Brian London poses with a bevy of colourful showgirls at the Blackpool holiday camp where he was training.
1st July, 1966

Brian London adjusts his headguard before stepping into the ring for a sparring session in his home town of Blackpool.
26th July, 1966

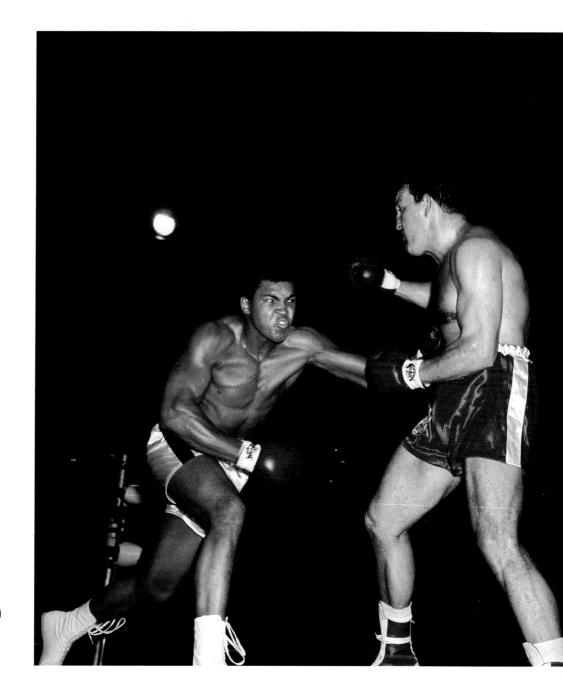

Demonstrating his
unorthodox boxing style,
*"floating like a butterfly,
stinging like a bee"*, the
nimble Muhammad Ali (L)
lands a hefty left to Brian
London's gut.
6th August, 1966

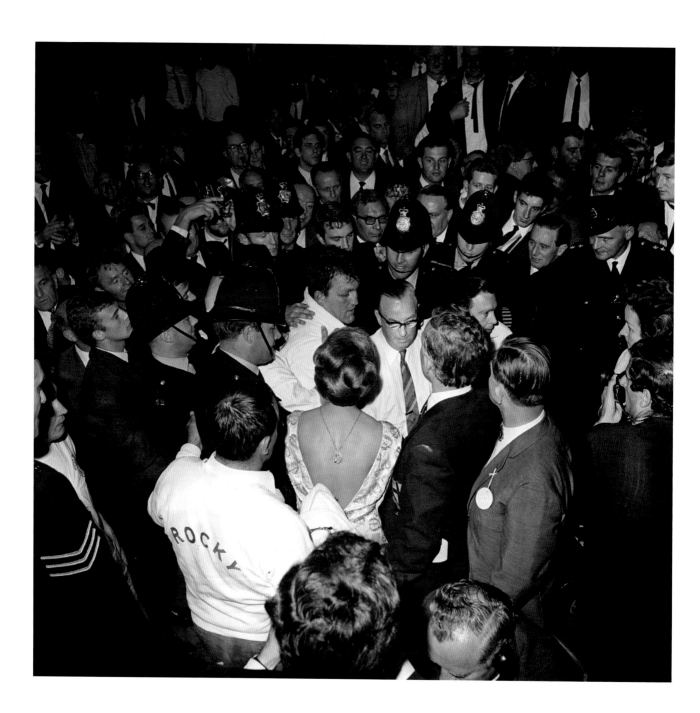

Facing page: Another contender dispensed with: Brian London is escorted from the ring after being knocked out in the third round of the fight against Muhammad Ali.

6th August, 1966

Give the man a big hand. Heavyweight boxer John Coker, from Sierra Leone, shows off his hands after being forced to pull out of the British Commonwealth Games, held in Kingston, Jamaica, because no gloves large enough for them could be found.

11th August, 1966

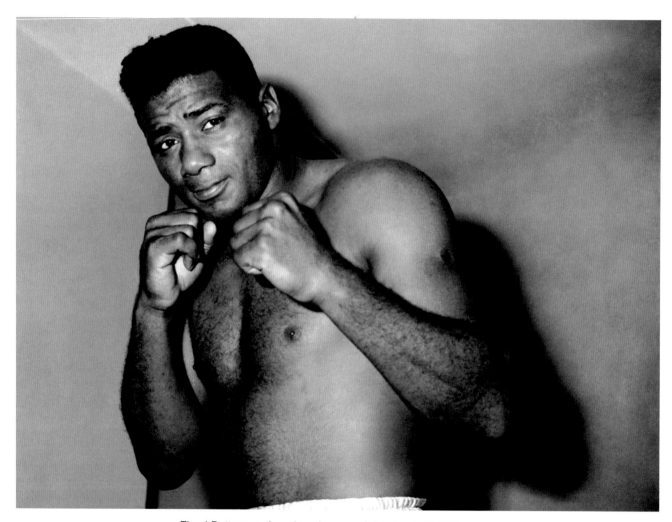

Floyd Patterson, American heavyweight, due to fight Henry
Cooper at the Empire Pool, Wembley on 20th September,
1966. Patterson would prevail over the 32-year-old Briton
with a knockout in the fourth round.
13th September, 1966

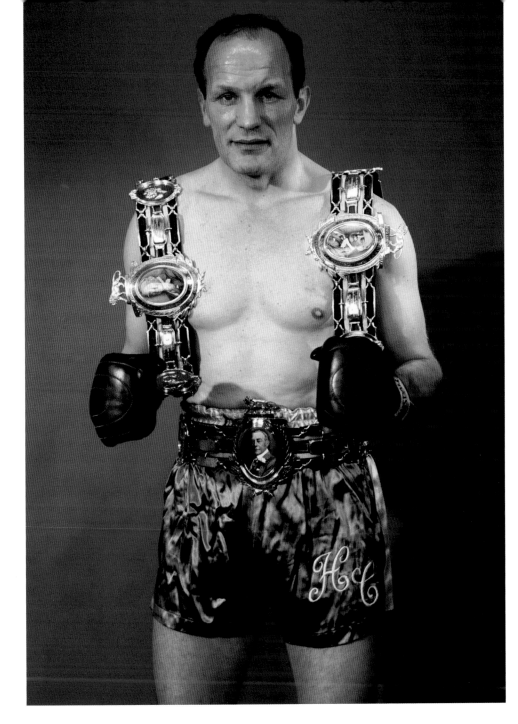

Henry Cooper with his three Lonsdale Belts. He is the only man ever to have won three belts outright. A Lonsdale Belt is awarded to the British champion who defends his title successfully twice.
16th October, 1966

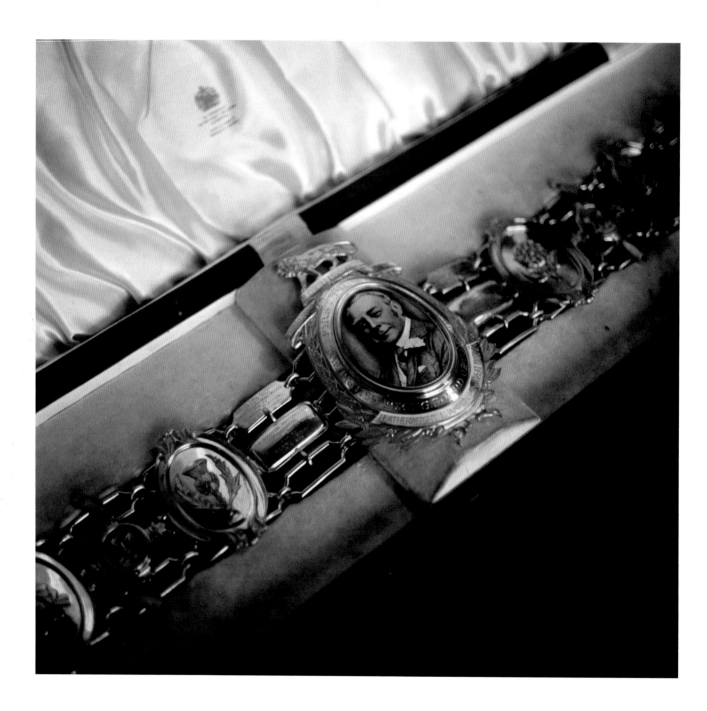

100 Years of Boxing • Twentieth Century in Pictures

Facing page: The Lonsdale Belt in its case. First awarded in 1909, the Lonsdale Belt is the oldest championship belt in boxing, and it is still awarded to the British champion at each weight division. A fighter may keep his belt if he retains it twice.

16th October, 1966

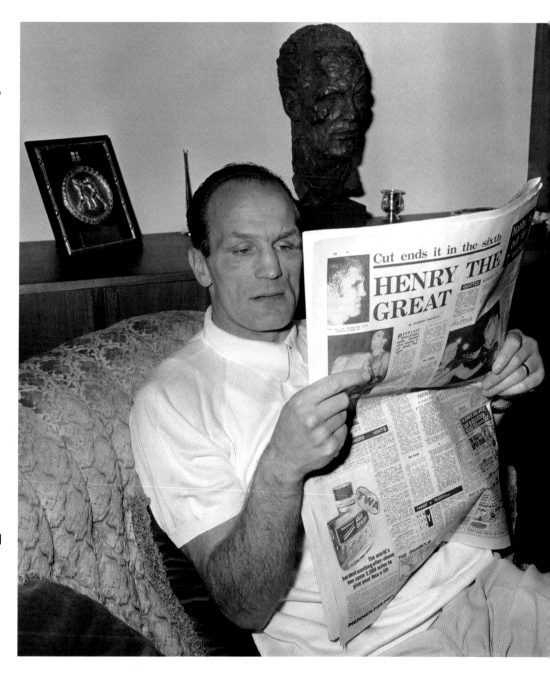

It's the front page of the newspaper that interests Henry Cooper at his Wembley, Middlesex home. He is already familiar with the back-page feature headed 'Henry the Great', the story of his six-round victory over Billy Walker in defence of his British heavyweight championship. Cooper, who has a damaged left eye as a battle souvenir, not only defended the title successfully for the eighth time, but also made a third Lonsdale Belt his own property.

8th November, 1967

Eleven-year-old Wayne Winstone is shown how to throw a left hook by his father, Howard Winstone, the British featherweight champion. Acting as sparring partner is Wayne's younger brother, Roy.
14th December, 1967

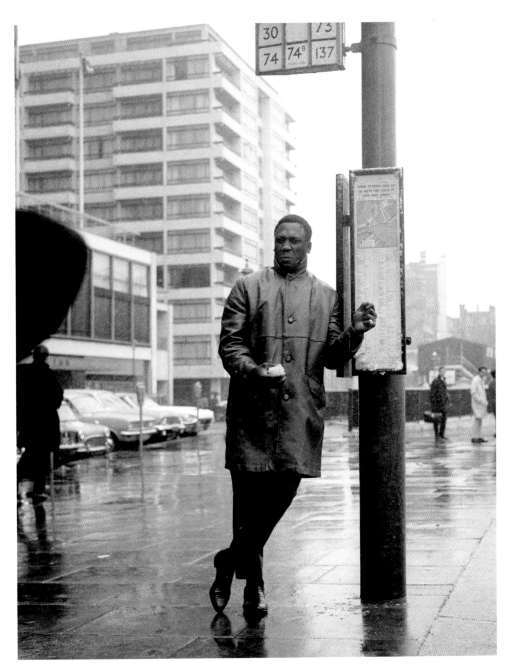

World heavyweight boxing champion Joe Frazier, in London as a guest of the Anglo-American Sporting Club, is doused by an April shower as he munches fruit while waiting for a bus.
2nd April, 1968

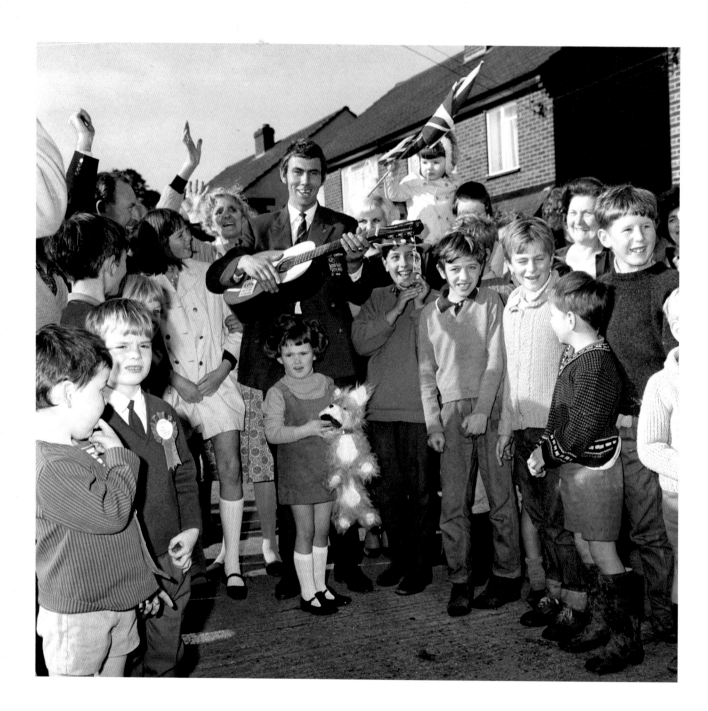

100 Years of Boxing • Twentieth Century in Pictures

Facing page: Guitar playing Chris Finnegan, Britain's gold medalist middleweight, arrived back home from the Olympic Games to a rousing welcome. Clutching a cuddly dog, a present from her father, is Pearl Finnegan, while peering from behind his left shoulder is his blonde wife, Cheryl.
29th October, 1968

Johnny Famechon, Australian featherweight, training for his fight with Britain's Jimmy Anderson in London. Famechon, who won the bout on points in the fourth round, had a professional record of 56 wins (20 by knockout), 6 draws and 5 losses when he retired in 1970. In 1991, he suffered horrific injuries when hit by a car while jogging. Having undergone Acquired Brain Injury neurological rehabilitation in the care of Ragnar Purje, he took his first steps after several months, and in June 1997 fulfilled his promise to walk down the aisle to marry fiancé Glenys Bussey.
20th May, 1969

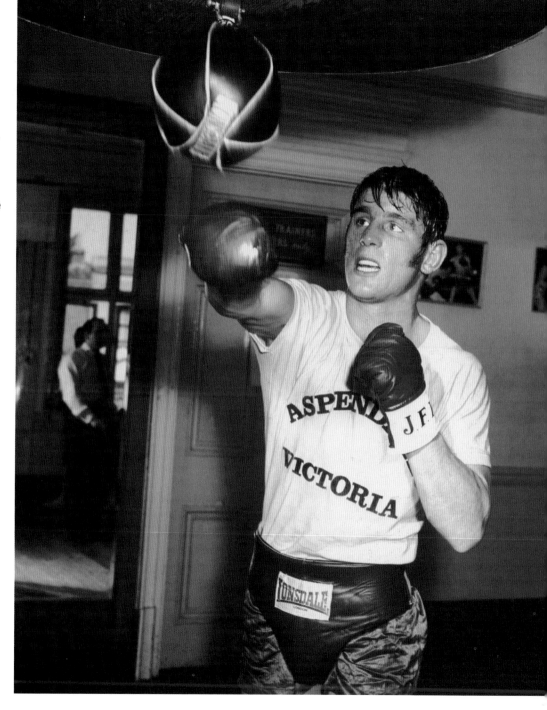

Birmingham born Johnny Prescott (L), known by the alias 'Playboy', can't even bring himself to look Joe Bugner in the eye as they shake hands after weighing in for their heavyweight match at the Royal Albert Hall. Bugner, 6ft 4in tall with an 82in reach, would beat Prescott on points in the eighth round.

20th January, 1970

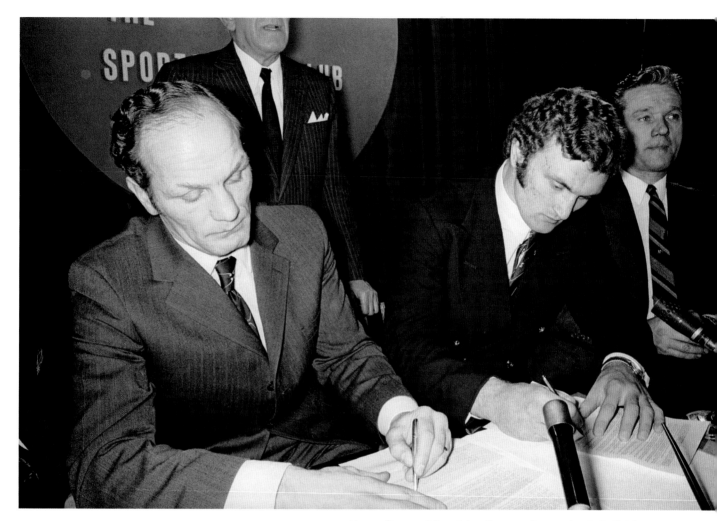

Henry Cooper (L) and Joe Bugner sign contracts to fight each other in March 1971. Bugner, at 21 and nearly 16 years Cooper's junior, had his sights set on claiming the British, Commonwealth and European titles.

27th January, 1971

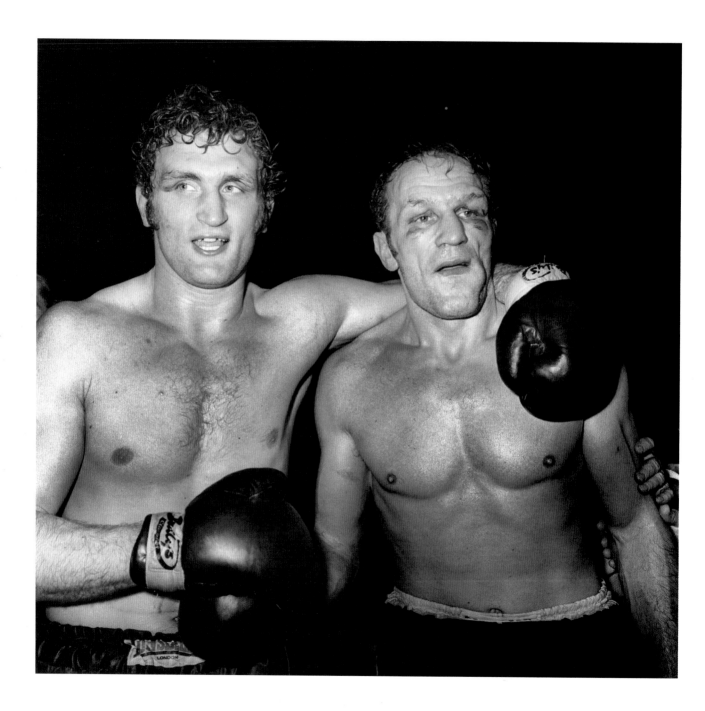

100 Years of Boxing • Twentieth Century in Pictures

Facing page: It was an awesome evening for Joe Bugner (L), who expresses respect for Henry Cooper by placing an arm around him, after beating the champion at the Empire Pool by ¼ of a point. The challenger won after a controversial decision by referee Harry Gibbs, sole arbiter in the bout, which was booed by the crowd. *"He's a fine young fighter,"* said the gracious Cooper, who announced his retirement after the match.

16th March, 1971

Scottish lightweight boxer Ken Buchanan strikes a confident pose in advance of his fight against Canadian Al Ford, at the Empire Pool, Wembley. He would win on points in the tenth round.

20th March, 1972

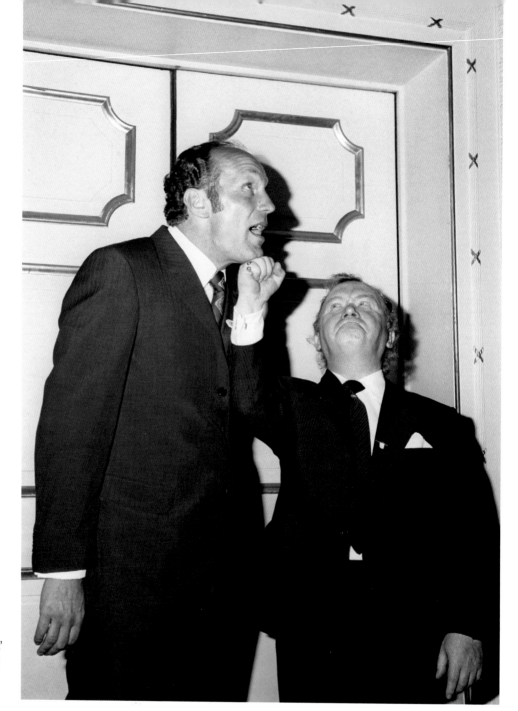

Henry Cooper, former British heavyweight champion, takes it on the chin from the pocket-sized comedian Charlie Drake at the Dorchester Hotel, Park Lane, London, where they were among the guests of honour at the annual Ladies' Lunch of the Variety Club of Great Britain.

13th June, 1972

Sparring on the beach are Chris Finnegan (R), in training
for his bout with America's Bob Foster for the world light
heavyweight title, and Johnny Cheshire. Both men had been
members of the 1968 Olympic Games boxing team.
15th September, 1972

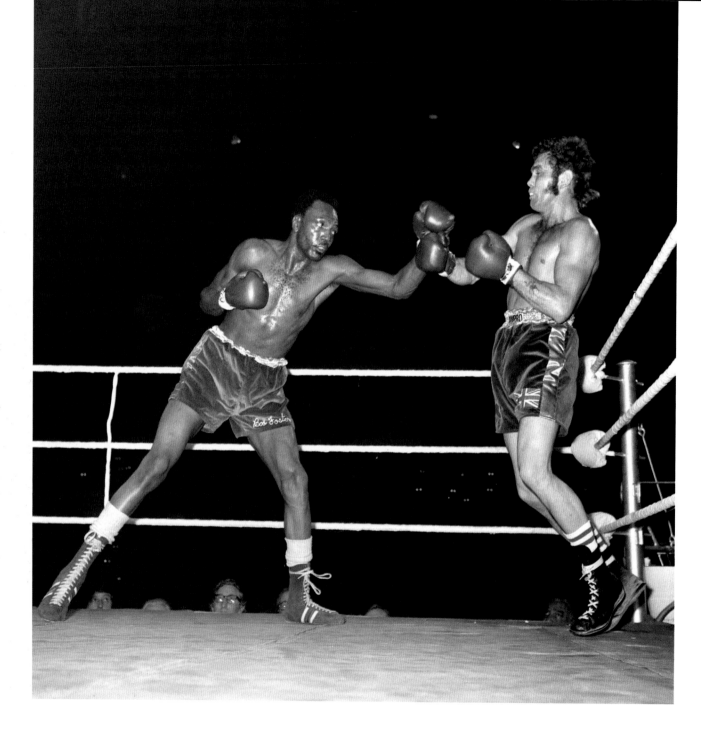

Facing page: Light heavyweight champion Bob Foster (L) uses his 6ft 3in height and 79in reach to good effect as he catches southpaw British challenger Chris Finnegan with a well-placed left hook.

26th September, 1972

Chris Finnegan (front) and Joe Bugner present a united front while training at Craven Arms Gymnasium, Lavender Hill, London. They are both on the same bill at the Empire Pool, Wembley, on 14th November, 1972. Bugner will meet the American Tony 'Irish' Doyle, while Finnegan will face the German fighter Rudi Schmidtke.

9th November, 1972

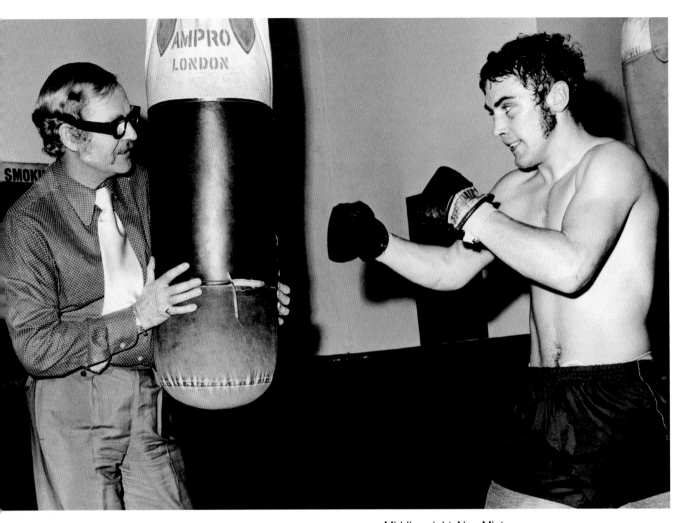

Middleweight Alan Minter
(R) hones his skills on the
punchbag, held by promoter
Mike Barratt.
24th March, 1973

American heavyweight boxer
Ken Norton gives promoter
Jack Solomons a lift.
11th May, 1973

Facing page: A rather swollen Joe Bugner, the morning after his points defeat by Joe Frazier. Born in Szőreg, Hungary, József Kreul Bugner fled his homeland at the age of six with his family following the 1956 Soviet invasion and settled in England. A well-respected and top-ranked contender during the 1970s, he fought many of the big names in heavyweight boxing, including Muhammad Ali, Henry Cooper, Ron Lyle and Jimmy Ellis.
4th July, 1973

Man in the middle. Referee Harry Gibbs gives Joe Bugner a count of nine, during the tenth round of his 12-round fight with former world heavyweight champion Joe Frazier. Bugner lost on points.
3rd July, 1973

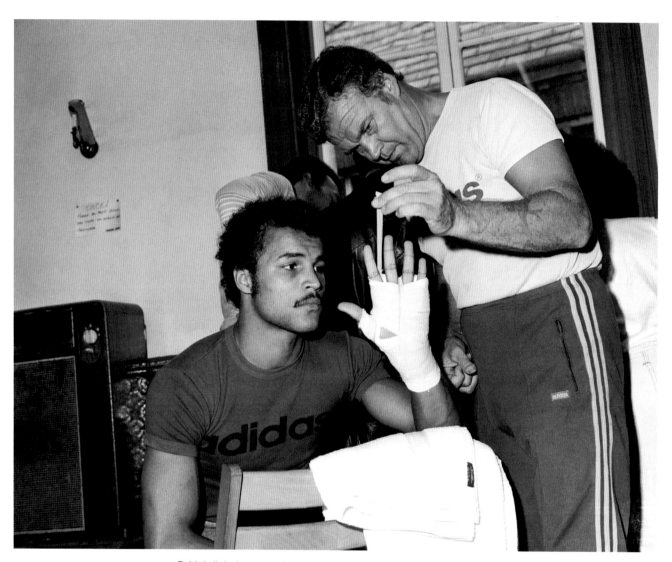

British light heavyweight champion John Conteh has his hands bandaged by his trainer, George Francis, during training for his forthcoming fight against Jorge Victor Ahumada, from Argentina. Liverpool born Conteh frequently graced the pages of the tabloids because of his partying lifestyle and love of women, which he later claimed was responsible for the premature decline of his boxing talents.

19th August, 1974

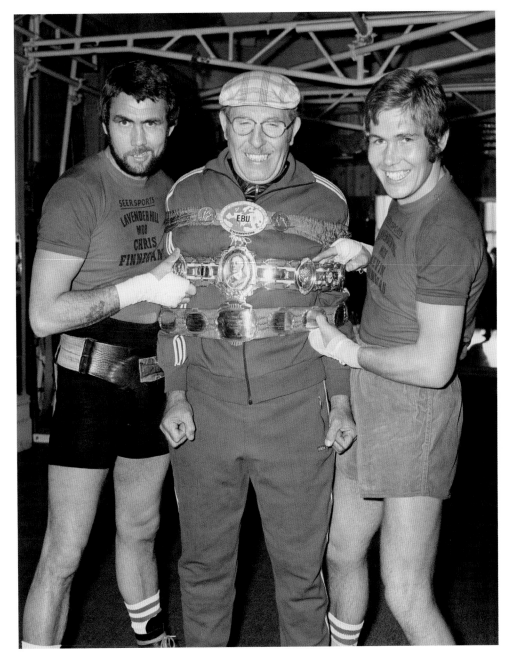

The fighting Finnegans. Former triple light heavyweight champion Chris Finnegan (L), and British and European middleweight champion Kevin Finnegan (R) belt up their trainer, Freddie Hill. The belts all belong to Kevin: (top to bottom) the European Boxing Union Belt; the Lonsdale Belt; and the Southern Area Middleweight Championship Belt.
2nd September, 1974

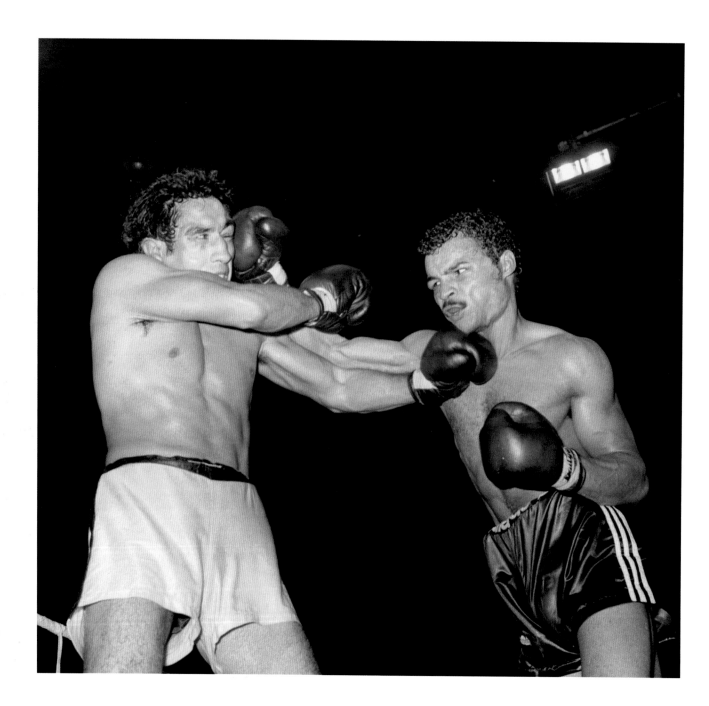

Facing page: John Conteh (R) launches a right hook as Jorge Ahumada tries to fend him off with a weak left hook to the chin. Conteh won the match to be crowned WBC light heavyweight champion after a steward's decision in the 15th and final round.

1st October, 1974

Trainer Eddie Futch reads the *Boxing News* in his hotel room. A heart murmur had prevented amateur boxer Futch, from Hillsboro, Mississippi, USA, from turning professional, but he found his métier in training other boxers. The impressive list of fighters who benefited from his tutelage includes Don Jordan, Joe Frazier, Ken Norton, Larry Holmes and several other world champions.

20th January, 1975

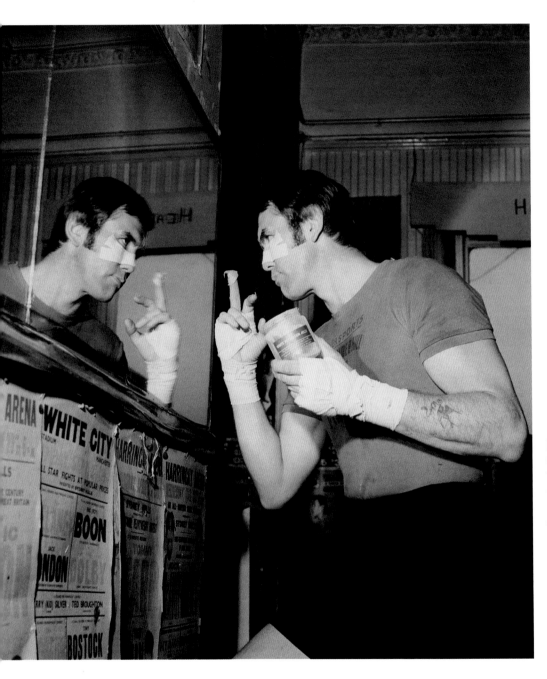

Mirror, mirror... Southpaw Chris Finnegan applies Vaseline to his face at the Craven Arms Gym, Battersea, London. Finnegan was due to fight fellow Briton Johnny Frankham, at the Royal Albert Hall, London, on 3rd June, 1975, for the vacant British light heavyweight title, a match he would lose on points in the 15th round.

29th May, 1975

Yorkshire heavyweight fighter Richard Dunn psyches himself up for his British and Commonwealth heavyweight title fight against Bunny Johnson on 30th September, 1975. Dunn beat Johnson, from Jamaica, on points after 15 rounds.
25th September, 1975

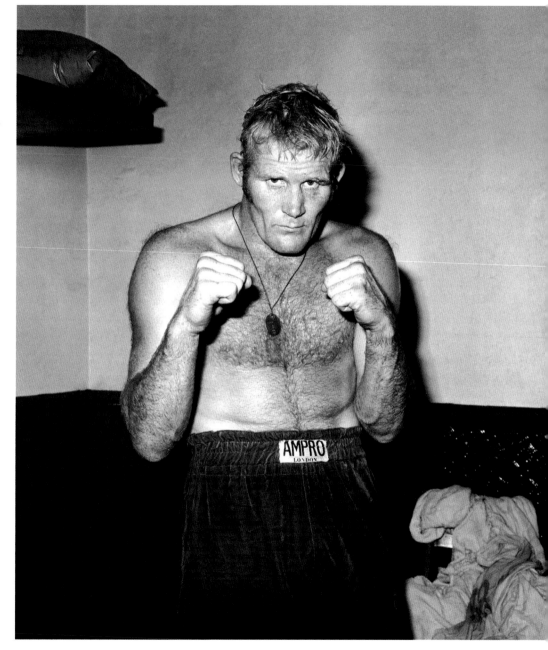

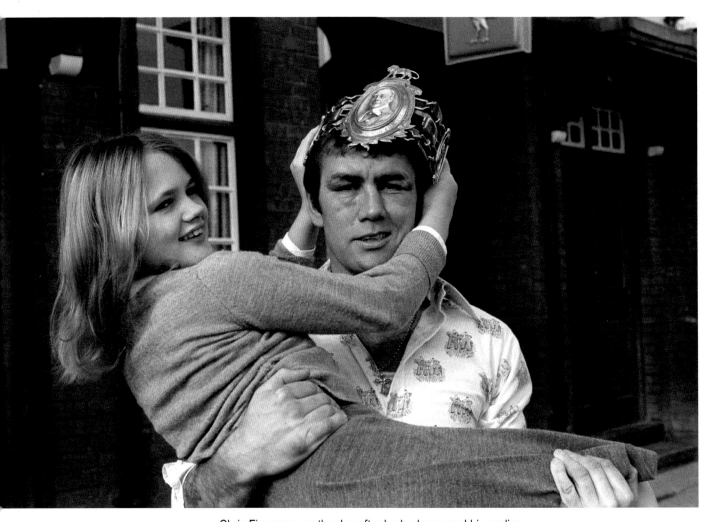

Chris Finnegan, on the day after he had avenged his earlier
defeat by Johnny Frankham for the British light heavyweight
championship, is 'crowned' with his Lonsdale Belt by daughter
Pearl, at their home in Iver Heath, Buckinghamshire.
15th October, 1975

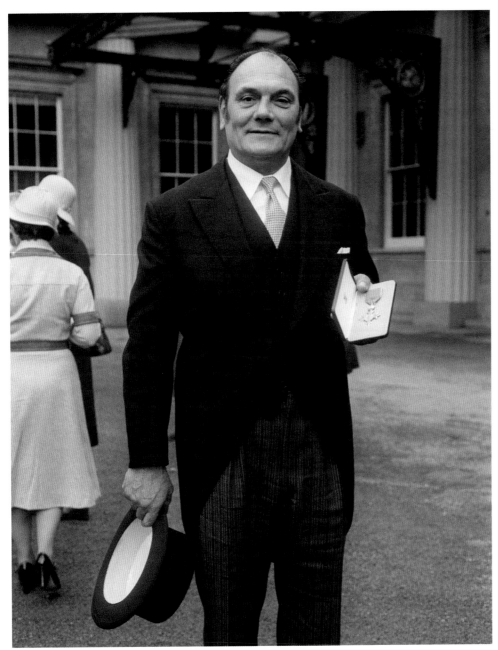

Referee Harry Gibbs shows off his OBE after his investiture at Buckingham Palace, London. In a long and distinguished career, Gibbs officiated at more than 40 world title fights involving such greats as Muhammad Ali, Mike Tyson and Joe Frazier. His most controversial decision occurred in 1971, when he adjudged Joe Bugner a slender points victory over British favourite Henry Cooper, effectively ending Cooper's career. Gibbs died at the age of 79 while on holiday in Spain in 1999.

24th February, 1976

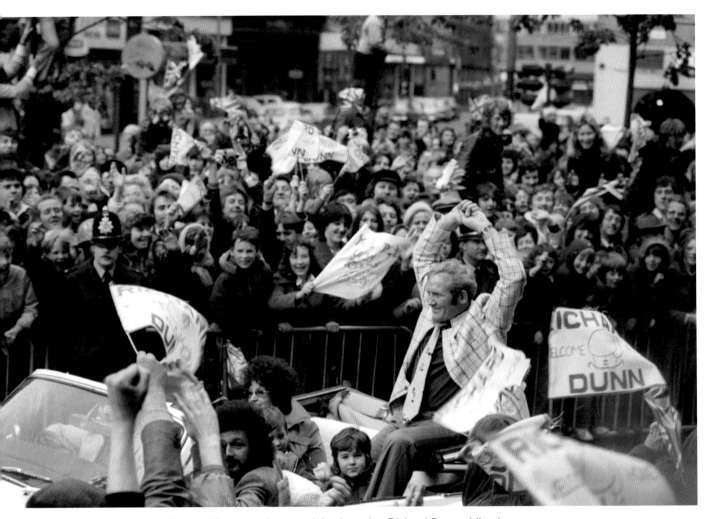

Loser still a winner. British and European heavyweight champion Richard Dunn, riding in an open-top car, responds with a boxer's salute to the Bradford crowds lining the street to give him a hero's welcome after his unsuccessful bid to win the world title from Muhammad Ali in the Olympiahalle, Munich, Germany two days earlier. Dunn had lost after a technical knockout in the fifth round of 15.

26th May, 1976

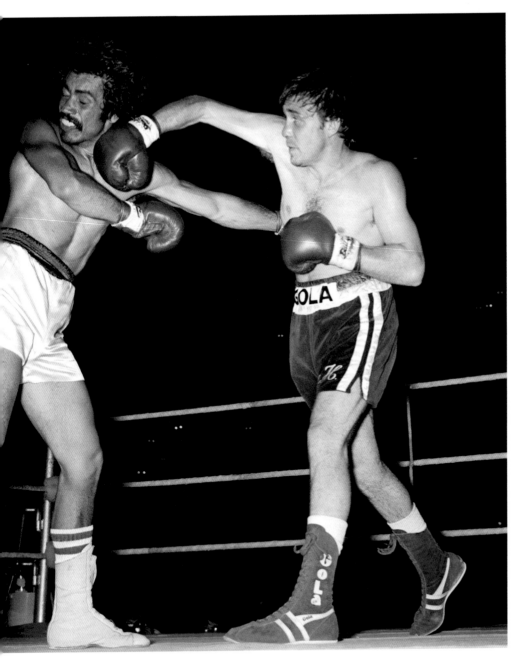

World welterweight champion John H Stracey, from Great Britain (R), in action against Carlos Palomino, the United States based Mexican.
22nd June, 1976

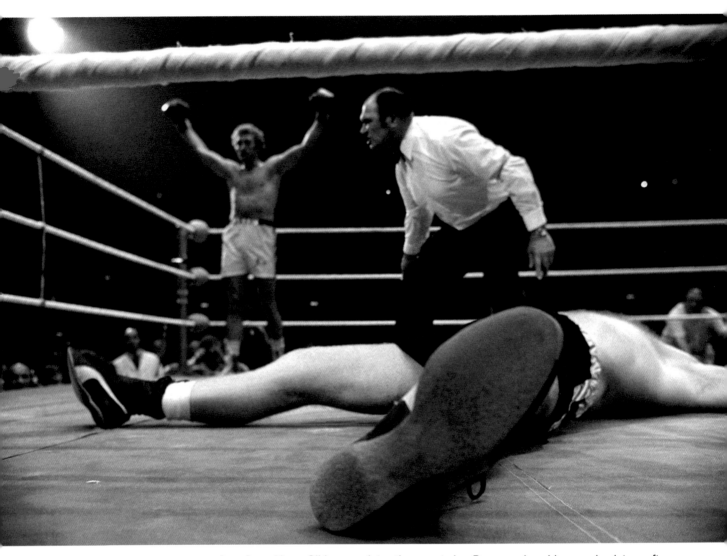

As referee Harry Gibbs completes the count, Joe Bugner raises his arms in victory after flooring Richard Dunn in the first round of the British, Commonwealth and European heavyweight title bout at the Empire Pool, Wembley.

12th October, 1976

Boxers in Y-fronts. British and European light welterweight champion Dave Green (L) and former world welterweight champion John H Stracey meet at the weigh-in at the Leicester Square Theatre for their fight that evening at the Empire Pool, Wembley. Green knocked out Stracey in the tenth and final round.

29th March, 1977

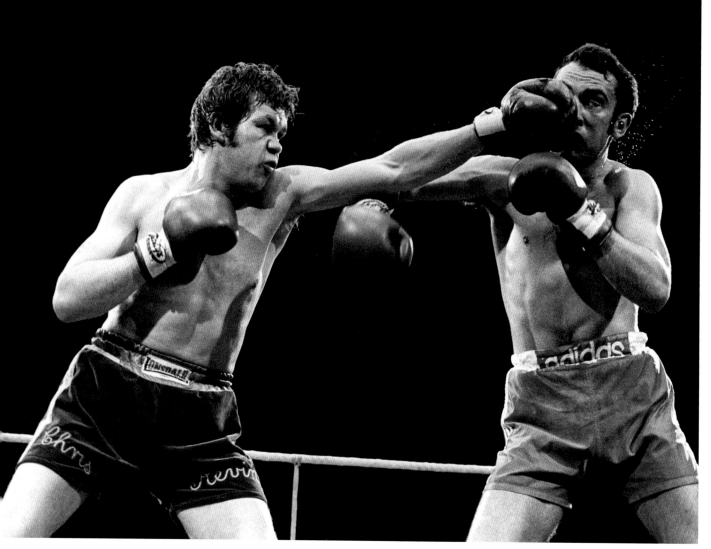

Kevin Finnegan (L) lands a solid left punch to the face of southpaw Alan Minter, but it would be to no avail. He lost this, the last of a trio of unsuccessful fights against 'Boom Boom' Minter for the British middleweight title, to points in the 5th round.

8th November, 1977

Footballer Kevin Keegan (L) and Henry Cooper fool around in a miniature boxing ring to promote Brut 33 deodorant. Sports personalities such as Muhammad Ali, motorcycle champion Barry Sheene and footballer Paul Gascoine have each represented 'the essence of man', but Cooper's slogan *"Splash it all over"* became a catchphrase in Britain during the 1970s.

31st March, 1980

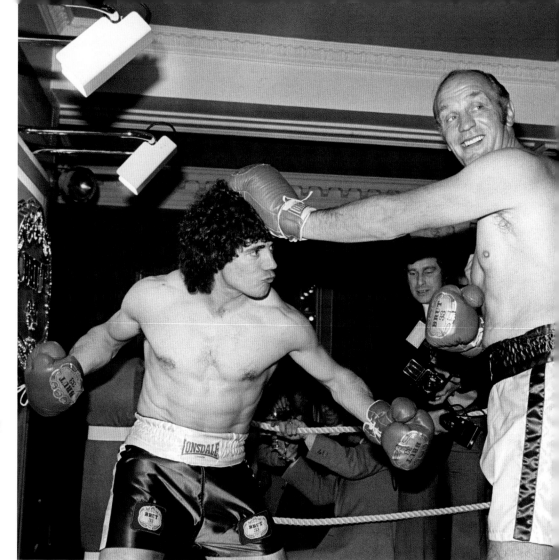

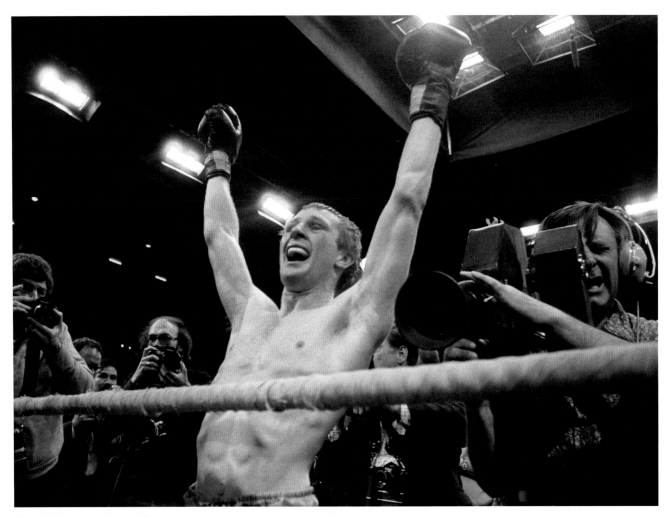

Scottish born southpaw Jim Watt celebrates the retention of his WBC lightweight title after defeating Howard Davis Jr by technical knockout in the 15th round, at Ibrox Park, Glasgow, Scotland.
7th June, 1980

Facing page: 'Marvelous' Marvin Hagler (L) surprises Alan Minter in a notorious bout at Wembley Arena. Prior to the match, Minter had courted controversy by stating, *"No black man is going to take my title away."* (Later he retracted the statement, saying that he meant *"No man".*) His run as world champion ended, however, when referee Carlos Berrocal stopped the fight three rounds in, after Minter sustained a cut eye. With victory awarded to Hagler, Minter's supporters rioted. Both boxers were ushered to the locker rooms by police under a hail of beer cans and glasses.
27th September, 1980

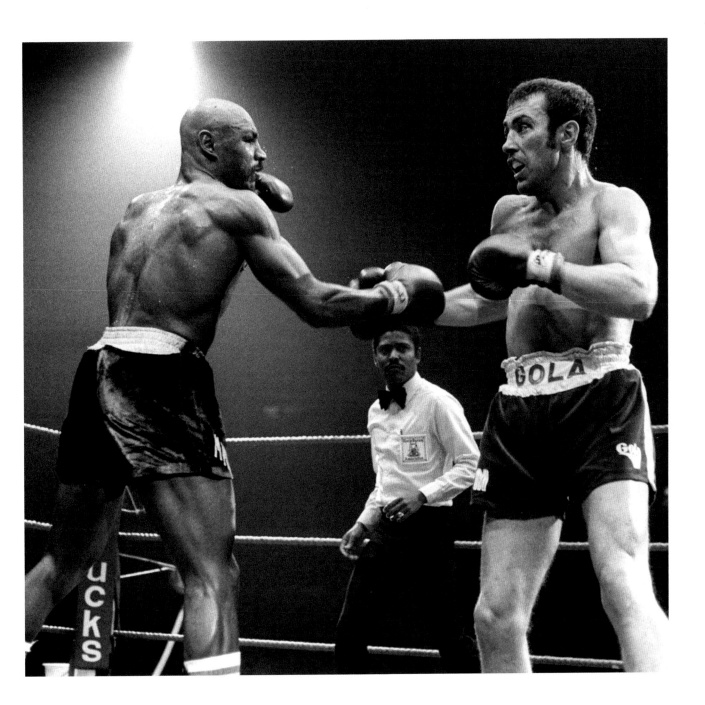

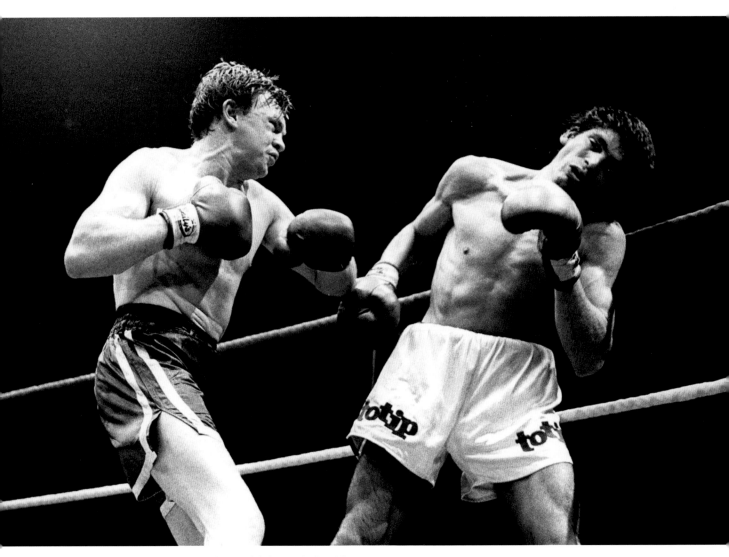

Aggressive attacking by Tony Sibson (L) forces Italian Matteo
Salvemini to the ropes, resulting in a win for the Briton,
who claimed the middleweight title. In an admirable career,
Sibson won 55 of his 63 bouts, 31 by knockout.
8th December, 1980

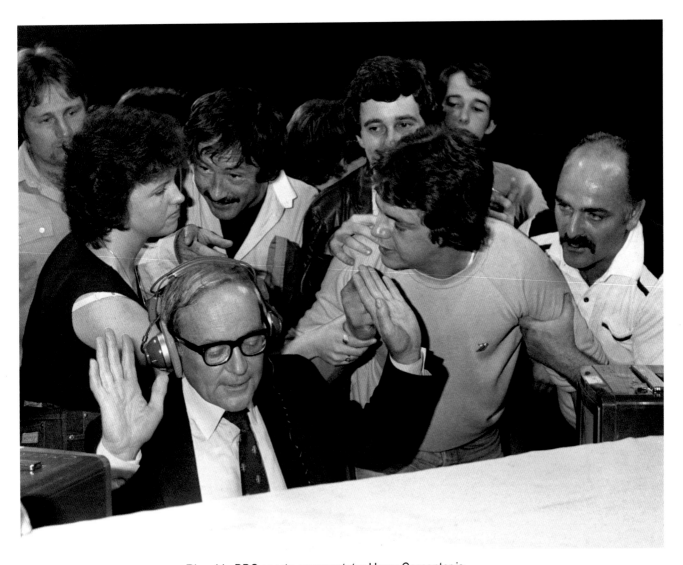

Ringside BBC sports commentator Harry Carpenter is
besieged by irate fans of Colin Jones, after the Welshman
had been disqualified in the third round of his welterweight
fight against Curtis Ramsey of the United States, the first of
only three losses he would sustain in his 30-fight career.
3rd September, 1981

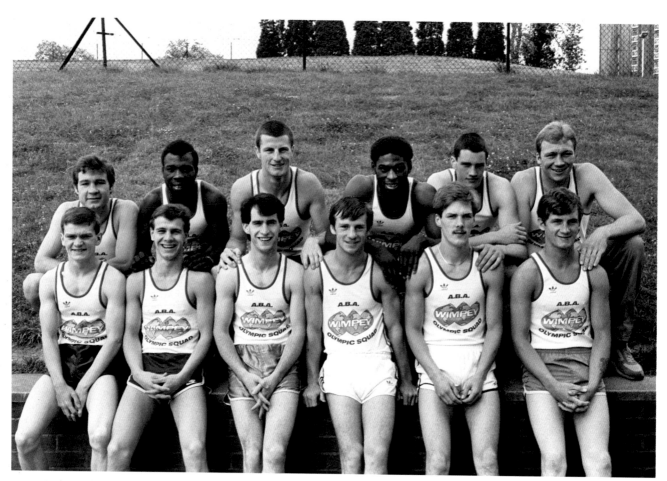

The British Olympic boxing team at the Crystal Palace Sports Centre, south London.
Back row, L–R: Michael Hughes, welterweight; Rod Douglas, light middleweight; Brian Schumacher, middleweight; Tony Wilson, light heavyweight; Douglas Young, heavyweight; and super heavyweight Robert Wells. Front row, L–R: John Lyon, light flyweight; Pat Clinton, flyweight; John Hyland, bantamweight; Kevin Taylor, featherweight; Alex Dickson, lightweight; and Dave Griffiths, light welterweight. Only Wells would bring back a medal, a bronze.
27th June, 1984

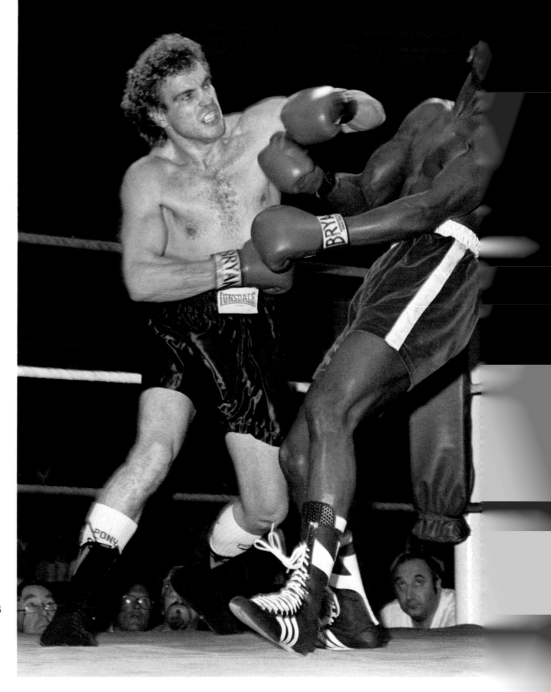

Sheffield's former European and Commonwealth light middleweight champion, Herol Graham (R), takes evasive action during his scheduled ten-round match with cruiserweight Jose Seys of Belgium. Graham won with a technical knockout in round six.

16th October, 1984

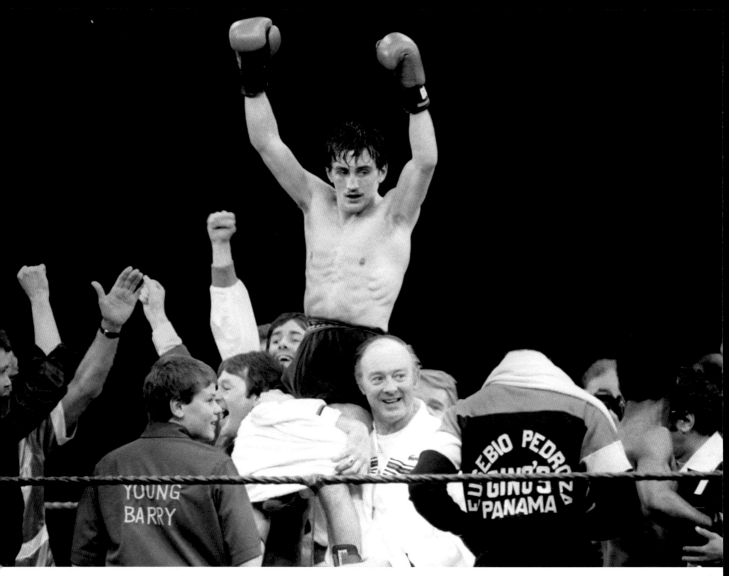

A victorious Barry McGuigan, from County Monaghan, Republic of Ireland, is carried aloft in celebration after winning the WBA world featherweight title fight against Panama's Eusebio Pedroza, at the Loftus Road football stadium, London. McGuigan was feted in his native Ireland by several hundred thousand fans, and subsequently became BBC Sports Personality of the Year, the first time the award had been presented to a person not born in the United Kingdom.

8th June, 1985

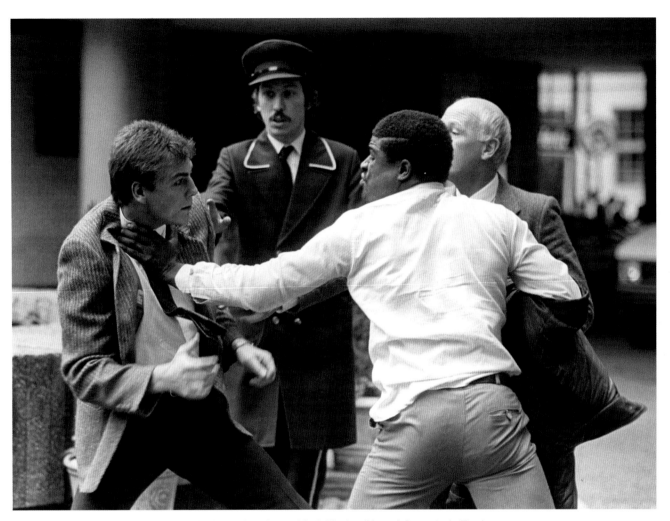

Media hype. Londoner Mark Kaylor (L) and Coventry's Errol Christie trade punches in front of the cameras during a press conference for the British middleweight title eliminator, at the Stakis Regency Club, London.
9th October, 1985

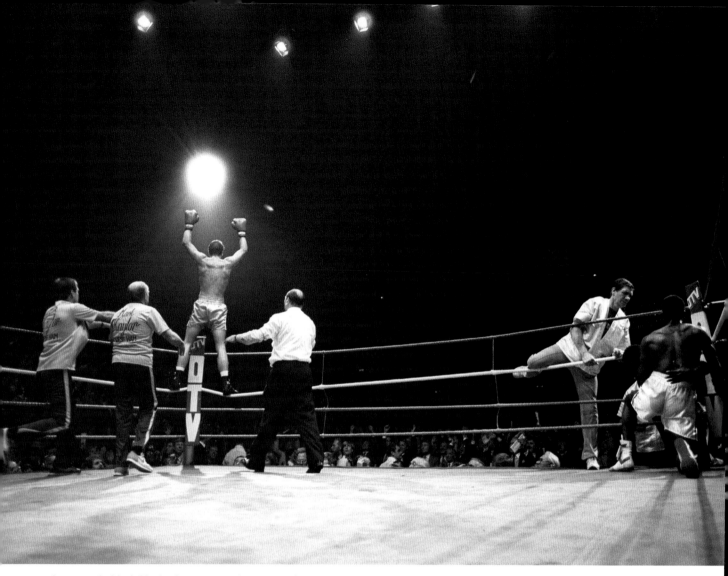

An ecstatic Mark Kaylor leaps on to the ropes after beating
Errol Christie, who remains on one knee on the canvas (R),
with an eighth-round knockout in the final eliminator for the
British middleweight title.
5th November, 1985

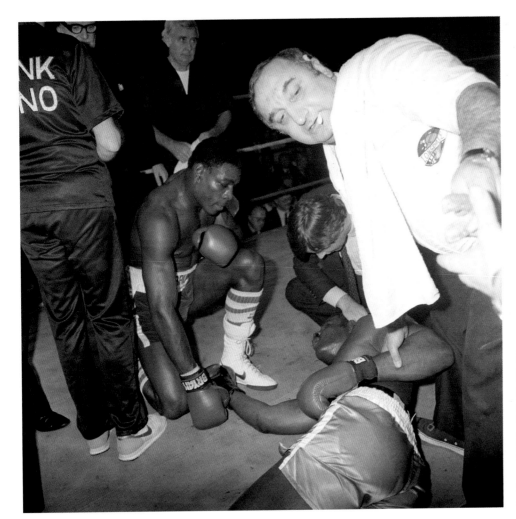

No laughing matter. London born Frank Bruno (kneeling) and his cornerman, Dennie Mancini (R), check on 'Laughing' Larry Frazier, from the USA, after the knockout in 2 minutes and 14 seconds of round two that ended the fight.

4th December, 1985

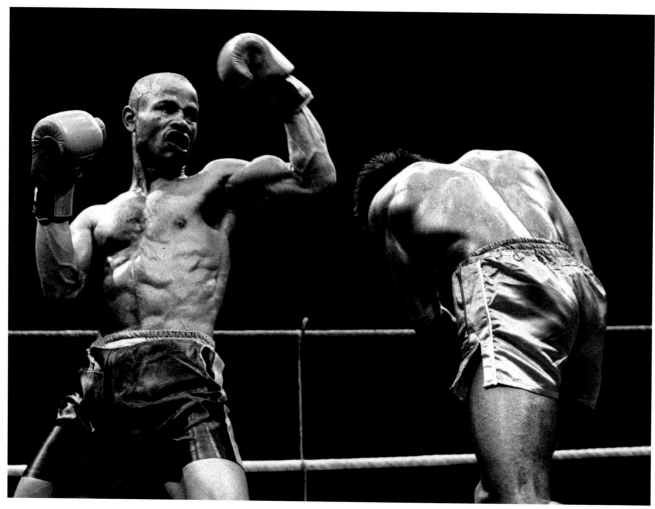

Nottingham's Tony Laing (L) on his way to victory over
Clinton McKenzie of Croydon, at the Royal Albert Hall
in London. Laing outpointed the ex-champion over
12 rounds to win the vacant British light welterweight title.

7th May, 1986

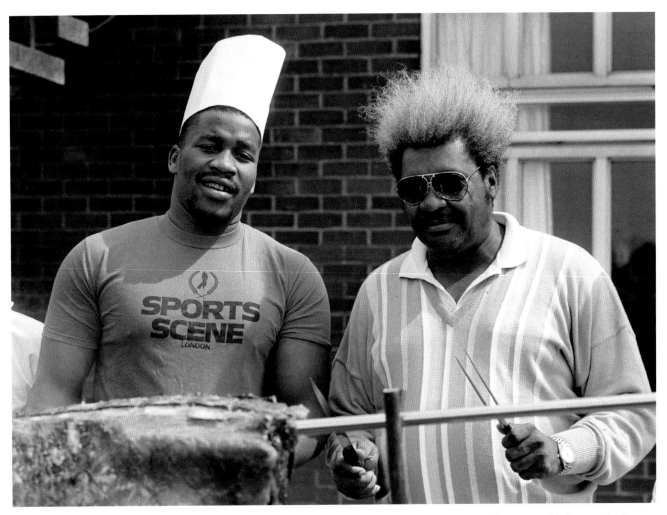

Bad-hair day. American world heavyweight champion Tim Witherspoon (L) dons a chef's hat as promoter Don King prepares to carve, during an American-style 'cook out' hosted by the boxer. Witherspoon was to defend his title against Frank Bruno at Wembley Stadium. In 1987, he would file a $25m suit against King and his son, Carl, the boxer's manager, who had retained half of Witherspoon's earnings as his fee, while most managers receive a third. King settled out of court, paying the fighter $1m.

13th July, 1986

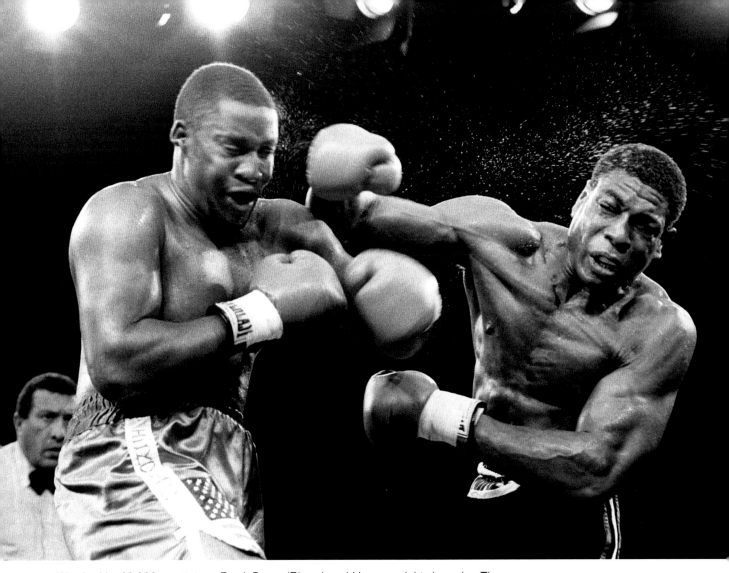

Watched by 60,000 spectators, Frank Bruno (R) and world heavyweight champion Tim Witherspoon land punches simultaneously during their clash at Wembley Stadium. Witherspoon, of Philadelphia, USA, retained his title after referee Isidro Rodriguez stopped the fight in the 11th round and Bruno was taken to hospital for an X-ray to his jaw. The British fighter received £1m from the promoter, while the champion took home only $100,000, an imbalance that triggered a subsequent legal suit.

20th July, 1986

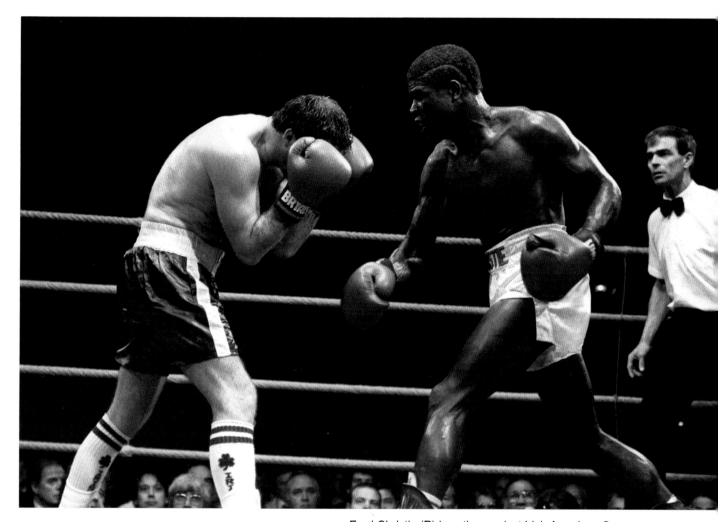

Errol Christie (R) in action against Irish American Sean Mannion at the Alexandra Pavilion, Muswell Hill, London, with referee Mickey Vann officiating the middleweight bout. Christie won on points in the tenth round. After retiring from the professional ring in 1993, he concentrated on teaching 'white-collar boxers', men and women without previous experience in the sport, to fight at special events.

29th October, 1986

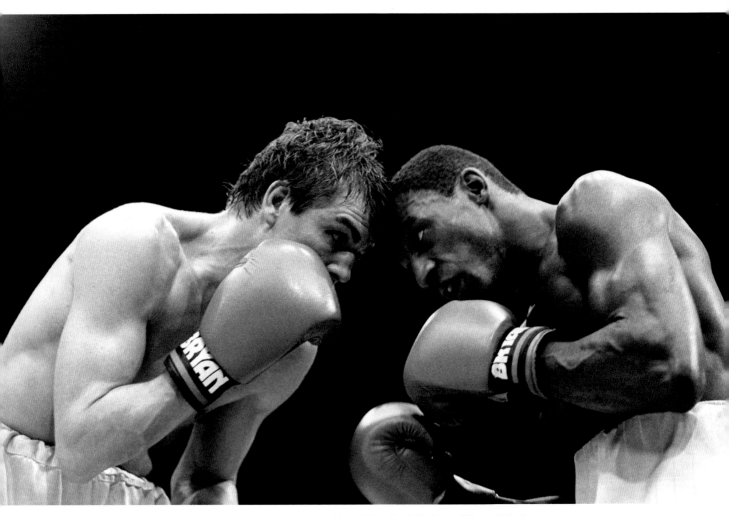

Close action between Herol 'Bomber' Graham (R) and Mark Kaylor in the opening minutes of the 12-round European middleweight title bout at Wembley. Graham won the fight in round eight with a technical knockout.

4th November, 1986

Entertainment and music promoter Harvey Goldsmith (L) and
boxing promoter Frank Warren before a press conference
in London to announce details of the London Arena, a
proposed £20m multi-purpose complex in the Docklands
enterprise zone on the Isle of Dogs, east London.
6th April, 1987

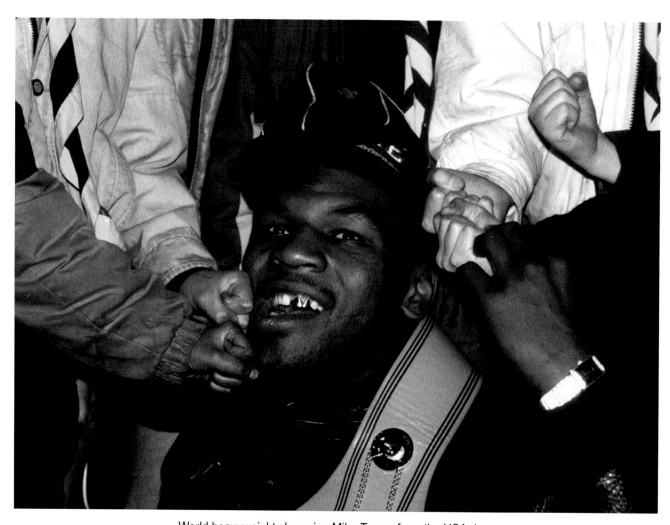

World heavyweight champion Mike Tyson, from the USA, is submerged beneath a barrage of punches from a local Scout troop, during his visit to Great Britain on the announcement that he would fight Frank Bruno.
15th March, 1987

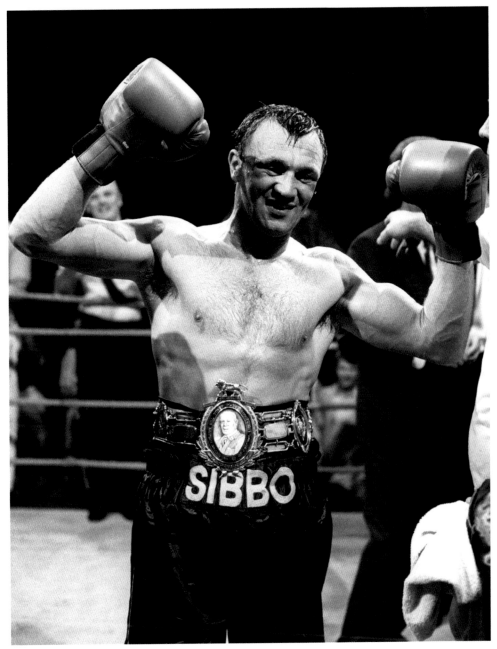

Leicester's Tony 'Sibbo' Sibson celebrates after winning a Lonsdale Belt by defeating British middleweight champion Brian Anderson of Sheffield for the British and Commonwealth middleweight titles at the Royal Albert Hall, London.
16th September, 1987

Comedian and television presenter Michael Barrymore
(R) and Irish singer Dana (C) perform a song and dance
routine with Frank Bruno. The boxer has long been a popular
celebrity guest on entertainment shows, and he appears
regularly in pantomime.
1st March, 1988

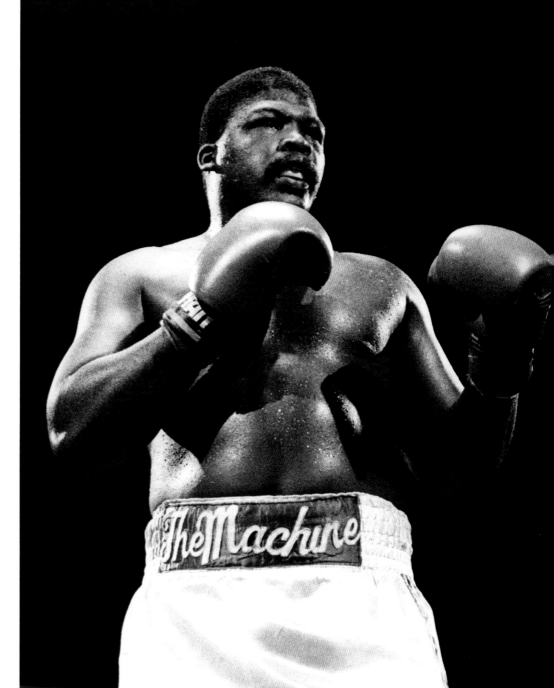

American 'Big John' Tate, 6ft 4in tall, stands ready to fight Britain's Noel Quarless in a heavyweight bout at York Hall, Bethnal Green, London. Tate lost his final professional fight on points in round ten. A bronze medalist in the 1976 Montreal Olympics, he held the world heavyweight title for five months in 1979. Having become addicted to cocaine during the 1980s, he was convicted of theft and assault and imprisoned. He died in a car accident in 1998 after suffering a massive stroke.

30th March, 1988

Ilford boxer Nigel Benn, nicknamed the 'Dark Destroyer', celebrates knocking out Ghanaian Abdul Umaru Sanda in the second round of the Commonwealth middleweight title fight, at the Alexandra Pavilion, Muswell Hill, London.
20th April, 1988

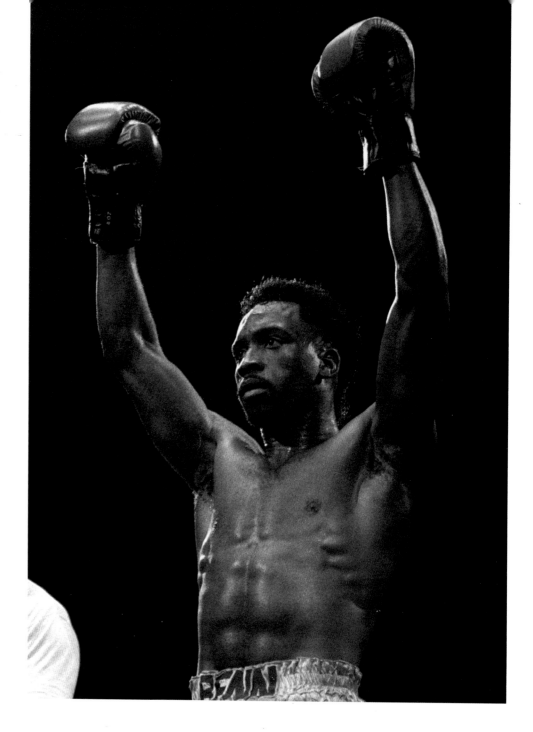

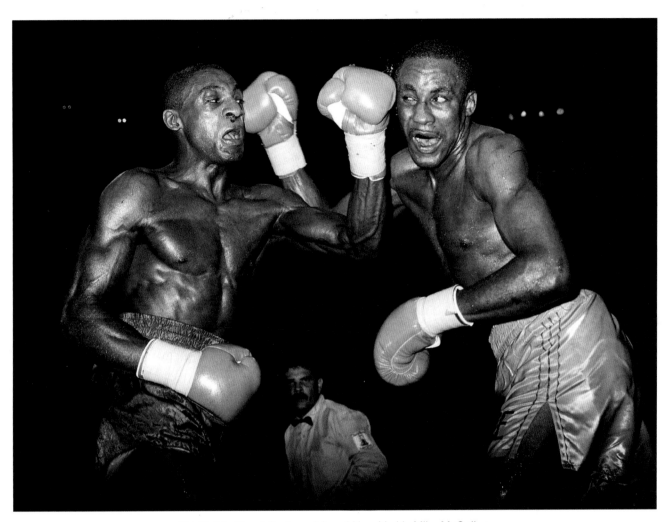

Sheffield's Herol Graham (L) and New York's Mike McCallum feel each other's punching power during the vacant WBA World Middleweight Championship fight at the Royal Albert Hall, London.
10th May, 1989

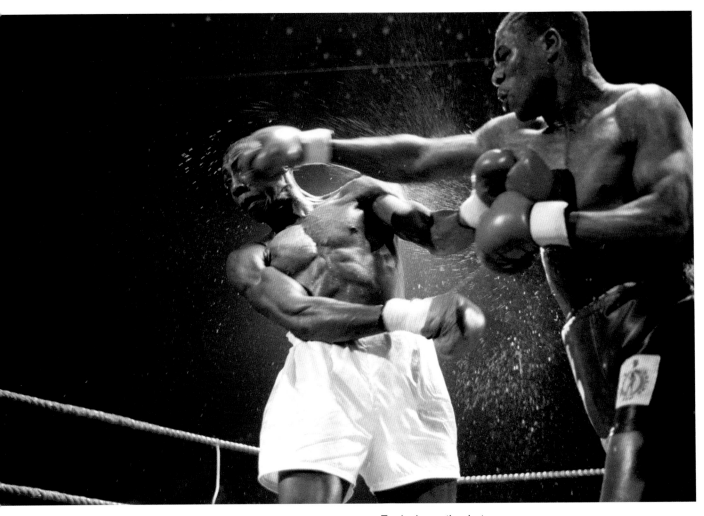

Explosive action between
Andy Straughn (R) and
Johnny Nelson during
the British cruiserweight
championship bout at the
Majestic Ballroom, Finsbury
Park, London.
21st May, 1989

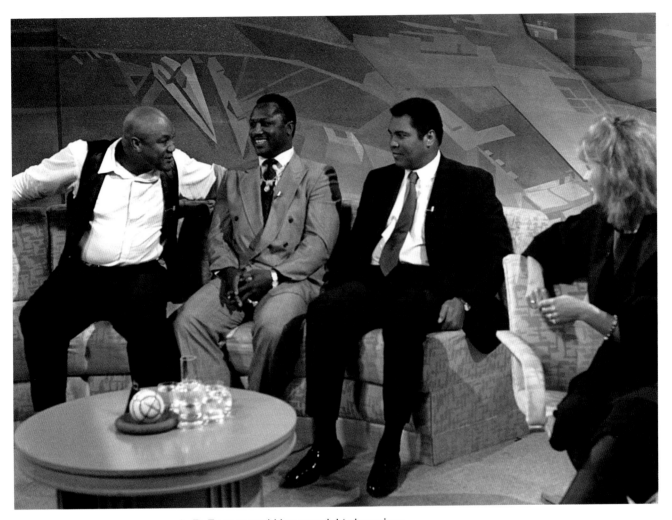

L–R: Former world heavyweight champions
George Foreman, Joe Frazier and Muhammad Ali
on the set of BBC television's chat show *Wogan*,
with stand-in host actress Joanna Lumley.
18th October, 1989

The legendary boxing trainer George Francis, who coached such champions as Frank Bruno, John Conteh, John Mugabi and Cornelius Boza Edwards. He became involved in boxing as a bare-knuckle street fighter in the slums of 1930s Camden Town, London, eventually fighting as an amateur before discovering his talent for training. Francis was found hanged at his home in 2002, aged 73, after the recent deaths of his wife, Joan, and his son, Simon, from cancer.

12th December, 1989

Heavyweight boxer Frank Bruno makes his stage debut in pantomime at London's Dominion Theatre. During the 1980s, the charismatic Bruno managed to combine his career as a boxer with television appearances on Comic Relief programmes and on stage in pantomime.

15th December, 1989

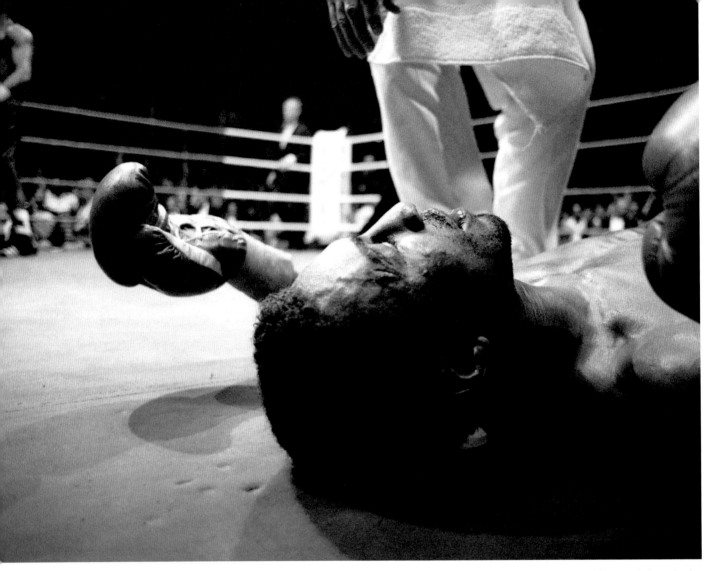

Michael Watson is knocked down during the WBA middleweight championship title fight against Mike McCallum; he lost the match in the 11th of 12 rounds.
14th April, 1990

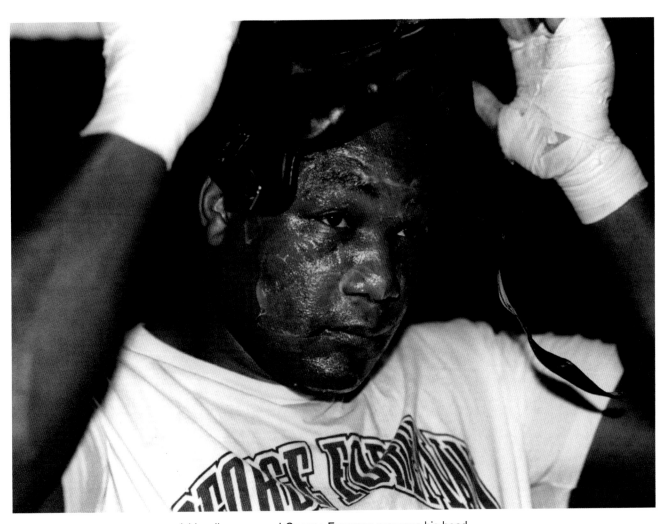

A Vaseline smeared George Foreman removes his head
guard during sparring ahead of his heavyweight bout with
Terry Anderson at Wembley Arena on 25th September,
1990. The 259lb, hard-hitting American would make short
work of fellow countryman Anderson with a knockout in 2
minutes and 59 seconds of the first round.

24th September, 1990

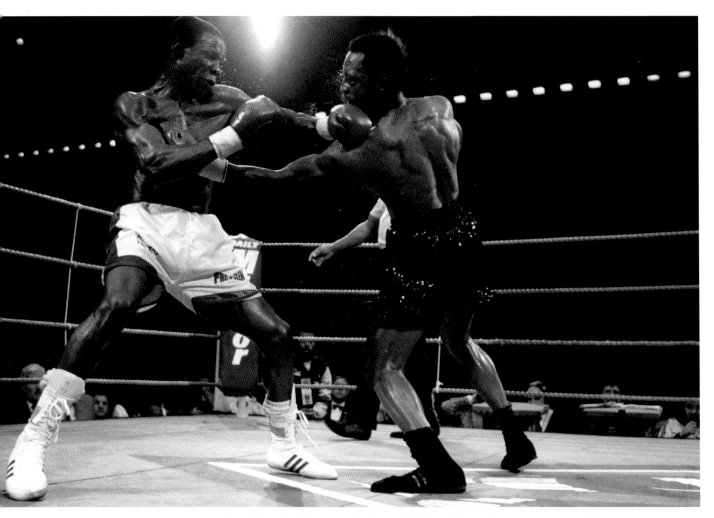

Fresh from his 20-second defeat of Brazilian Reginaldo
Dos Santos to win the intercontinental middleweight title,
Chris 'Simply the Best' Eubank (L) trades blows with WBO
world middleweight title-holder Nigel Benn, at the National
Exhibition Centre, Birmingham. Eubank would claim Benn's
belt with a technical knockout in the ninth round, a match
regarded by aficionados as an all-time classic.
18th November, 1990

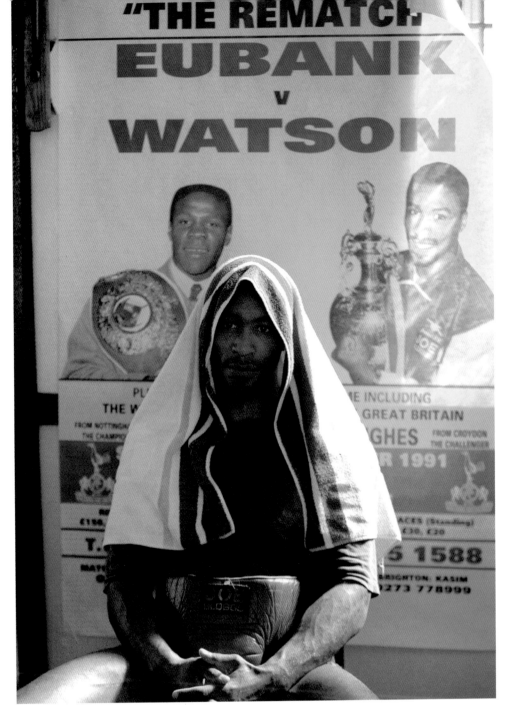

A contemplative Michael Watson sits in front of a poster advertising his much-hyped rematch with Chris Eubank for the WBO super-middleweight title, on 21st September, 1991. In their previous meeting in June, Eubank had won the WBO middleweight title on the majority decision of the judges in the 12th and final round of an exciting bout.

5th September, 1991

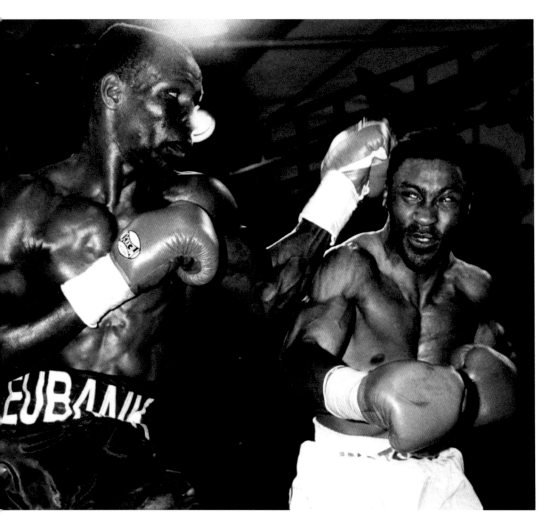

At the super-middleweight title bout at White Hart Lane, Tottenham, Chris Eubank (L) dodges a right from challenger Michael Watson. Although behind on the scorecards, Eubank fought back in round ten and, although knocked down in the 11th, recovered to launch a powerful uppercut that sent Watson crashing back into the ropes. The bell rang and the fighters returned to their corners, although Watson appeared concussed.

21st September, 1991

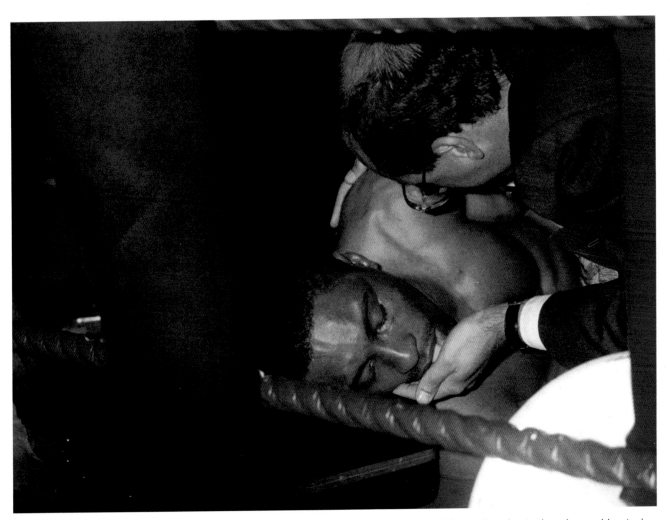

The 12th round began with Eubank determined to deliver a knockout, since he could not win on points. After Watson received a barrage of punches, referee Roy Francis stopped the fight. Moments later, Watson collapsed. He was rushed to hospital, where his life was saved by emergency surgery to remove a blood clot from his brain. He spent 40 days in a coma, a year in intensive care and six more years in a wheelchair, but eventually he recovered some ability to walk and talk.

21st September, 1991

Jamaican born boxer Lloyd Honeyghan crowns himself with the winner's cup, after beating Londoner Mickey Hughes with a technical knockout in the fifth of 12 rounds to become the Commonwealth light middleweight champion, at the International Centre, Brentford, Essex. Referee Dave Parris had stopped the fight due to a cut on the bridge of Hughes' nose.

30th January, 1993

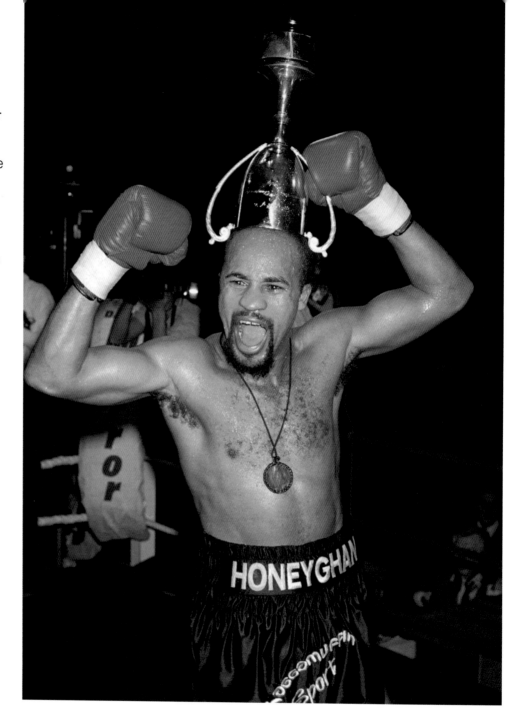

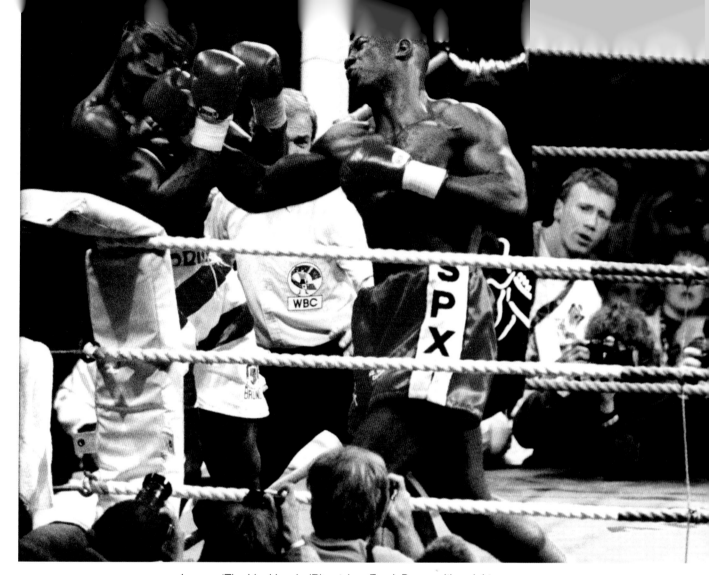

Lennox 'The Lion' Lewis (R) catches Frank Bruno with a right hook, during the WBC world heavyweight title fight at Cardiff Arms Park, Cardiff, Wales. In the seventh round, referee Mickey Vann warned Lewis about holding and hitting, but Bruno was unable to recover, and soon after Vann stopped the match.
1st October, 1993

The 'Dancing Destroyer', Herbie Hide (L), and WBO
heavyweight champion Michael Bentt (R) are separated after
brawling during a news conference in London to announce
their forthcoming title fight.
10th January, 1994

An amateur bout between Cheryl Robinson (L), of West Bromwich, and Lorraine Farley, of Liverpool. Progress towards accepting women as boxers was slow, and women were not permitted to compete as amateurs until 1988, when the Swedish Federation allowed fights. Norway, Finland, Canada and the USA followed suit. In 1994, the International Boxing Association (AIBA) announced a licensing scheme covering women boxers. In 1996, the Amateur Boxing Association of England (ABA) lifted the 116-year ban on women boxing.

20th February, 1994

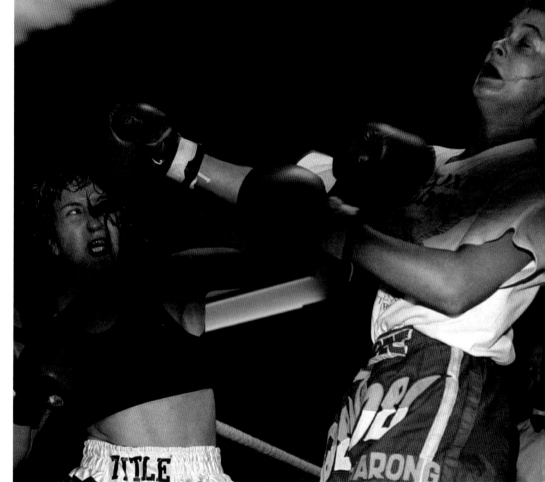

A jubilant Nigel Benn after his opponent, Gerald McClellan, had been counted out in the tenth round of the super middleweight title fight by referee Alfred Azaro, at the New London Arena, Millwall. His joy was short lived. McClellan, who had knocked Benn out of the ring in the first round and down in the eighth, collapsed in his corner. He was rushed to hospital, where a blood clot was found on his brain. McClellan is now blind, partially deaf and largely wheelchair bound.

25th February, 1995

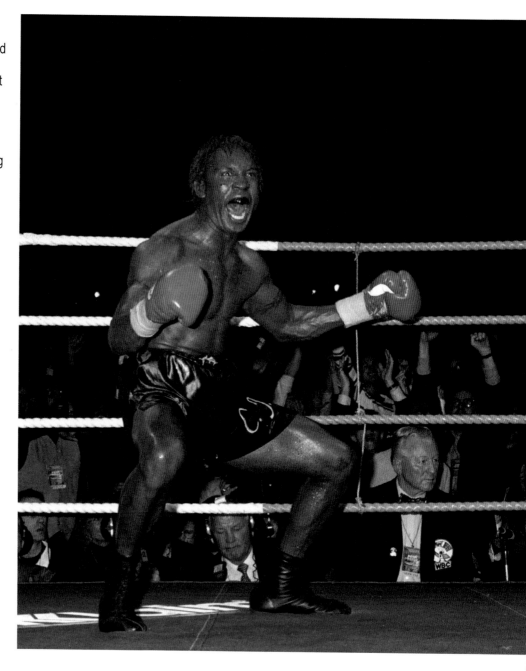

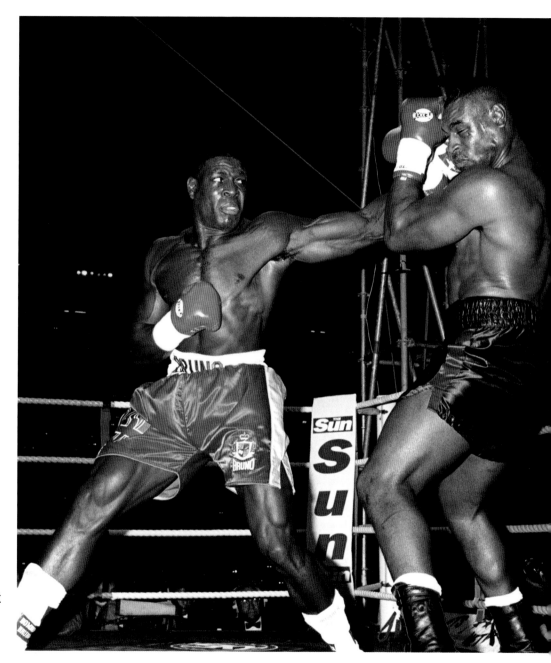

Frank Bruno throws a left to the head of WBC heavyweight champion Oliver 'The Atomic Bull' McCall in the first round of their contest at Wembley Stadium for the world heavyweight title. After a lacklustre performance by McCall in the first ten rounds, the British fighter built up a big lead on the scorecards and won the fight by unanimous decision in the 12th round.

2nd September, 1995

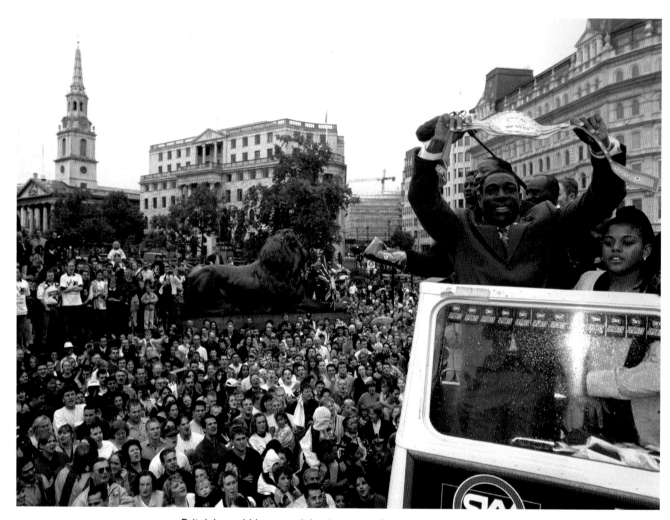

Britain's world heavyweight champion, Frank Bruno, with his
daughter, Rachel, displays the WBC belt he had won after an
epic battle with Oliver McCall the previous week at Wembley
Stadium. The open-top bus carried Frank and his family from
Marble Arch to Trafalgar Square during a parade organized
by satellite television channel Sky Sports, dubbed 'VB Day'
(Victory for Bruno Day).
10th September, 1995

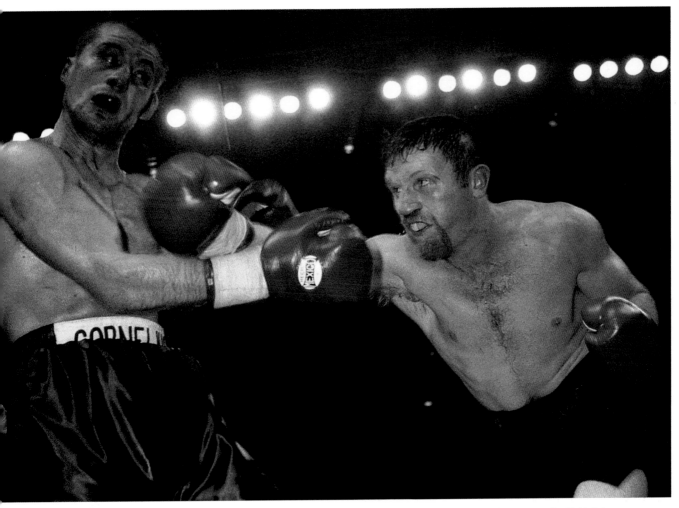

The 'Celtic Warrior', Steve Collins, rocks British boxer Cornelius Carr during their WBO super middleweight title fight at The Point in Dublin, Ireland. Collins retained his title on a unanimous points decision. The Irish boxer successfully defended the title he had taken from Chris Eubank seven times, including a second fight with Eubank and two against Nigel Benn.
26th November, 1995

Six months after he won the world heavyweight title, Frank Bruno battles with Mike Tyson at the MGM Grand, Las Vegas, USA. They had fought in 1989, when Bruno had challenged Tyson for the unified world title. On that occasion, Bruno, despite 'wobbling' Tyson for the first time in his career, lost by technical knockout; on their second meeting, he lost when the bout was stopped in round three as he went down on the ropes, unable to defend himself.

16th March, 1996

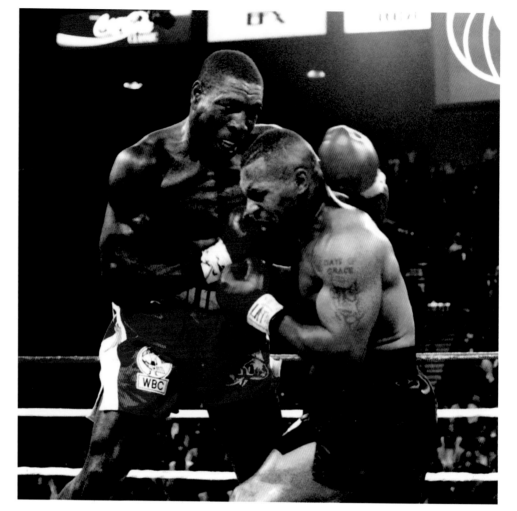

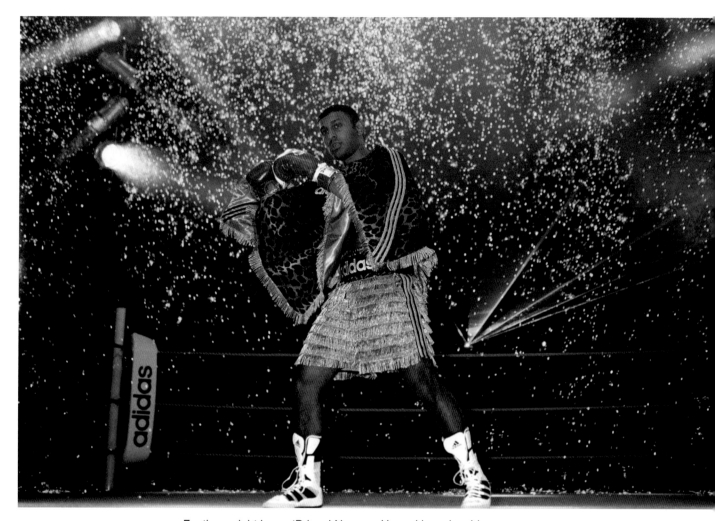

Featherweight boxer 'Prince' Naseem Hamed launches his
new Adidas sponsorship deal in his usual flamboyant style in
Brixton, south-west London. Under a ten-fight sponsorship
contract, the WBO featherweight champion of the world
would be sporting the company's logo alongside his familiar
penchant for leopardskin.
16th May, 1996

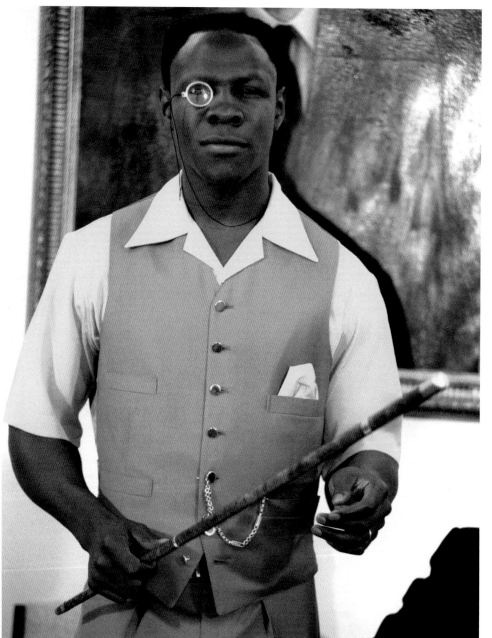

Facing page: 'Prince' Naseem Hamed prepares to defend his featherweight title against Billy Hardy, in the Nynex Arena, Manchester, on 3rd May, 1997. Despite Hamed's swagger and showmanship, he possessed a unique boxing style that frequently caught his opponents off guard. Hardy would suffer an ignominious defeat by technical knockout in just 1 minute and 33 seconds of the first round.
January, 1997

Former WBO middle and super middleweight champion Chris Eubank, who announced his boxing comeback, beginning with a bout against Argentinian Dario Matteoni in Cairo on 12th October, 1996. The eccentric London born boxer is typically attired as a stereotypical upper-class Englishman, and famously wears a monocle and carries a walking cane. His lisp is attributed to the loss of his entire top row of teeth at the age of 28, due to an allergic reaction to a gum guard.
8th August, 1996

Marie Leefe (R) lands a straight right on best friend Marie Davies, during the first officially sanctioned women's amateur boxing match to be held in the United Kingdom, at the Creamery Sports and Social Club in Whitland, Pembrokeshire. The two 16-year-olds, using the ring names 'Cheesey' and 'Slaps', were allowed to fight after a change in the Queensberry rules. The three-round bout was won by Leefe.
31st October, 1997

Chris Eubank (R) and
Carl Thompson in action.
Thompson beat Eubank to
retain his WBO cruiserweight
world title at the Nynex
Arena in Manchester.
18th April, 1998

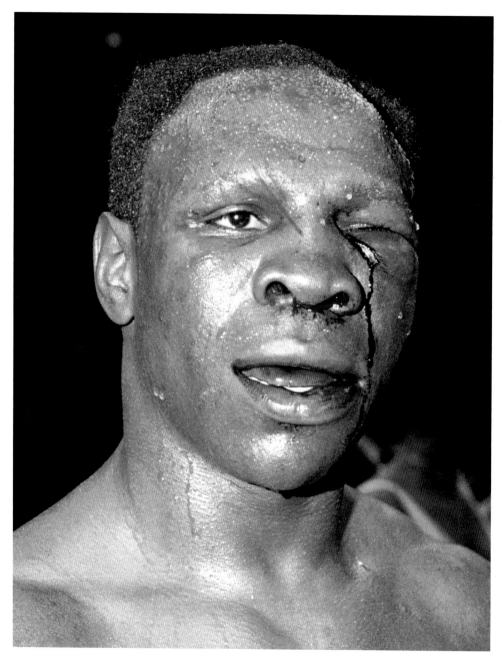

The bloodied face of British boxer Chris Eubank after the fight at the Nynex Arena, where he failed to win the WBO cruiserweight title on points from Carl Thompson. The match was stopped after the ninth of ten rounds on doctor's advice, when Eubank's left eye closed completely from swelling. Eubank quit the ring with a professional record of 45 wins and 5 losses.

18th April, 1998

Larger-than-life American promoter Don King (R) meets with manager Frank Maloney, who represents WBC champion Lennox Lewis, in London. King announced that he would give the world the title match it demanded: Lennox Lewis against Evander Holyfield.
12th October, 1998

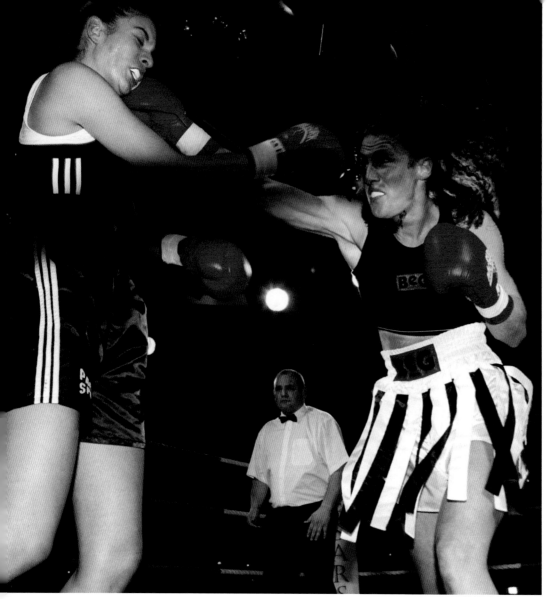

Welterweight Jane Couch (R) lands a punch on German boxer Simona Lukic, at Caesar's Palace, Streatham, London; she won the bout with a technical knockout in the second round. Couch became the first officially licensed British female boxer in March 1998, after claiming sexual discrimination by the British Boxing Board of Control, which had refused to grant her a professional licence. Supported by the Equal Opportunities Commission, Couch had the decision overturned by tribunal.
25th November, 1998

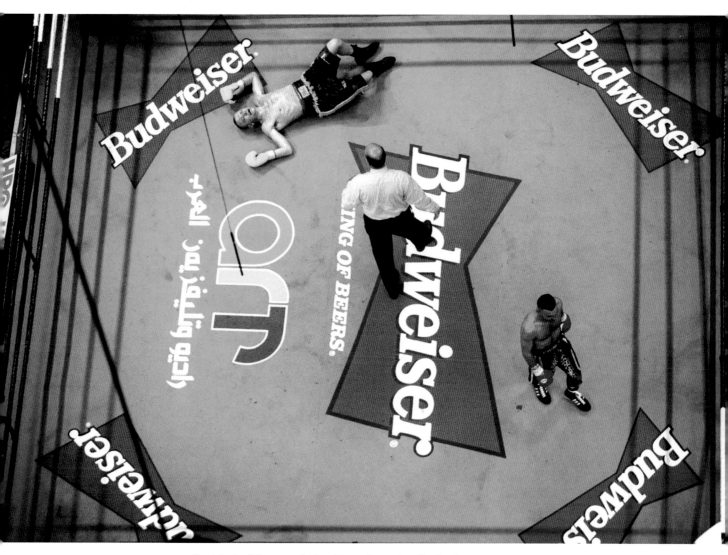

Paul Ingle (L) is counted out by referee Joe Cortez in
the 11th, penultimate round as 'Prince' Naseem Hamed
walks nonchalantly away. The match, at the MEN Arena,
Manchester, was the 12th defence of the WBO featherweight
title by the flamboyant 'Naz'.
10th April, 1999

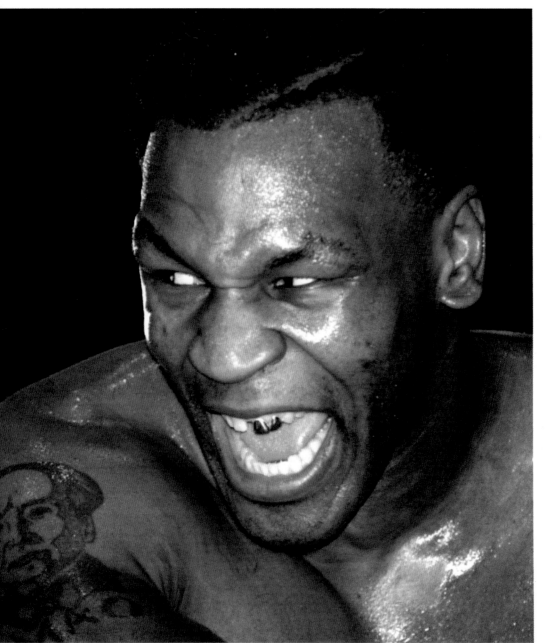

Facing page: Flying visit. 'Prince' Naseem Hamed makes his entrance on a 'flying' carpet for the WBO featherweight title fight against South African Vuyani Bungu, at Kensington Olympia. Hamed was famous for his extravagant entrances, which included being carried to the ringside on a palanquin, walking on a fashion-style catwalk and being lowered into the centre of the ring by elevator.
11th March, 2000

Mike Tyson, 'The Baddest Man on the Planet', during an open training session at his private gym in the Grosvenor House Hotel, London. Amid controversy as to whether the American should have been allowed into the country, Tyson made preparations for his fight against Julius Francis at the MEN Arena, Manchester, on 29th January, 2000. In just four minutes and three seconds, Tyson dispensed with Francis.
25th January, 2000

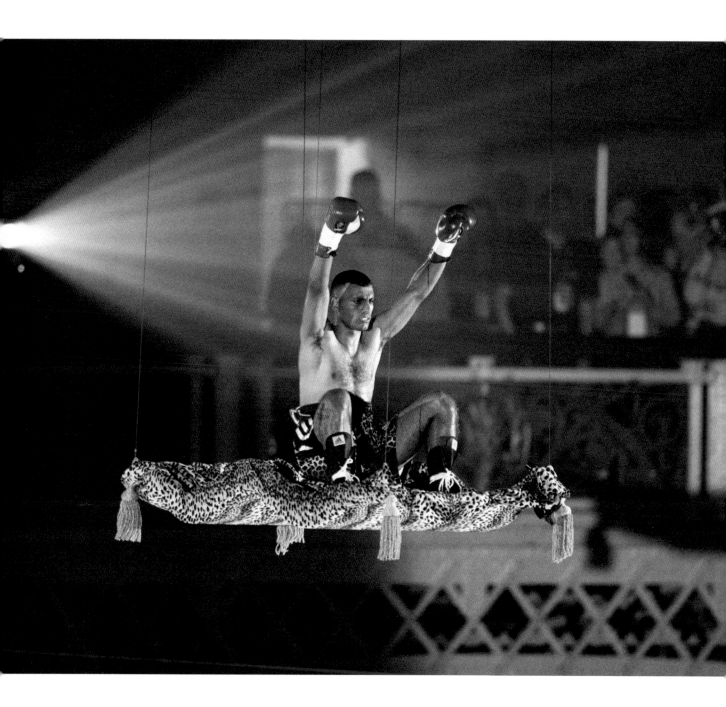

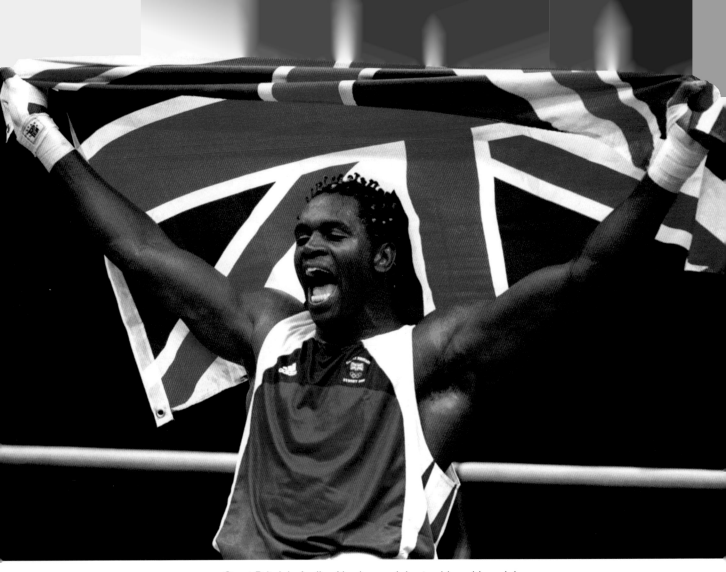

Great Britain's Audley Harrison celebrates his gold medal
win over Kazakhstan's Mukhtarkhan Dildabekov, at the 2000
Olympic Games in Sydney, Australia. Harrison was the first
British fighter to win a gold in the super heavyweight division.
He was awarded an MBE after his medal win and turned
professional the following year.

1st October, 2000

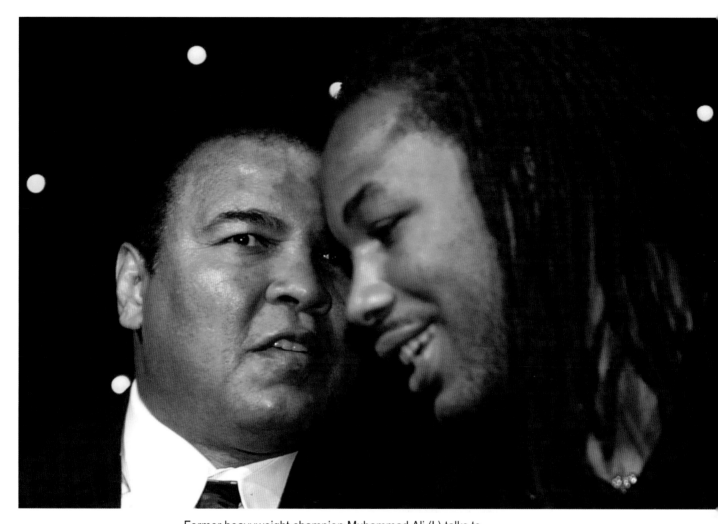

Former heavyweight champion Muhammad Ali (L) talks to
current heavyweight champion Lennox Lewis at the London
launch of the video game *Knockout Kings 2001*, designed for
the Playstation2 console and due for release in March 2001.
15th January, 2001

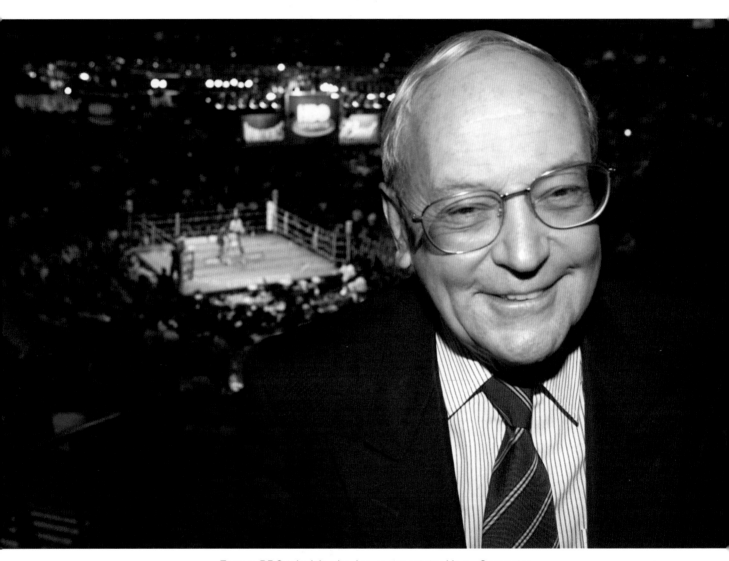

Former BBC television boxing commentator Harry Carpenter joins the studio team as expert analyst at Carnival City, Johannesberg, South Africa, ahead of the world heavyweight title fight between champion Britain's Lennox Lewis and American challenger Hasim Rahman.

21st April, 2001

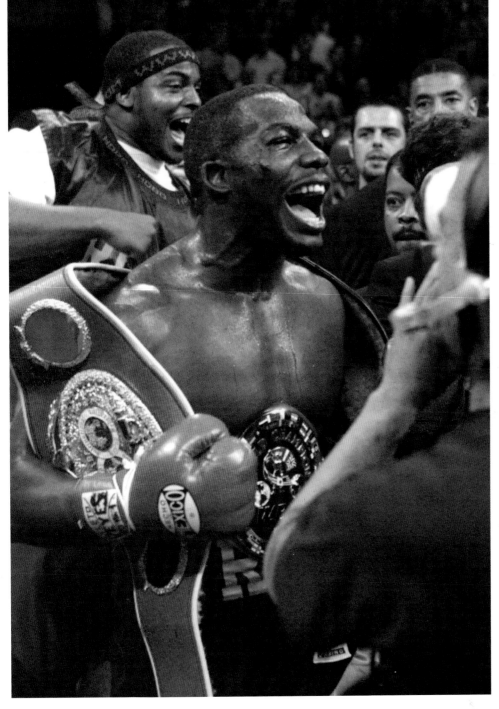

Hasim 'The Rock' Rahman, who knocked out Lewis in the fifth round to become the new WBC/IBF/IBO heavyweight champion, celebrates with the three belts that Lewis had held prior to the world heavyweight title fight at Carnival City.

22nd April, 2001

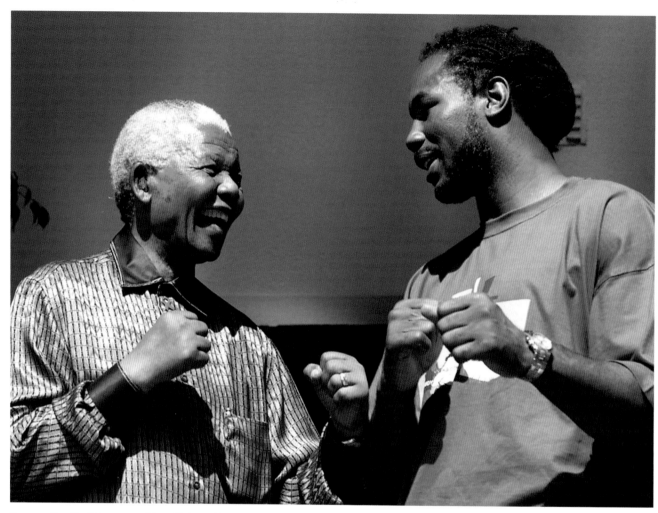

Former South African president Nelson Mandela, in Johannesburg, squares up to former world heavyweight champion Lennox Lewis after the boxer had told the media that he intended to win back his heavyweight titles.
23rd April, 2001

Facing page: Erich 'Butterbean' Esch, resplendent in his trademark 'stars and stripes' shorts, shows off to his public before the heavyweight bout against Britain's Shane Woollas (R). The rotund pugilist – who is also a kickboxer and mixed martial artist – typically fights four-round bouts (normally for less experienced or club fighters). Woollas succumbed to Esch's powerful punching in the first round.
16th June, 2001

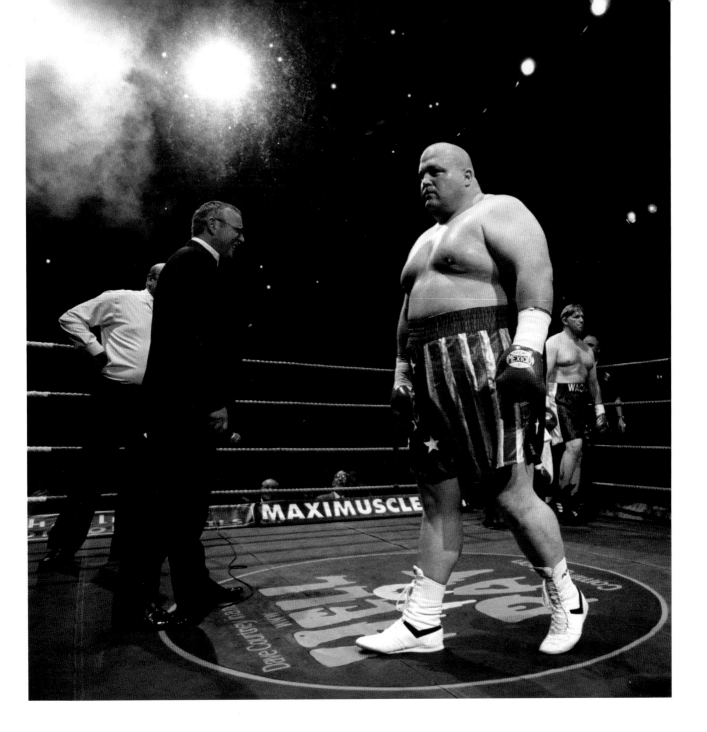

Joe Calzaghe (L) with his father and trainer, Enzo, during a training session in Newbridge Gym, south Wales, ahead of his super middleweight title fight with Charles 'The Hatchet' Brewer at the International Arena, Cardiff. 'Fighting Dragon' Calzaghe, whose father is Sardinian and mother Welsh, defeated Brewer by unanimous decision in the 12th round.
11th April, 2002

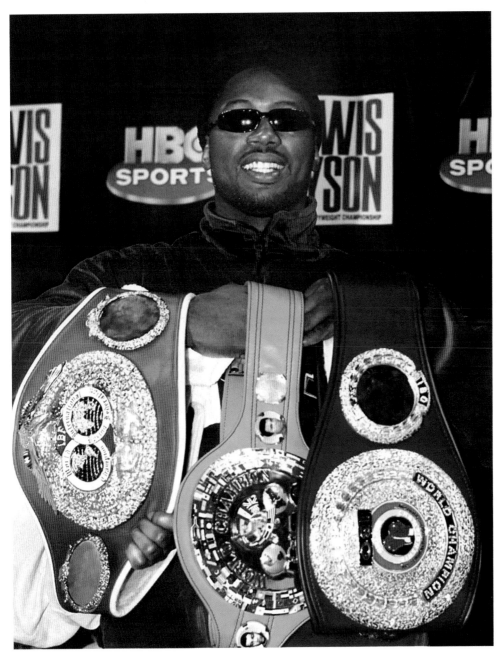

Lennox Lewis holds his three retained heavyweight title belts (WBC, IBF & IBO), the day after he had knocked out the former champion, Mike Tyson, with a right hook in the eighth round at the Pyramid Arena, Memphis, USA. Lewis' superior reach had prevailed over Tyson, who became sluggish, suffering from a swollen face and cut eyes.

9th June, 2002

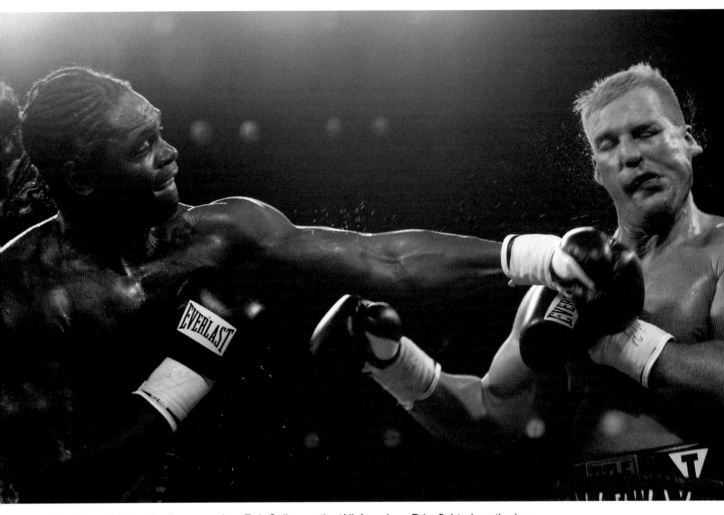

Southpaw Audley Harrison smashes Rob Calloway, the 'All-American Prizefighter', on the jaw during their heavyweight bout at the Fountain Leisure Centre, Brentford, Middlesex. Referee Mikey Vann called a halt to the fight shortly after the bell had sounded to start the fifth round, when it became apparent that Calloway's jaw was broken.

8th February, 2003

World champion Jane Couch (R), from Bristol, and Bulgarian champion Borislava Goranova clash in their eight-round, non-title, light welterweight fight at the Marriott Hotel, London. Couch had twice beaten Goranova, and would succeed again when the referee stopped the fight in the seventh round. Talks were continuing about a possible clash with Laila Ali, daughter of the legendary Muhammad Ali.

26th February, 2003

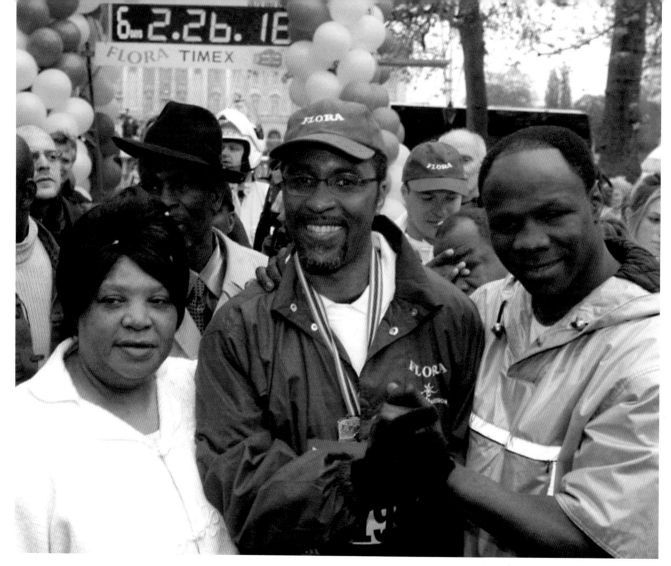

Michael Watson, 38 (C), with his mother, Joan, and boxer Chris Eubank on The Mall in central London, after he had crossed the finishing line of the 2003 Flora London Marathon. Watson, partially disabled after suffering a near-fatal brain injury during the WBO super middleweight title clash with Eubank in 1991, crossed the finishing line six days after setting off on the 26.2-mile marathon. He raised over £1m for the British Brain and Spine Foundation through his incredible achievement.
19th April, 2003

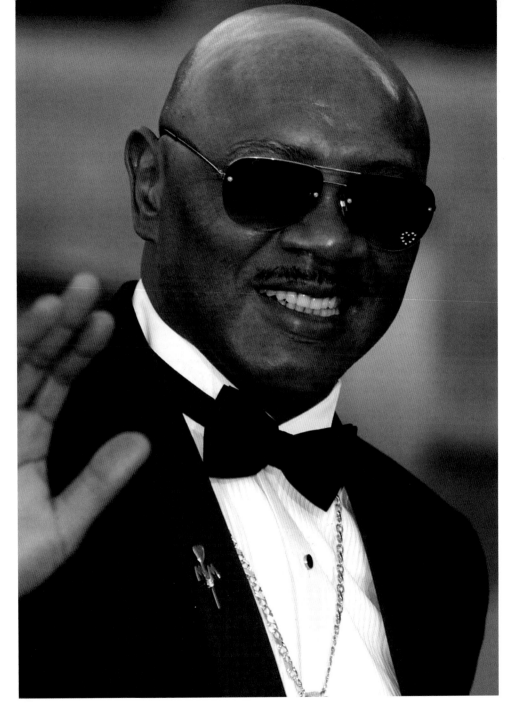

The former undisputed middleweight champion of the world, Marvelous Marvin Hagler, arrives for the Laureus World Sports Awards at the Forum Grimaldi in Monte Carlo. After his boxing career (62 wins, 3 losses and 2 non-decisions, with 52 knockouts), Hagler quit and moved to Italy, where he became the star of action films. Father of five children by his first wife, he remarried in 2000 to Kay, an Italian.

20th May, 2003

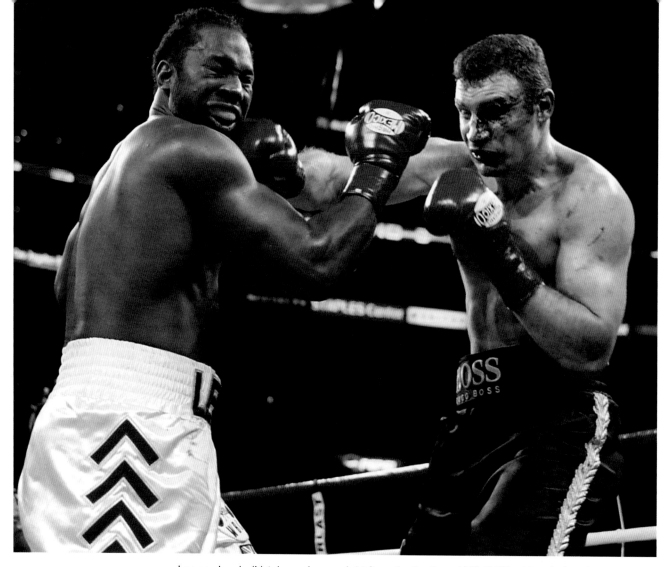

Lennox Lewis (L) takes a heavy right from the badly-cut Vitali Klitschko, during the sixth round of the WBC and IBO world heavyweight title fight at the Staples Center Arena in Los Angeles, USA. Although Ukrainian Klitschko was ahead on the judges' scorecards, the doctor stopped the fight in the sixth round after the cut, opened by Lewis in the third round, obscured the fighter's vision. Lewis was awarded victory by technical knockout. Subsequently, he quit the sport.

22nd June, 2003

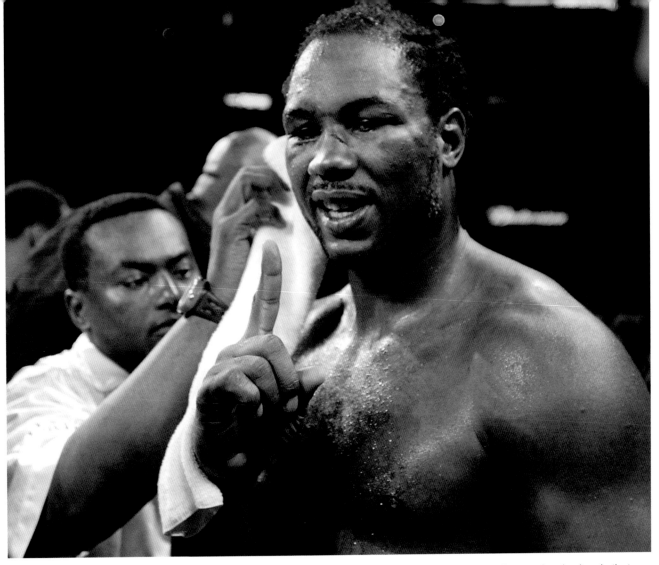

Lennox Lewis signals that he's still the number-one heavyweight in the world after Vitali Klitschko was stopped by the corner doctor at the end of the sixth round due to cuts around his left eye.
22nd June, 2003

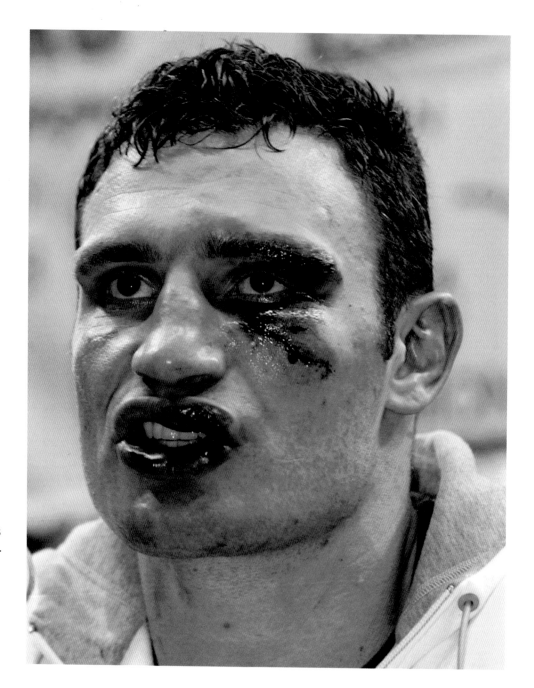

Defeated, with stitches on his eyebrow and cheek, a bloodied Vitali Klitschko talks at a post-fight press conference at the Staples Center Arena, following his bout against Lennox Lewis. The 6ft 7½in-tall Ukrainian was the first professional boxing world champion to hold a PhD, in sports science, hence his ring name, 'Dr Iron Fist'.
22nd June, 2003

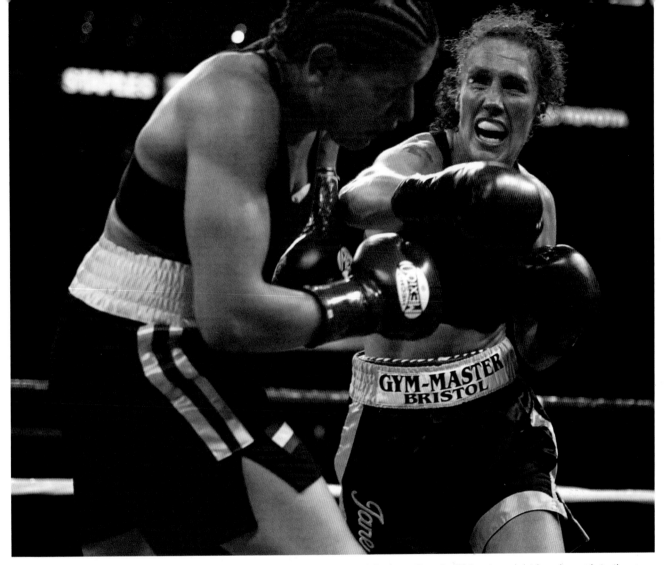

Britain's Jane Couch (R) lands a right-hand punch to the head of American Lucia Rijker, during the former's points defeat in the junior middleweight division at the Staples Center Arena in Los Angeles, USA.
22nd June, 2003

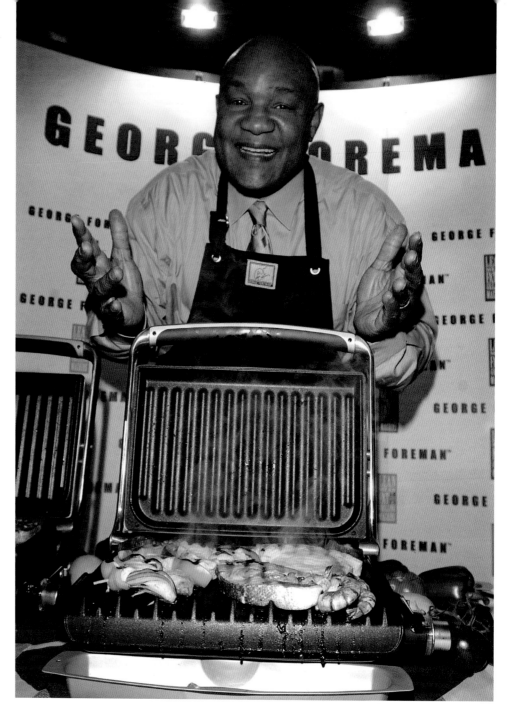

Two-time former heavyweight champion of the world George Foreman, in central London to launch the 'Cafe George', one of the new additions to his hugely popular Lean Mean Fat-Reducing Grilling Machine range. Marketed as a way to 'knock out the fat' (via slanted heating surfaces), more than 80 million grills have been sold since 1994, earning Foreman considerably more money than he made as a boxer.
17th December, 2003

Olympic silver medalist in the 2004 Athens Olympic Games, at the age of 17, Amir Khan, from Bolton, Greater Manchester, signed with boxing promoter Frank Warren in 2005. His professional debut in the light welterweight category took place on 16th July, 2005 at the Bolton Arena, against southpaw David Bailey, from London. The newcomer would win by technical knockout in just 1 minute and 49 seconds of the first round.

13th July, 2005

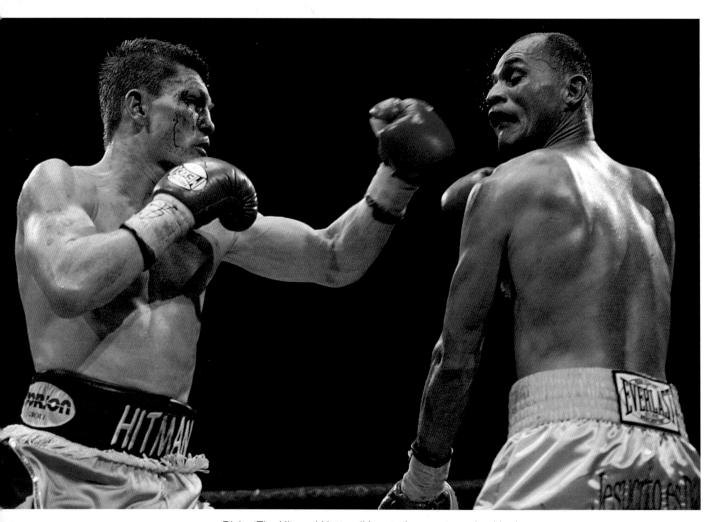

Ricky 'The Hitman' Hatton (L), sporting a cut received in the first round, battles it out with the Colombian Carlos Maussa, during the IBF/WBA light welterweight title unification bout, at the Hallam FM Arena, Sheffield, South Yorkshire. Maussa was counted out in the ninth of 12 rounds.

26th November, 2005

Scott Harrison during a press conference at the Marriott Hotel, Glasgow, Scotland to promote his WBO world featherweight title fight against Joan Guzmán, from the Dominican Republic. Harrison's career was marred by problems with drink and drugs, and brushes with the police on assault, breach of the peace and drink-driving charges. He was stripped of his WBO title in December 2006 and lost his licence to box.

10th January, 2006

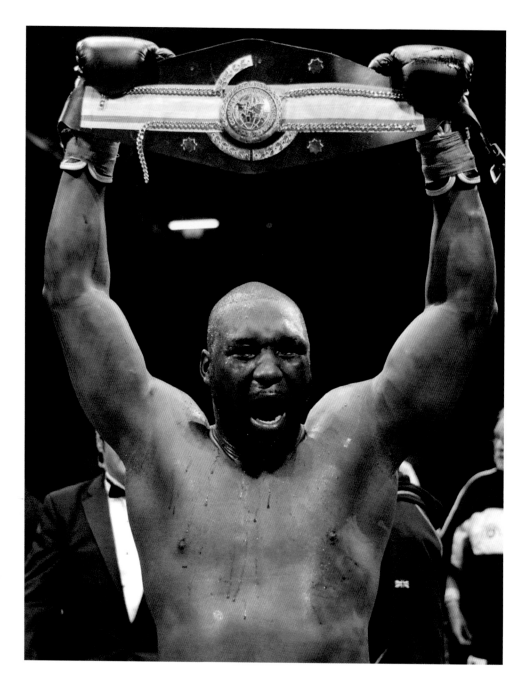

Danny Williams celebrates with the belt after defeating Matt Skelton in the Commonwealth heavyweight championship bout at the ExCel Arena, London. Williams beat Skelton on a split points decision to retain the title.
26th February, 2006

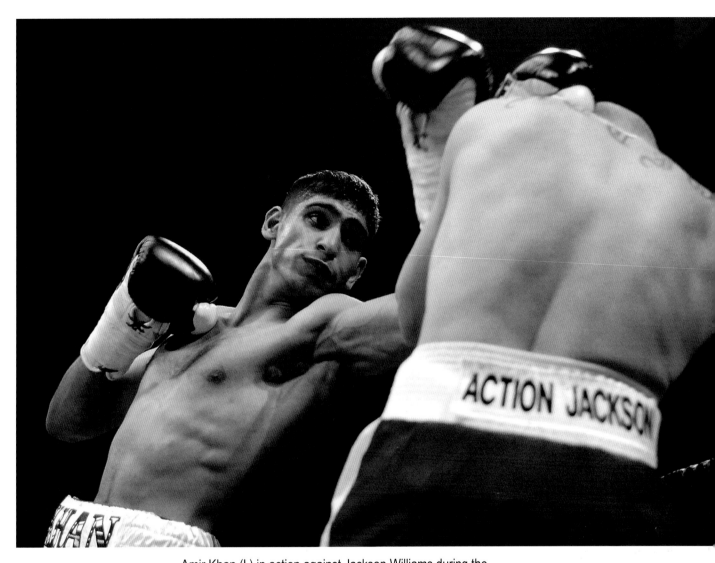

Amir Khan (L) in action against Jackson Williams during the lightweight bout at the ExCel Arena, London. Khan made it six out of six wins by stopping Williams in the third round.
26th February, 2006

Rising British star, 20-year-old Amir Khan outside the King's Hall Conference Centre in Belfast, Northern Ireland. Khan would feature in his first fight in Belfast on 20th May, 2006. His opponent would be the 30-year-old Hungarian Laszlo Komjathi. Khan would win on points in the sixth and final round.

27th March, 2006

Ricky Hatton, returning to fight at light welterweight after a move to welterweight, poses outside the Billy 'The Preacher' Graham Gym in Denton, Greater Manchester, where he was preparing for his fight on 20th January, 2007 against Juan Urango at the Paris Las Vegas Hotel and Casino, Las Vegas, USA. Hatton won a 12-round unanimous decision against the Colombian fighter.

4th January, 2007

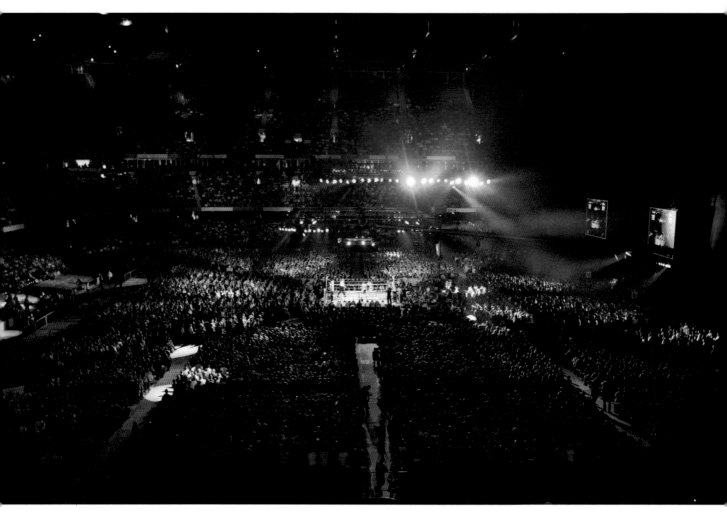

A full house watches the Welsh undefeated super middleweight champion Joe Calzaghe in action against America's Peter Manfredo, at the Millennium Stadium, Cardiff. It was Calzaghe's 20th title defence, and one he would win in the third round when the referee stopped the fight after Manfredo seemed unable to reply to the Welshman's onslaught.

7th April, 2007

Former world boxing champion turned anti-war activist
Chris Eubank, 40, is led away by police after parking his
7-tonne American Peterbilt 379 truck outside Downing
Street, Whitehall, London. Witnesses said that the truck
was emblazoned with a message to Prime Minister Gordon
Brown demanding a withdrawal from Iraq.
22nd May, 2007

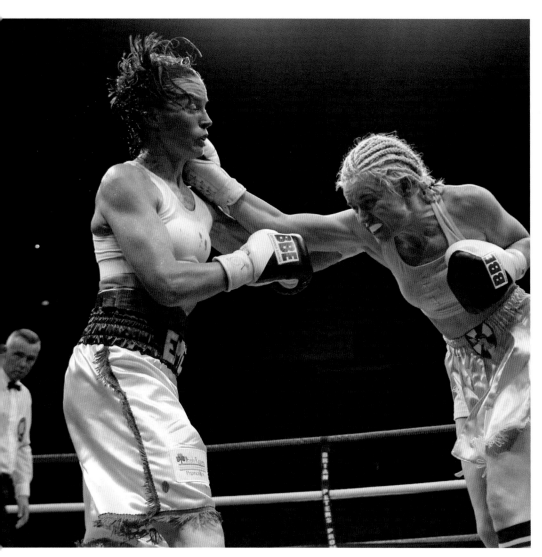

American boxer Jill Emery (L) clashes with Russian born Angel McKenzie, of England, during the first professional female boxing match in the Republic of Ireland, held at The Point, Dublin. Emery won by referee's decision in the eighth round.
23rd June, 2007

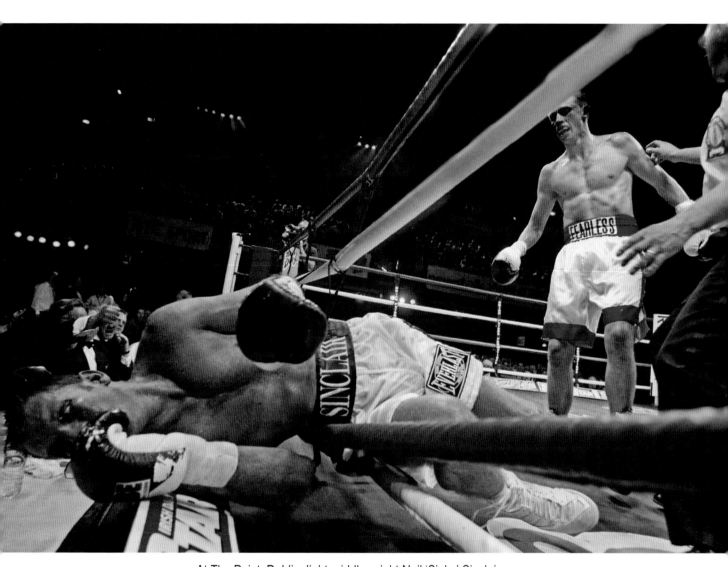

At The Point, Dublin, light middleweight Neil 'Sinky' Sinclair, from Belfast, is knocked through the ropes in the fifth round by 'Fearless' Francis Jones, from Darlington, County Durham, and counted out by referee David Irving.
23rd June, 2007

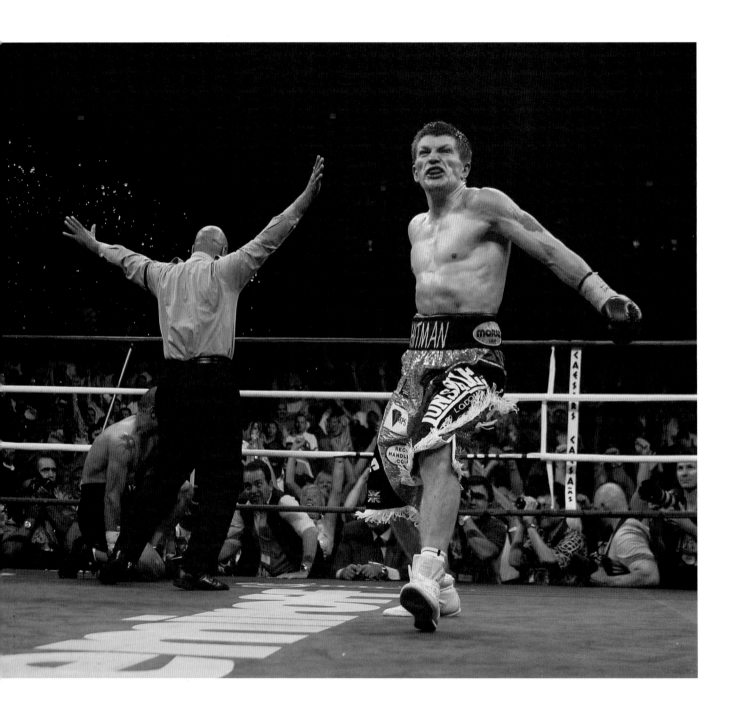

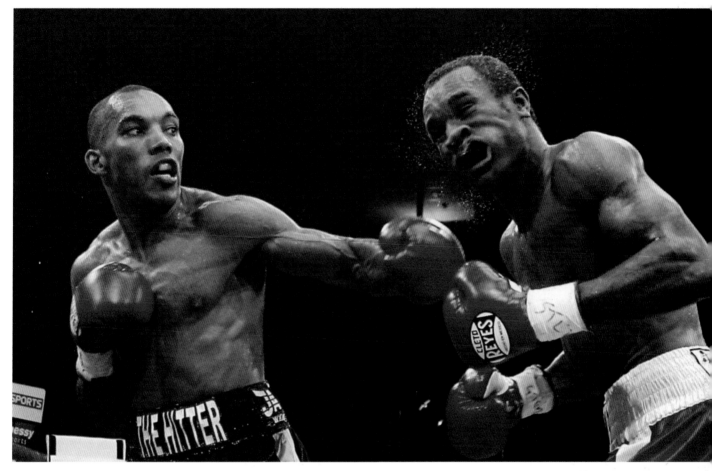

Facing page: England's Ricky Hatton celebrates defeating
Mexico's Jose Luis Castillo after a fourth-round stoppage at the
Thomas & Mack Center, Las Vegas, Nevada, USA. In a match
during which both fighters were cautioned against excessive
clinching, a 'perfect' left hook to the liver from Hatton sent
Castillo to the canvas and, unable to stand up, he was counted
out by referee Joe Cortez. Later it was discovered that the
punch had broken four of the Mexican's ribs.
23rd June, 2007

A fierce left from Sheffield's
Junior 'The Hitter' Witter (L)
connects with the yielding
jaw of 'Vicious' Vivian Harris,
from Guyana, during the
WBC light welterweight
world championship bout at
Doncaster Dome, Doncaster,
Yorkshire. Harris, sent to the
canvas, was counted out.
7th September, 2007

A boxing match in progress at the National Arena in Dublin, Ireland. The indoor sports venue was opened in 1993 as a basketball arena, but today the 2,000-seat facility hosts other sporting events in addition to boxing, including hockey, football and gymnastics.

21st October, 2007

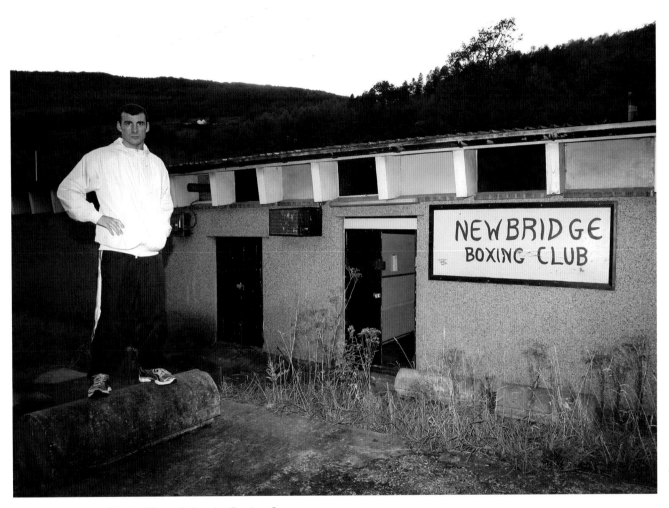

Joe Calzaghe outside the Enzo Calzaghe Boxing Gym, Abercarn, South Wales. Calzaghe became BBC Sports Personality of the Year in 2007, which made him the first Welsh winner of the prestigious award since show jumper David Broom in 1960.

30th October, 2007

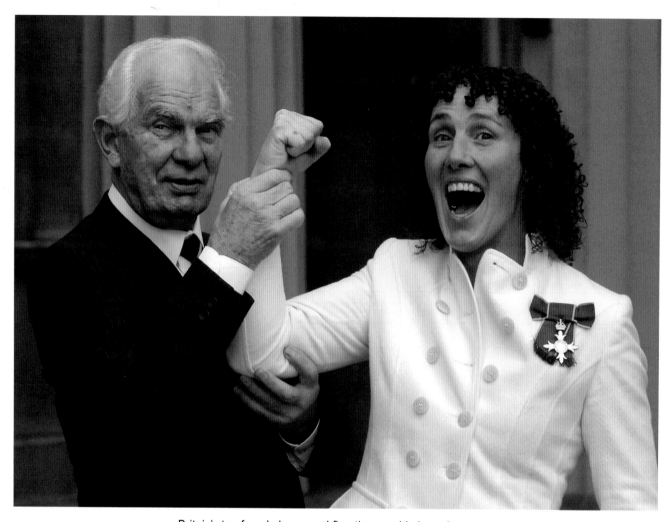

Britain's top female boxer and five-time world champion, Jane Couch, with trainer Tex Woodward, after collecting her MBE from the Prince of Wales during an investiture ceremony at Buckingham Palace, London.
2nd November, 2007

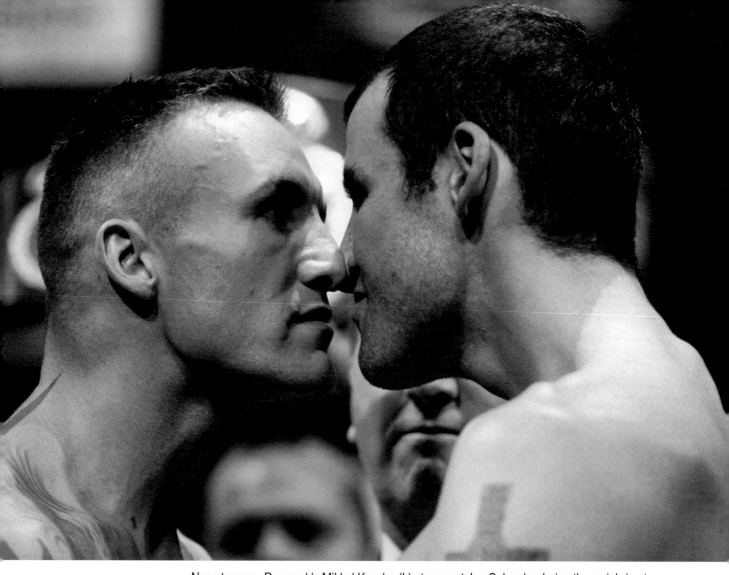

Nose to nose. Denmark's Mikkel Kessler (L) stares out Joe Calzaghe during the weigh-in at St David's Hall, The Hayes, Cardiff. The Welsh champion had accepted $5m to fight fellow undefeated champion Kessler in a unification bout for the WBO/WBA/WBC and *Ring* magazine super middleweight titles. In front of a record 50,000 fans at Cardiff's Millennium Stadium, on 3rd November, 2007, Calzaghe would win by unanimous decision after an exhilarating fight.
2nd November, 2007

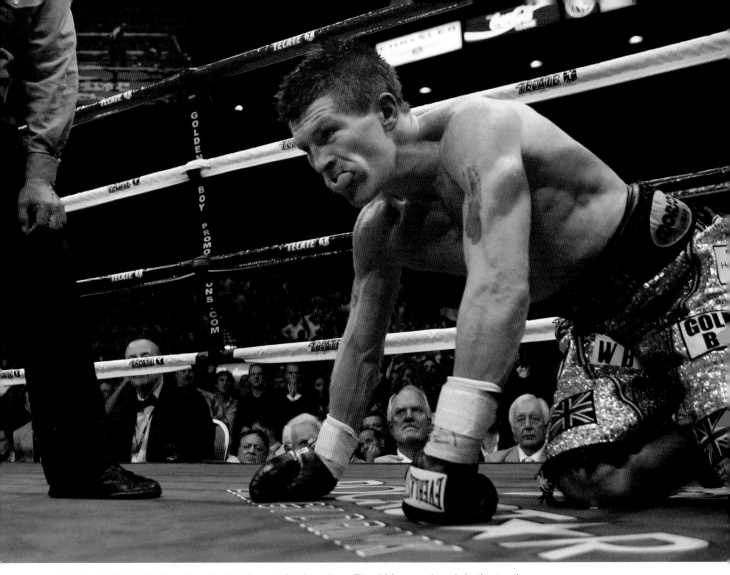

England's Ricky Hatton, knocked to the mat by American Floyd Mayweather Jr in the tenth round of the WBC welterweight title fight at the MGM Grand Garden Arena, Las Vegas, USA. In a match that saw Hatton angered by referee Joe Cortez' point penalization for punching behind the head, Mayweather took the advantage and delivered a few more punches to the face before Cortez called a halt to the action, and a dazed Hatton fell back down again.

8th December, 2007

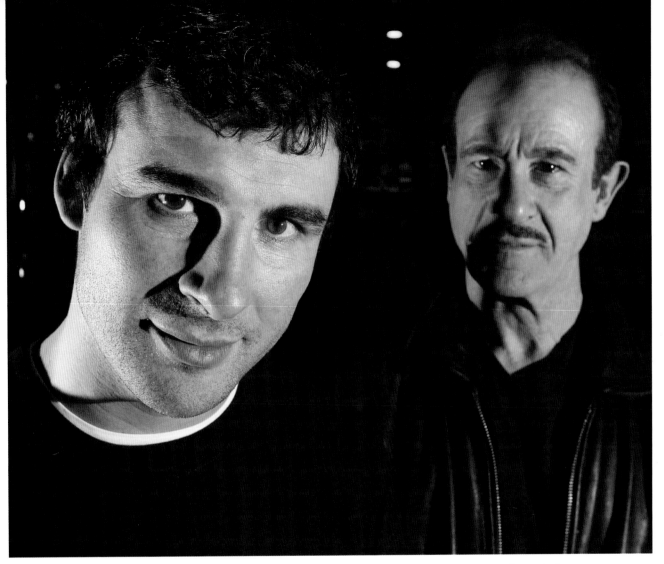

Joe Calzaghe (L) with his father, Enzo, during a press conference at Planet Hollywood, London, to announce the forthcoming fight with the USA's Bernard Hopkins in Las Vegas on 19th April, 2008.
23rd January, 2008

David 'The Hayemaker' Haye celebrates his victory over Welshman Enzo 'Big Mac' Maccarinelli following the WBC/WBA/WBO cruiserweight fight at the O2 arena, Greenwich, in London. Haye triumphed in the second round with a stunning right hand to Maccarinelli's head, followed by a flurry of punches and a subsequent knock down. Maccarinelli rose unsteadily and wobbled back to his corner before referee John Keane waved the bout off.
9th March, 2008

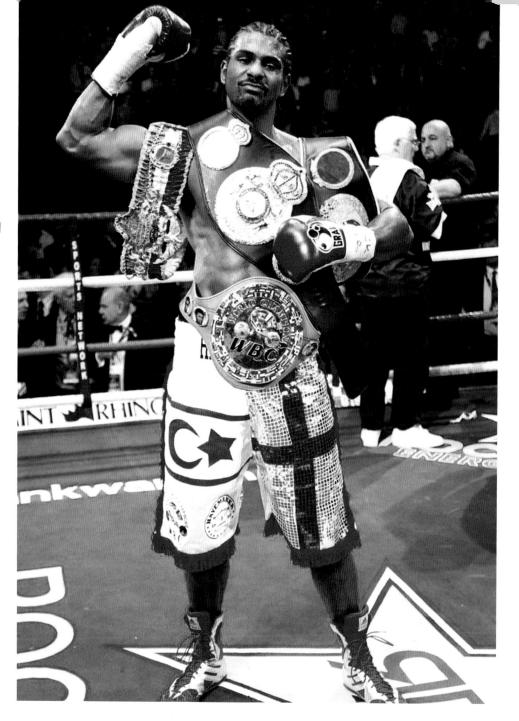

Frank Bruno (L) and former Olympic athlete Sebastian Coe get ready to run the London Sainsbury's Sport Relief Mile on Victoria Embankment, London. The event involved more than 100,000 participants taking part in 23 simultaneous events in other towns and cities.

16th March, 2008

Boxing trainer Enzo Calzaghe in reflective mood at the Newbridge Boxing Club, Newbridge, South Wales, which he took over on the retirement of Paul Williams. Calzaghe, originally from Sardinia, coaches his son, undefeated light heavyweight champion Joe Calzaghe, in addition to cruiserweight champion Enzo Maccarinelli, light welterweight champion Gavin Rees and world title challenger Gary Lockett.
18th March, 2008

British Prime Minister Gordon Brown (C) with members of Great Britain's Olympic boxing squad: (L–R) Bradley Saunders, Joe Murray, James DeGale, Khalid Yafai, Frankie Gavin, Billy Joe Saunders and Tony Jeffries. The squad was attending a reception in the prime minister's private office at the Houses of Parliament, London during preparations for their participation in the Beijing Olympics in the summer.

19th March, 2008

With a look of steely
determination, Joe Calzaghe
poses during a workout at
the Newbridge gym.
26th March, 2008

Boxing gloves come in various styles, weights and colours, in vinyl or leather. Speed gloves and bag gloves (8–10oz) protect the hands from scrapes during work on punching bags, while sparring gloves (14–20oz) and fight gloves (8–10oz) are cushioned to protect both boxers. Before competition, gloves are laced up, sealed with tape and signed by an official to ensure they are not tampered with.
26th March, 2008

Amir Khan (R) sparring at Gloves Community Centre, Bolton, Lancashire. He would face
Martin Kristjansen, from Denmark, in the WBO intercontinental lightweight title and WBO
lightweight title eliminator, on 5th April, 2008. Khan floored Kristjansen three times in the
seventh round and won with a technical knockout.

27th March, 2008

England's Carl Froch makes a theatrical entrance before the super middleweight bout at Nottingham Arena against unbeaten Pole Albert Rybacki. Froch dispensed with Rybacki in the fourth round of a scheduled 12.

10th May, 2008

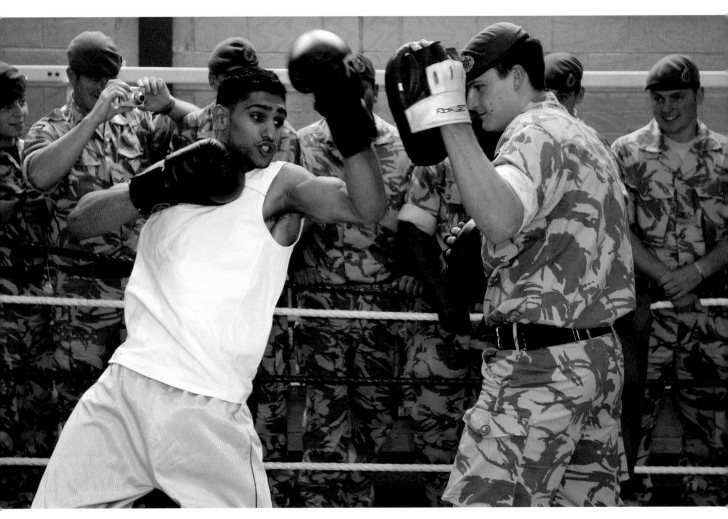

Amir Khan (L) spars with Kingsman Scott Craven of the 1st Battalion Duke of Lancaster's Regiment at the Gloves Community Centre in Bolton, Lancashire.

21st May, 2008

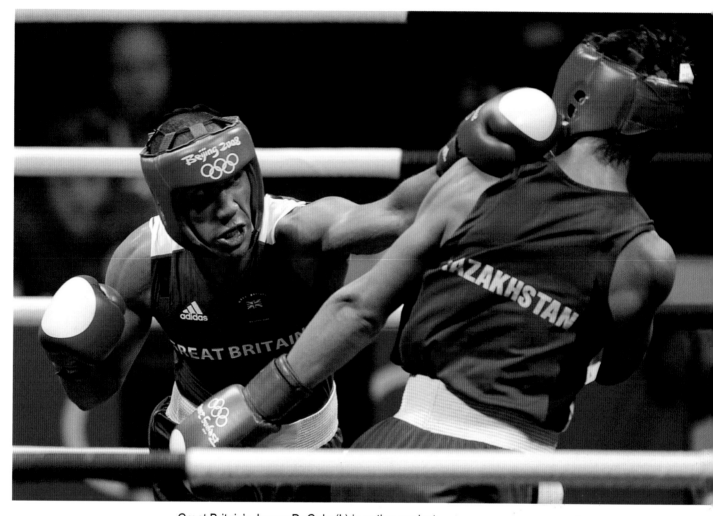

Great Britain's James DeGale (L) in action against
Kazakhstan's Bakhiyar Artayev during their quarter-final
middleweight bout at the Beijing Workers' Gymnasium
in Beijing, China on day 12 of the 2008 Olympic Games.
DeGale would go on to win a gold medal after defeating
Cuban Emilio Correa.
20th August, 2008

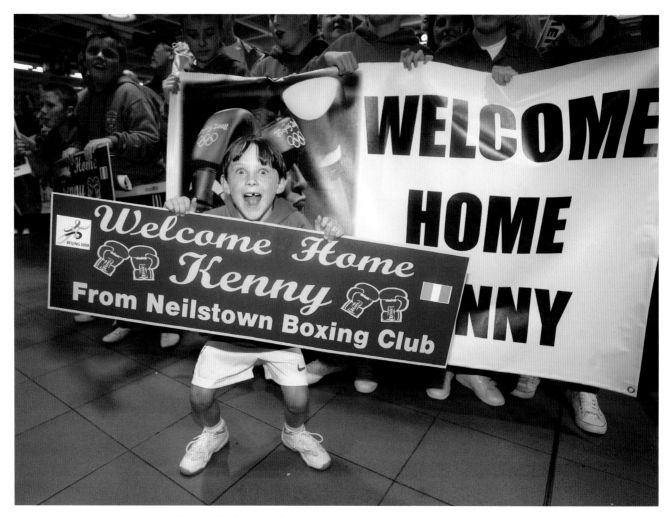

Fans of Irish boxer Kenny
Egan, who had won a silver
medal in the Beijing Olympic
Games, await his return at
Dublin Airport.
26th August, 2008

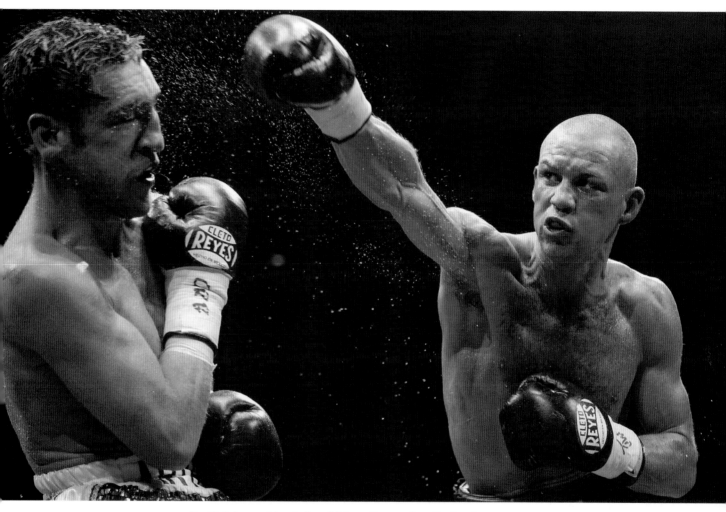

Scottish boxer Alex Arthur (L) in action against England's Nicky Cook, during their WBO super featherweight championship title fight at the *Manchester Evening News* Arena, Manchester. Arthur relinquished the title by unanimous decision in the 12th and final round.

6th September, 2008

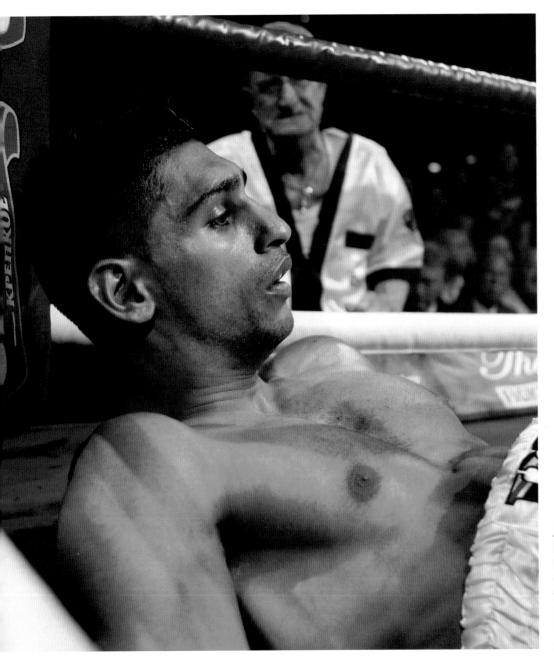

A dazed Amir Khan after being knocked out by Breidis Prescott during their Commonwealth lightweight title fight at the *Manchester Evening News* Arena, Manchester.
6th September, 2008

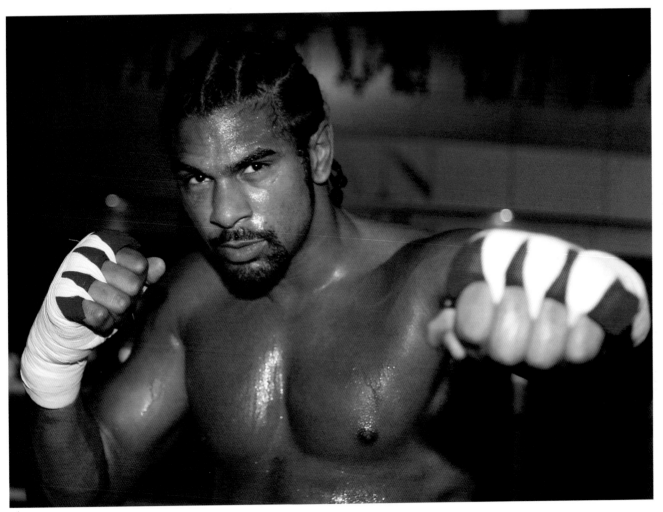

Heavyweight boxer David
Haye during a workout at the
O2 Arena, London.
16th September, 2008

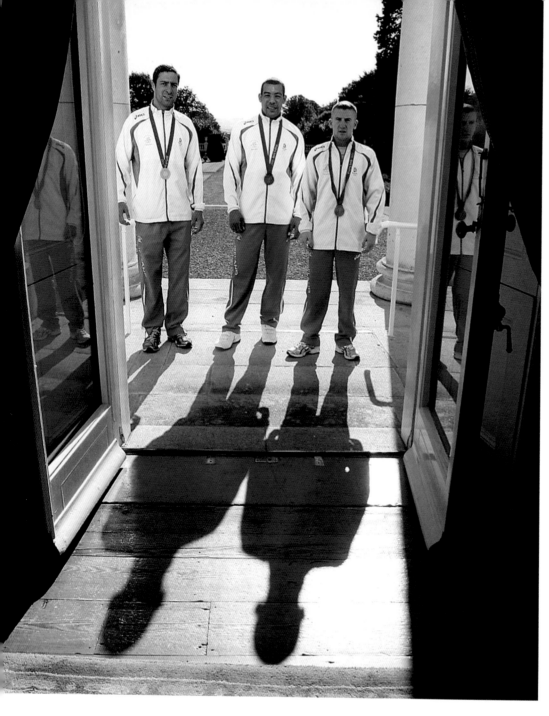

L–R: Boxers Ken Egan (light heavyweight), Darren Sutherland (middleweight) and Paddy Barnes (light flyweight) during a reception for the Irish Olympic Team, hosted by President Mary McAleese and her husband, Dr Martin McAleese, at Aras An Uachtarain, Phoenix Park, Dublin.
20th September, 2008

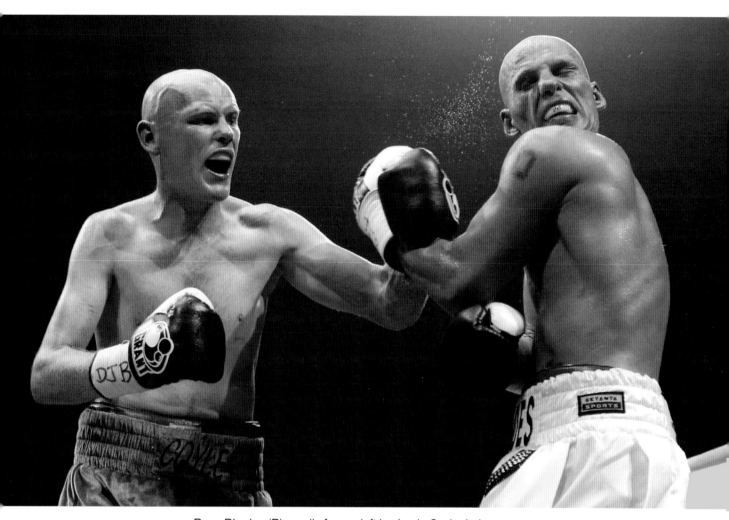

Ryan Rhodes (R) recoils from a left by Jamie Coyle during
the British light middleweight title fight at Hillsborough
Leisure Centre in Sheffield. Rhodes' pounding paid off, and
he won the bout by unanimous decision after 12 rounds.
20th September, 2008

Derry gold. English featherweight Derry Mathews prepares to enter the ring for his British eliminator title fight against Martin Lindsay, from Belfast, at Hillsborough Leisure Centre, Sheffield.
20th September, 2008

Trainer Anthony Farnell (former WBU middleweight champion) spars with Tony Bellew (L) as boxer Joe Selkirk jumps the bar, during a training session at Farnell's Arnie's Gym in Manchester.

25th September, 2008

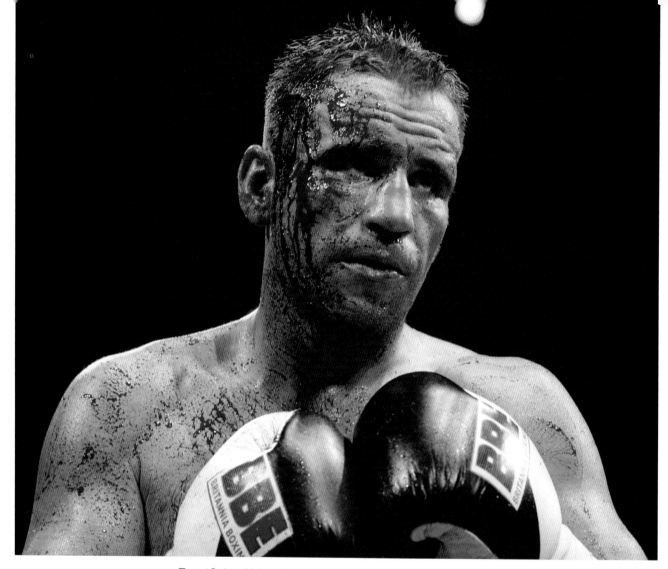

Tony 'Oakey Kokey' Oakey received a cut in round five of the bout for the vacant Commonwealth light heavyweight title at Everton Park Sports Centre, Liverpool against Welshman Nathan Cleverly, going on to lose by unanimous decision after 12 rounds.

10th October, 2008

Joe Calzaghe adopts a cheeky stance after his points victory over American Roy Jones in the light heavyweight bout at Madison Square Garden, New York, USA.

8th November, 2008

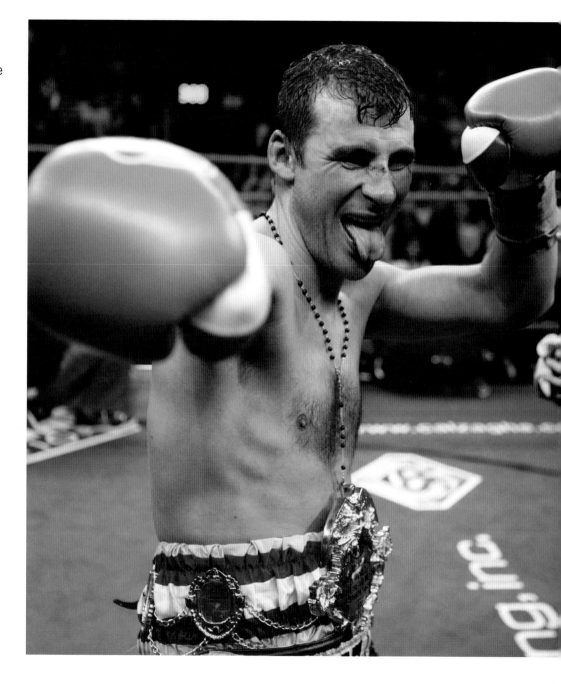

Referee Ritchie Davies stops the featherweight fight between Crawley's Robin Deakin (L) and Belfast's Kevin O'Hara, at Bethnal Green's York Hall after 1 minute and 58 seconds of the first round, awarding a win to O'Hara by technical knockout.

8th November, 2008

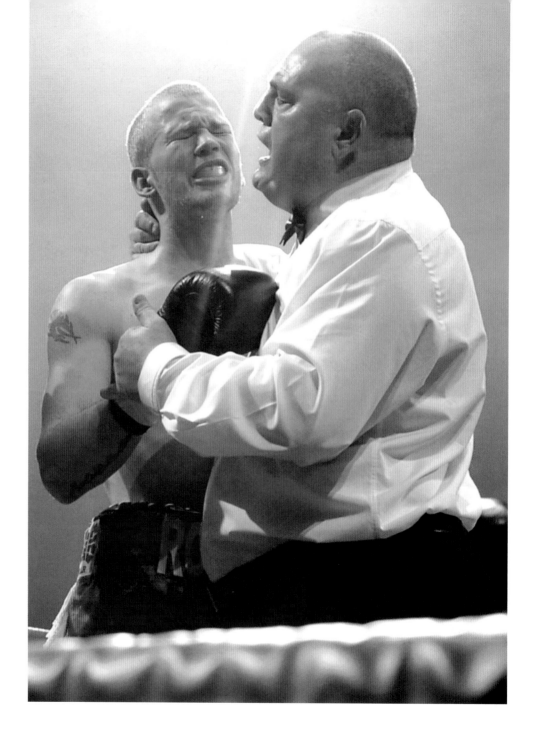

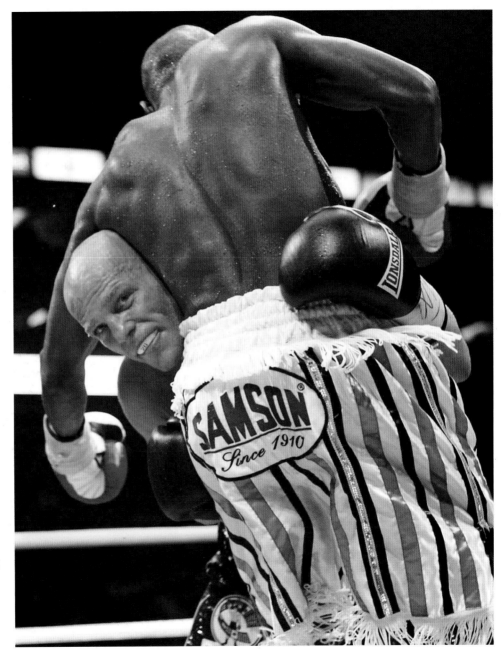

Great Britain's Ryan Rhodes (L) grapples with South African Vincent Vuma during their WBC light middleweight title fight at the O2 Arena, London. Rhodes came through 12 tough rounds to beat Vuma and take the title.
15th November, 2008

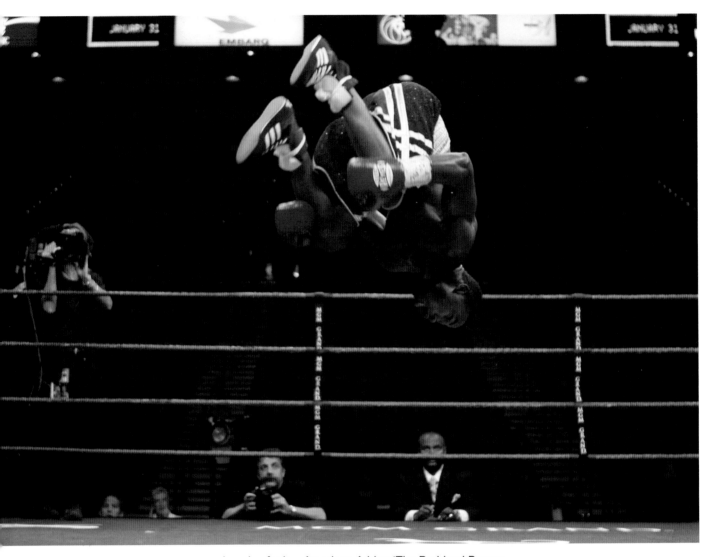

Jumping for joy. American Adrien 'The Problem' Broner celebrates defeating fellow countryman Terrance Jett during a lightweight fight at the MGM Grand Hotel, Las Vegas, USA.
22nd November, 2008

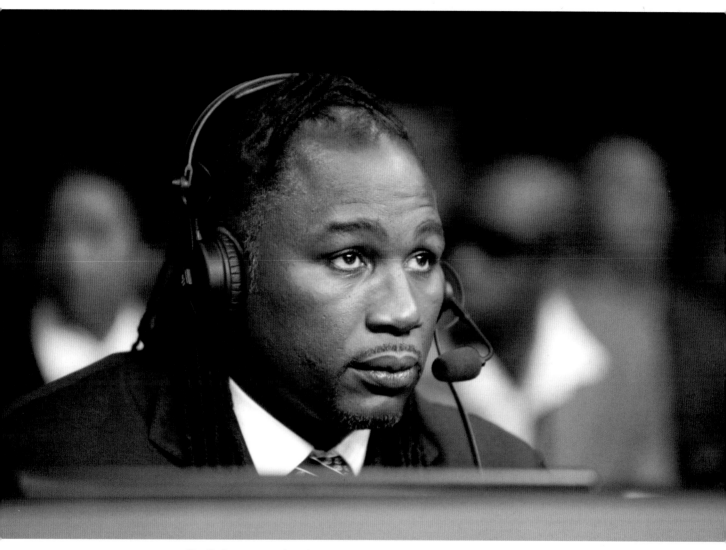

Studied concentration. Lennox Lewis watches England's
Ricky Hatton defeat American Paulie Malignaggi during
the IBF light welterweight fight at the MGM Grand Hotel,
Las Vegas, USA.
22nd November, 2008

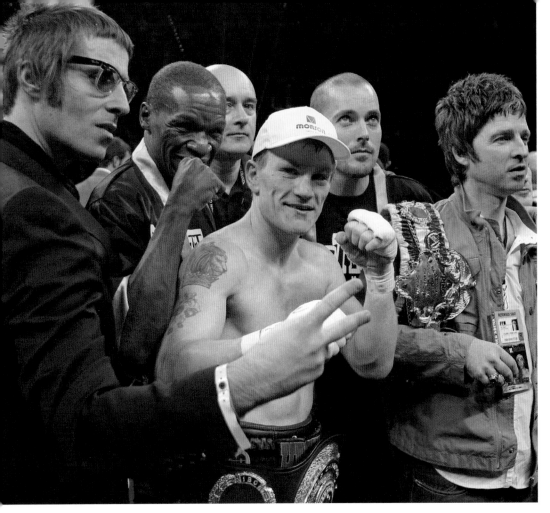

Boxing fans Liam and Noel Gallagher from rock band Oasis (L and R respectively) help Ricky Hatton (C) celebrate after he had defeated Paulie Malignaggi during the IBF light welterweight fight.
22nd November, 2008

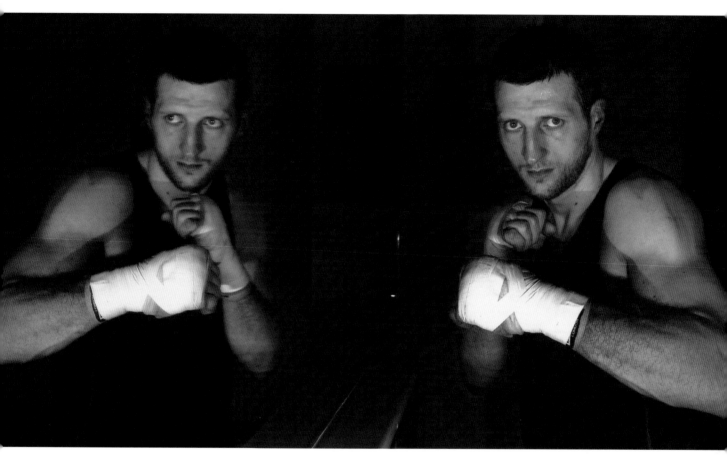

Mirror image. Carl Froch after a training session at the Liberty Gym, in his birthplace, Nottingham. Froch turned professional in 2002, relatively late in life, at the age of 25. He took the vacant WBC middleweight title on 6th December, 2008 after defeating Haitian-Canadian Jean-Thenistor Pascal. At the time, it was Pascal's only defeat in his 25-bout career.

2nd December, 2008

Birmingham born Frankie Gavin, who announced his decision to turn professional in October, 2008, after a distinguished amateur career, during which he had won gold medals in the 2006 EU Amateur Championships, the 2006 Commonwealth Games and the 2007 World Amateur Boxing Championships. Having signed a contract with Frank Warren, he would be trained by former world middleweight champion Anthony Farnell.
18 December, 2008

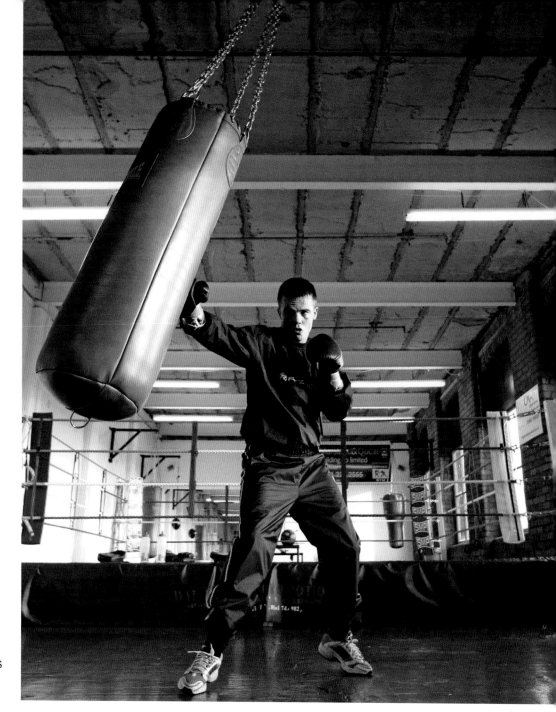

Frankie Gavin works the punchbag at Anthony Farnell's Arnie's Gym, Manchester. Gavin is in training for his professional debut on 28th February, 2009 against George Kadaria, from Georgia, a bout he would win in the fourth and final round by technical knockout, in what was described by pundits as a 'scrappy' fight.

18th December, 2008

Boxer Steve Bell tapes up
his hands during a training
session at Arnie's Gym
in Manchester.
14th January, 2009

L–R: James DeGale, Billy Joe Saunders and Frankie Gavin following a press conference at the National Indoor Arena in Birmingham. Frank Warren had recently revealed that the three members of the 2008 Olympic boxing team would become the latest additions to his stable, with the comment *"These guys are the future of British boxing."*
19th January, 2009

Former WBU middleweight champion Anthony Farnell at his gym in Failsworth, Manchester. Farnell retired from the ring in 2004 to concentrate on training.
21st January, 2009

Anthony Farnell (L) watches
Anthony Crolla do press-ups
at his gym in Failsworth,
Manchester.
2009

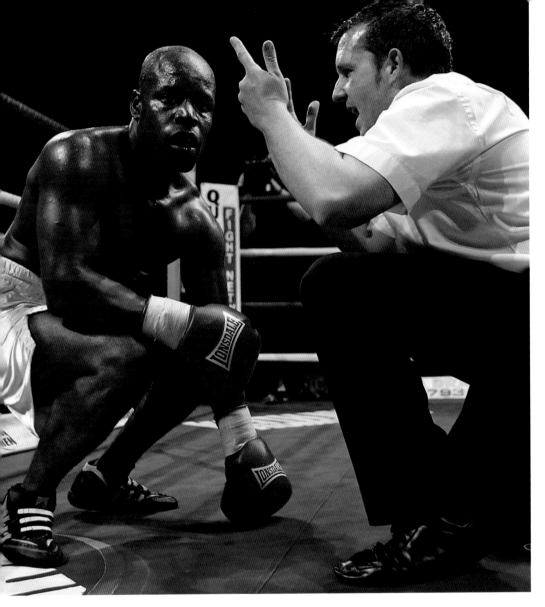

Sherman Alleyene (L), from Watford, is given the count by referee Reece Carter after being knocked down in the third of four scheduled rounds by Swindon's Marlon Reid in a super middleweight bout at the Oasis Leisure Centre, Swindon in Wiltshire.
13th February, 2009

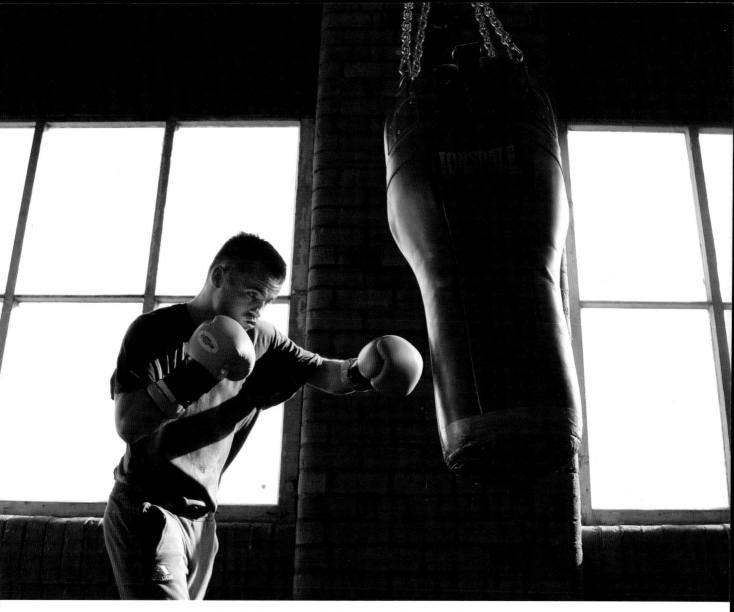

Frankie Gavin preparing for his forthcoming second professional bout against Mourad Frarena of France, in May 2009. Seeking a slicker performance than his first professional win, the young boxer excelled, winning with a third-round stoppage at Belfast's Odyssey Arena.
10th March, 2009

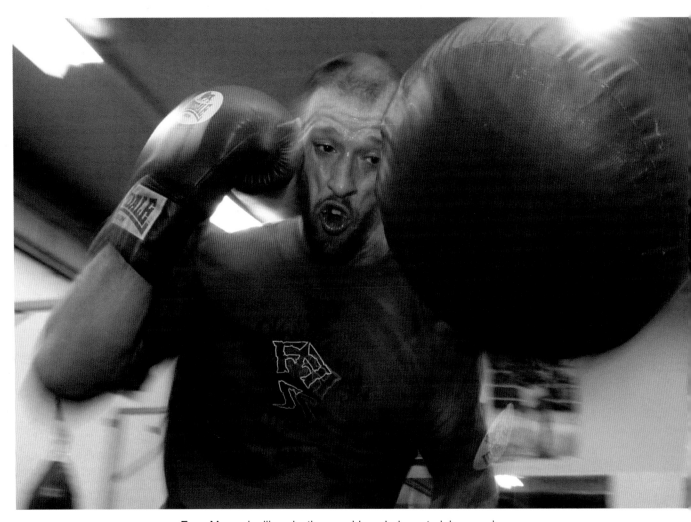

Enzo Maccarinelli works the punchbag during a training session at Shannon's Gym, Pennyhill Park, Openshaw, Manchester.
11th March, 2009

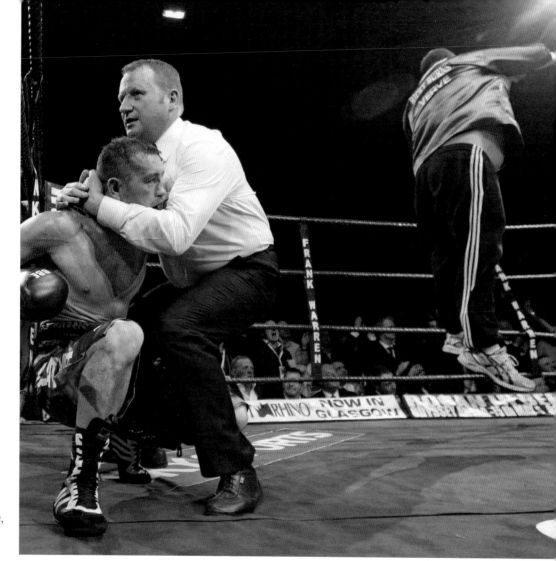

Ricky Burns' trainer, Billy Nelson (R), punches the air after referee Howard John Foster (C), seen supporting Michael Gomez, stops the fight in the seventh round of the Commonwealth super featherweight title bout at Bellahouston Leisure Centre, Glasgow, Scotland.
27th March, 2009

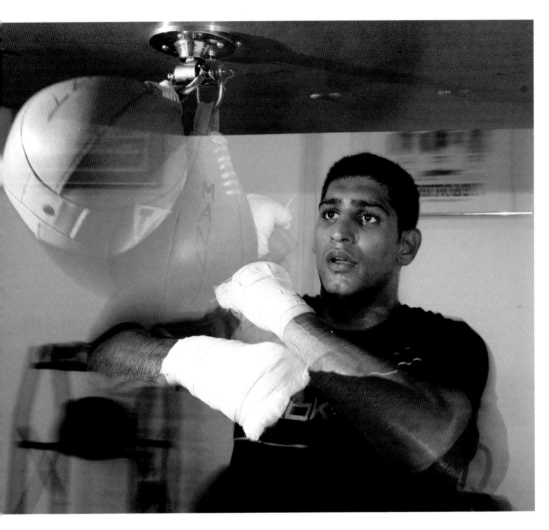

Great Britain's Amir Khan hones his skills at the IBA Gym in Las Vegas, USA, after it had been announced that his WBA light welterweight title fight against Andreas Kotelnik would be postponed for three weeks and switched from London to Manchester.
30th April, 2009

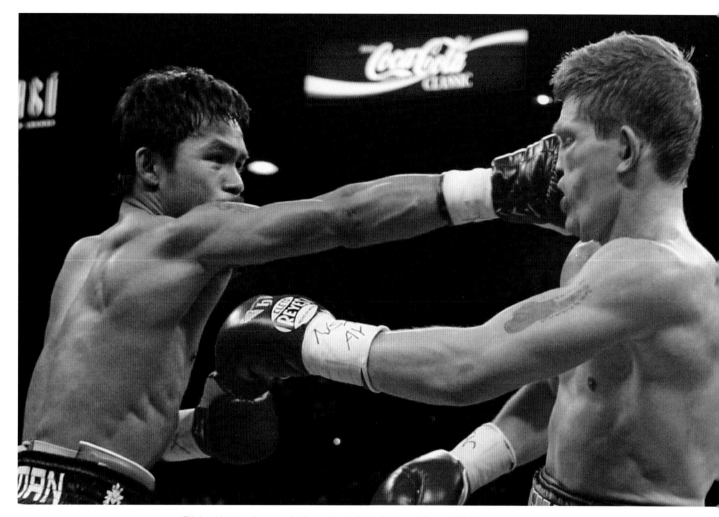

Ricky Hatton is caught by a straight right hand from Filipino Manny Pacquiao during the fight for the IBO and *The Ring* magazine light welterweight titles, at the MGM Grand, Las Vegas, USA. Hatton, who appeared sluggish, was floored twice in the first round.

2nd May, 2009

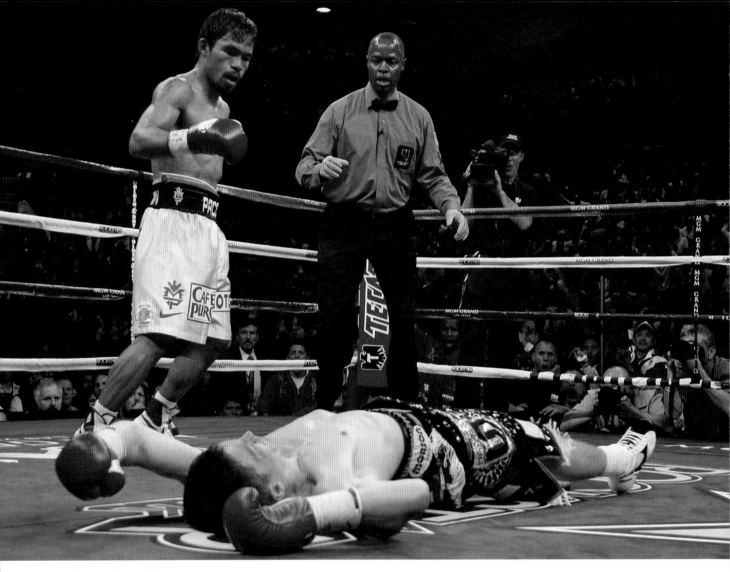

Hatton crashes to the canvas
after being felled by Pacquiao
for a third time, while referee
Kenny Bayless counts him
out one second before the
end of the second round.
2nd May, 2009

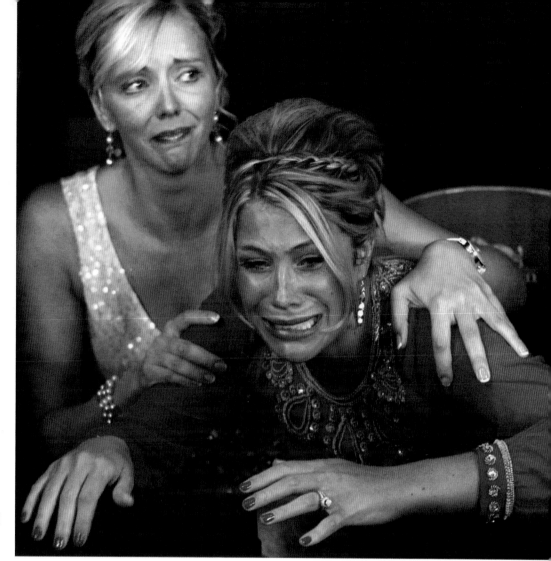

Ricky Hatton's fiancée, Jennifer Dooley, is consoled by his brother's girlfriend, Jenna Coyne, after Hatton was knocked out by Manny Pacquiao during the light welterweight fight at the MGM Grand, Las Vegas, USA.
2nd May, 2009

Floyd Mayweather Snr, from The Bronx, New York City, talks to the media during the Trainer's Round Table press conference at the MGM Grand Hotel, Las Vegas, USA. Mayweather, a welterweight contender during the 1970s and 1980s, formerly trained his son, five-division champion Floyd Mayweather Jnr, until a family rift resulted in a split. In 2007, Mayweather Snr discovered that he was the father of another boxer, 19-year-old Justin Jones, after a DNA test proved positive.
5th May, 2009

The great smell of success. Sir Henry Cooper at Repton Boys Club, London on the day the 75-year-old former champion received a lifetime achievement award from Brut and the London Ex-Boxer's Association.

7th May, 2009

Ireland's Martin Rogan sports a swollen eye after the heavyweight Commonwealth title bout against England's Sam Sexton, at the Odyssey Arena, Belfast, Northern Ireland, was stopped by the referee. This was hometown hero Rogan's only professional loss, and it was surrounded by controversy after the ringside doctor had forced the stoppage. The Commonwealth Boxing Council ordered a rematch, which had to take place no later than November 2009.

15th May, 2009

Child's play. Joe Calzaghe faces off against six-year-old Freddie Goggin, from Bow, London, in HMV's Oxford Street store, where the young contender defeated Calzaghe by knockout in Nintendo's Punch Out game for the Wii.

24th May, 2009

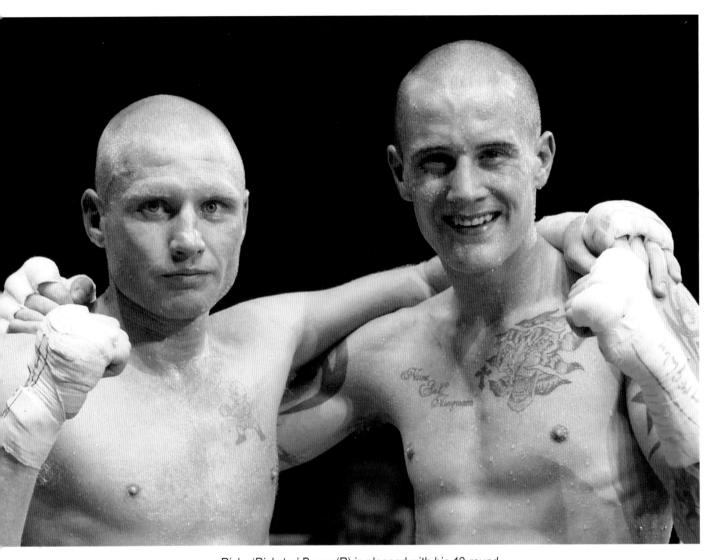

Ricky 'Rickster' Burns (R) is pleased with his 12-round
points win over Kevin 'Sweet Pea' O'Hara (L) during
the Commonwealth super featherweight title fight
at the Bellashouston Sports Centre, Glasgow.
19th June, 2009

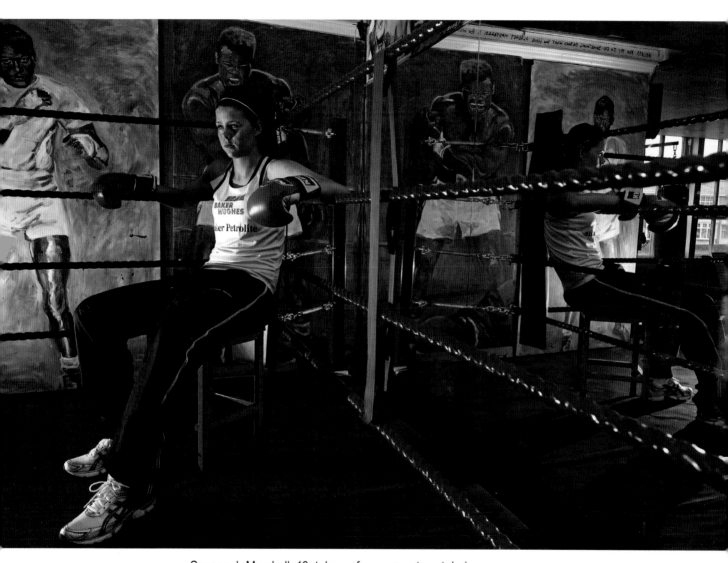

Savannah Marshall, 18, takes a few moments out during
a workout at the Headland Boxing Club in Hartlepool.
Six-foot-tall Marshall hopes to be a contender for Olympic
glory in the 2012 London Games.
27th July, 2009

The Publishers gratefully acknowledge Press Association Images, from whose extensive archives the photographs in this book have been selected. Personal copies of the photographs in this book, and many others, may be ordered online at www.prints.paphotos.com

AMMONITE
PRESS

PRESS
ASSOCIATION

For more information, please contact:

Ammonite Press

AE Publications Ltd, 166 High Street, Lewes, East Sussex, BN7 1XU, United Kingdom
Tel: + 44 (0)1273 488006 Fax: + 44 (0)1273 472418
www.ammonitepress.com